Making Routes

Journeys in Performance 2010-2020

Laura Bissell and David Overend

with
Helen Billinghurst, Nic Green, Lewis Hetherington,
Sarah Hopfinger, Adrian Howells, Jamie Lorimer,
Ishbel McFarlane, Sofie Narbed, Laura A. Ogden,
Phil Smith, Filipa F. Soares, Jenny Swingler
and Scott Twynholm

Published in this first edition in 2021 by:

Triarchy Press
Axminster, UK
www.triarchypress.net

A catalogue record for this book is available from the British Library.

ISBNs:
Print: 978-1-913743-38-3
ebook: 978-1-913743-39-0

Cover image: Walkway on Cramond Island, Firth of Forth.

All images are the authors' own unless otherwise specified.

Printed by TJ Books Limited, Padstow, UK

For Autumn

For Iona and Ruairidh

Contents

Contributors

Laura Bissell is Interim Head of Contemporary Performance Practice at the Royal Conservatoire of Scotland. Her research interests include contemporary performance practices, technology and performance, feminist performance, ecology and performance, and performance and journeys. Her recent collaborative projects have been interdisciplinary, focusing on rewilding performance, while her solo research has explored shorelines and tidal spaces as sites for performance. She is co-editor of *Performance in a Pandemic* with Lucy Weir (Routledge 2021).

David Overend is a Lecturer in Interdisciplinary Studies at the University of Edinburgh. His research focuses on contemporary theatre and performance, often at the intersection with cultural geography. As a director, David has worked for the National Theatre of Great Britain and several other theatres, and has toured internationally with award-winning productions. He is editor of *Rob Drummond Plays with Participation* (Bloomsbury Methuen Drama 2021).

Helen Billinghurst is a multidisciplinary artist, educator, researcher and writer. With a background as a film maker, she now works within the expanded fields of painting and drawing. Collaborating with Phil Smith as Crab & Bee, Helen makes walks, performances, poetry and exhibitions. They have worked together on an exhibition and walking project called *Plymouth Labyrinth* (funded by Arts Council England), and a residency at Teats Hill slipway (for Take Apart, Plymouth 2019). Their book, *The Pattern* (Triarchy Press 2020), is based on walks across Southern England and Wales.

Nic Green is an award-winning performance-maker based in Glasgow, Scotland. Her work is varied in style and method, with forms often found through collaborative and relational practices with people, place and material. Her work has received several awards, commissions and recognitions including the inaugural Forced Entertainment Award, a Herald Angel, "Best Production" at Dublin Fringe, The Adrian Howells Award for Intimate Performance, and a Total Theatre Award for Best Physical/Visual Theatre at the Edinburgh Fringe.

Lewis Hetherington is a playwright, director and performance-maker. His work is rooted in collaboration and storytelling. He is interested in the possibility of creative activity creating space for social change. He has won two Fringe First Awards, the Arches Brick Award, and an Adelaide Fringe Award, as well as commissions from organisations such as the National Theatre of Scotland and the Traverse Theatre. He was Creative Fellow at the Institute for Advanced Studies in the Humanities at the University of Edinburgh in 2019. He is also an Associate of The PappyShow. His work has toured extensively throughout Scotland the rest of the world including performances in Australia, Canada, China, Germany, Japan, Saudi Arabia, Singapore, and the USA.

Sarah Hopfinger is a performance practitioner, researcher and lecturer, with specialisms in ecological performance, intergenerational practice and chronic pain and dance. Her practice sits between contemporary performance, live art and choreography. She makes solo performance and directs and co-devises performances with a diversity of collaborators, including children and adults, professional and nonprofessional performers, disabled and non-disabled people, and nonhuman materials.

Adrian Howells (1962-2014) was one of the world's leading figures in the field of one-to-one performance practice. His work explored themes such as confession, intimacy, risk and depression through the use of persona and performing acts of care. Howells' award-winning work initiated new challenges and innovations in performance art, 'intimate theatre' and socially engaged art, and was performed internationally. In 2016, *It's All Allowed: The performances of Adrian Howells*, edited by Deirdre Heddon and Dominic Johnson, was published by Intellect.

Jamie Lorimer is Professor of Environmental Geography in the School of Geography at the University of Oxford. His research explores the histories, politics and cultures of wildlife conservation. Past projects have ranged across scales and organisms – from elephants to hookworms. Jamie is the author of *Wildlife in the Anthropocene: Conservation after nature* (Minnesota 2015) and *The Probiotic Planet: Using life to manage life* (Minnesota 2020).

Ishbel McFarlane is a performer, writer and theatre maker from Kinross, now in Glasgow, via Edinburgh. Her work focuses on social

justice, feminism, place, history and language. Ishbel is the writer and performer of the play, *O is for Hoolet* (Salamander Street 2020) – a one-woman show about the Scots language. Winner of The Arches Platform 18: New Directions Award.

Sofie Narbed is British Academy Postdoctoral Fellow and previously Lecturer in Cultural Geography at Royal Holloway, University of London. Her work explores the geographies of dance and bodily practice with a particular focus on Latin America. She is particularly interested in critical decolonial approaches to the making and remaking of danced worlds. In her research she engages with theories of the body, creativity, contemporaneity, and decoloniality.

Laura A. Ogden is a cultural anthropologist interested in the politics of environmental change and conservation. Her work contributes to theoretical discussions in political ecology, environmental anthropology and post-humanist philosophy. She has conducted ethnographic research in the Florida Everglades, with urban communities in the USA, and is currently working on a long-term project in Tierra del Fuego, Chile. Laura is on the faculty in the Department of Anthropology at Dartmouth College, New Hampshire, and is affiliated with Dartmouth's Program in Latin American, Latino and Caribbean Studies.

Phil Smith is a performance-maker, writer and academic researcher, specialising in work around walking, site-specificity, mythogeographies, web-walking, somatics and counter-tourism. With artist Helen Billinghurst, he is one half of Crab & Bee, who have completed an exhibition and walking project called *Plymouth Labyrinth* (funded by Arts Council England), a short walking project in the Isles of Scilly, and a residency at Teats Hill slipway.

Filipa F. Soares is an environmental anthropologist and cultural geographer interested in the politics of wildlife conservation and forest management. She is currently a research fellow at the Institute of Social Sciences, University of Lisbon. Filipa completed her PhD in Geography and the Environment at the University of Oxford, with a thesis about the socio- and biopolitical implications of rewilding for the governance of forest disturbance regimes in the UK. Past projects included research in Portugal on the sociocultural dimensions of a possible reintroduction of wolves and birds of prey, attitudes towards renewable energies (wind farms) and representations of wolves and birds in Portuguese literature.

Jenny Swingler is a performance artist, writer and researcher. She was a TV baby and her work traces how the world of images haunt her real world. Jenny's performance and writing practice instigates a troubling or stirring up of our daily encounters with screen images. The work is always negotiating a line between the comic and something appalling but invisible. Jenny has taken work to the Battersea Arts Centre, The Roundhouse, Meyerhold Theatre Centre, Istanbul Municipal Theatre and The Bike Shed.

Scott Twynholm is a Scottish composer. He was a member of Looper with Stuart David of Belle & Sebastian, formed the electro-pop band Hoboken with filmmaker Jonathan Carr and released solo records under the Metrovavan pseudonym. Music from Looper appeared in many films including *Vanilla Sky* and Palm D'or nominated *Edukators*. Scott's music often spans the worlds of contemporary classical and experimental pop. Releases include the soundtrack to the documentary about artist and writer Alasdair Gray and an extended dance work, *In the Ink Dark*, for choreographer Luke Pell. In 2018 he also scored *Make Me Up*, the first feature film by multi-media artist Rachel Maclean. He is published by Mute Song.

Introduction: Pathways in performance

In 2010, against the backdrop of a putative 'turn' to mobilities in the social sciences (Sheller and Urry 2006; Urry 2007), we became interested in the ways in which theatre and performance were frequently taking place on the move. We wanted to follow the paths that were being made in this field, as well as creating some of our own. To this end, we established Making Routes – a network and online resource for artists and researchers working with mobilities in contemporary performance. We arranged a launch event at the Arches arts centre in Glasgow, set up a website at makingroutes.org, sent out invitations, and hoped that others might be interested enough to set off on this journey with us. Ten years later, the mobile collective that emerged from this event is still going strong, with a growing membership and numerous blog posts on the site. Making Routes has served as a valuable testing ground for our thinking and practice in journey-based performance. It also now exists as a document of our collaborations, projects and findings. This book gathers together a selection of the texts that have appeared over the years in order to consolidate an ongoing research project, to take stock of where we have arrived at the beginning of a new decade, and to ask, 'where next?'.

Over the ten years of this project, the patterns and purposes of our journeys have changed. These shifts and fluctuations have been related to changes of address and workplace, country of habitation, having children, concerns about the climate crisis and, most notably since the start of 2020, the governmental advice to 'stay at home' during a global health crisis. It is significant that the decade of work represented in this book ended with a period of enforced immobility. When the COVID-19 pandemic reached the UK, the first government announcement was the cancellation of all but essential travel on 16th March and then the national lockdown was implemented a week later

on the 23rd. Movement, or lack of movement, became a defining feature of this moment, as other strange and disconcerting mobilities became apparent. In the first months of the lockdown, it transpired that airlines were flying empty jumbo jets across the Atlantic to protect their slots on prime sky routes (Haanappel 2020). Initially, the vast reduction in air and road travel, and a significant fall in fossil fuel burning, meant that pollution fell drastically. This was short lived, however, and as large-scale production economies ground back into action, coronavirus appears to have had a negligible, if not adverse, effect on global emissions (Friedlingstein et al. 2020). That all our activity, our movement, connects to other things and has a causal relationship to the wider ecology of the biosphere, should not be a surprise, but the speed and severity of change to existing structures and systems created a sense that everything was in flux. What had seemed permanent, immobile and unchangeable was collapsing, and in this emergency, in this enforced human stasis, something else had emerged.

In *The Faraway Nearby*, Rebecca Solnit (2013) discusses the etymology of the word 'emergency'. The root of the word is from 'emerge' – *to appear* or *to be revealed*. Solnit (2020) suggests that it is in emergencies that we are revealed, "as if you were ejected from the familiar and urgently need to reorient". During lockdown, our physical worlds became smaller. Our journeys were on foot for a maximum period of an hour (as per the government guidelines), and, due to this, they became limited in range and scope. But as our patterns of movement were confined to a radius solely of the local, even these journeys became meaningful, perhaps because of their limits, familiarity and repetition. Concurrently, a growing reliance on micro-technologies connected us in new ways to collaborators in other places, who may be experiencing this moment in very different ways. The imperative to reorientate our relationships with places and re-evaluate the journeys we make is an important lesson from this period of lockdown. These changes, brought about or expanded by the pandemic, will continue to determine mobile practices for some time to come.

What have we learned about performance and journeys in the past ten years? That at times, it is not where you go that is the most important thing about journeying: it is the performance of movement itself, the transitions from place to place, the sense of mobility that has been a

luxury, a joy, a meditation and in some cases, a lifeline. This has been thrown into sharp relief at a time when these journeys are curtailed. At this juncture, we want to reflect on the agency and affordances we have experienced over the years. Making Routes now offers a forum to think together with others about the new directions that mobile performance will need to take as we emerge from this particular emergency, just as others continue to shape the routes and contexts through which we travel.

Departures...

In 2010, David was based at the Arches, where he was completing a practice-based doctorate at the University of Glasgow, developing a 'relational' theatre practice in response to a dynamic cultural venue housed beneath the city's thirteen-track Central Station (Overend 2011a). Journeys featured heavily in this work: fleets of cars parked outside the nightclub; walking tours of the building; directionless trainlines installed in the derelict spaces below. As Laura completed her own doctoral research in the same department – a thesis on the female body, technology and performance (Bissell 2011) – she was also engaging with journey-based work, considering how technology might be used to document and record journeys in various ways, while also working as a production manager for the touring work of performance artist Adrian Howells. Our independent concern with, and experience of, the relationship between performance and mobility converged when we attended *Hitch* – a production at the Arches by our collaborator, the Scottish theatre maker Kieran Hurley.

Hitch is a touring theatre production that recounts a young activist theatre-maker's hitchhike from his home in Glasgow to the Italian city of L'Aquila to protest at the G8 summit. The 35th summit took place in June 2009 in central Italy. Leaders of the world's richest nations came together in a region that had recently been devastated by an earthquake – a last-minute change of venue that brought heavy criticism of opportunism against Silvio Berlusconi's government. A high level of activism surrounded the event, and many travelled to L'Aquila to protest in solidarity with local people against a range of issues, from climate change to nuclear policy. Hurley decided to join the travelling protestors by hitchhiking his way to Italy, hoping to

meet people along the way to gather a sense of how different communities throughout Europe were responding to the global events that the summit intended to address. This was a journey into the unknown that relied on the kindness of strangers. As Hurley travelled, information on his progress could be accessed through an installation at the Arches, which was regularly updated with reports, videos and images from his trip. On his return, he created an hour-long theatre performance, through which the journey was narrated, accompanied by a live band.

The people Hurley met along the way, the visitors to the original installation, his collaborators, and the audiences who attended the performances, are all part of the relational realm that *Hitch* generated and responded to (Overend 2013a). This project introduced a concern with relationality that resonated with our own mobile practice. We set out to investigate the various ways that performance travelled out from its origins to connect to dispersed communities in diverse places.

Accompanying the Making Routes launch event, David posted an inaugural essay that set out to explore such "pathways in performance" (Overend 2011b). This short text suggests that contemporary theatre practice is particularly suitable as a mobile artform. This is a collection of practices that have always been located on vectors (movements through time and space) and interstices (points between entities):

> The work that develops from this project aims to tap into these trajectories, and to understand the ways in which they can be incorporated into a performance aesthetic. The scope of the project, and the directions that it takes, will of course remain in flux – a continual journey of discovery that builds new relationships along its routes.

Since then, we have walked creatively through cities and wild places, toured internationally with theatre productions, crossed bodies of water, and followed footpaths, trainlines and roadways. We have also chosen to stop moving and attune to a multiplicity of human and non-human vectors that define the places we inhabit. It has been a decade of movement, which has come to an end with a global pandemic that has radically redefined our mobile lives, giving us cause to stay at home and to question the frenetic lifestyles that we have occasionally been caught up in.

Tracing the evolution of our project through the various texts on the Making Routes website reveals how much has happened, and how much our thinking and practice have evolved within an emerging field. We have frequently returned to some of the ideas and concerns in that original post, but our subsequent texts have also extended and developed these, to reflect on the complex potentialities of contemporary mobile performance, and to develop what has become a uniquely productive strand of our independent and collaborative research practice. As is always the case with this literally dynamic subject, a great deal has changed since 2010. We therefore offer a reflection on developments in mobile performance in this time. This is followed by a summary of the sections that follow, which chart the evolution of our ongoing project towards its next ten years.

Performance 'on the move'

The last decade or so has seen a burgeoning interest in mobile theatre and performance studies (Wilkie 2015; Groot Nibbelink 2019). This has been developed in regard to performances *about* journeys, but also those that literally travel, both within and between sites. Work in this area has tended to focus on "the embodied activity of movement itself and the experiential opportunities that open up" through mobilising performance (Birch 2011, 199). Touring practices and themes of mobility in theatre-based performances have also been explored (Rae and Welton 2007; Overend 2015). As Fiona Wilkie points out, mobility has always been a defining quality of performance – an art from that is perpetually "on the move, ephemeral and difficult to contain" (2015, 1). Nonetheless, the context of contemporary mobilities has changed significantly in recent decades and until the pandemic, people were "travelling further and faster, if not more often" (Urry 2007, 4). Wilkie notes the impact of these shifts on performance practice, charting a series of productive exchanges between performance and transport systems, as a significant dimension of contemporary mobility.

The emergence of mobility as a key concern in theatre and performance is a response, and contribution, to a paradigmatic shift that explores the centrality of mobility to various aspects of society. This has been recognised across several disciplines, from geography to

architecture and anthropology (Merriman and Cresswell 2012; Guggenheim and Söderström 2010; Elliott and Urry 2010). John Urry's "mobilities paradigm" offers an influential grounding for much of this work, providing "a wide-ranging analysis of the role that the movement of people, ideas, objects and information plays in social life" (2007, 17). Importantly, for Urry, these processes are *performative* as "different modes of travel involve different embodied performances" that effect change on the places that they move through and the people who move through them (37).

Concurrently, developments in the field of site-specific performance have shifted concern to performative movement through and between sites. This evolution from site-based to journey-based approaches is identified by Wilkie, who argues that "site-specific performance also has the tools to enable a re-imagining of what it means to live in a mobile world" (2012, 204). Importantly, Wilkie does not see this mobility turn as a challenge to existing models of performance-making. In fact, she cites Nick Kaye in order to point out that despite a "perceived orthodoxy" that associates site-specific work with notions of fixity, groundedness and security, site-specific art has long been understood as inherently dynamic. For Kaye, site itself is mobile, a process in constant flux that neither was, nor will be, "a stable point of origin", or "a specific, 'knowable' point of destination" (2000, 96-97). Nonetheless, while many examples can be found of site-specific artists conceiving of site as mobile, Wilkie identifies a shift "from performance that inhabits a place to performance that moves through spaces" (2008, 90). This mobility turn – the actual, physical experience of travelling through space – opens up site-specific performance to an expanded relational realm.

Before 2020, in contemporary theatre and performance, it seemed that everyone was on the move: spectators; actors; programmers and researchers (Skantze 2013; Welton 2007). Most of these journeys have been afforded by a high degree of network capital. Theatre practitioners and academics often lead mobile lives; the result of a "series of transformations" in professional and personal spheres deriving from the 'mobilisation' of contemporary social practices (Elliott and Urry 2010, 3). For Anthony Elliott and John Urry, writing in the pre-COVID 'rich north', "it has become almost impossible to undertake the routine 'practices' of business and professional life without regular train journeys, flights, taxi rides, tourist buses, email,

text, phoning, skyping and so on". A new demographic emerged as millions of 'globals' conducted their lives across international borders through "ever-changing, frenetic networking" (22). This has had both positive and negative implications for personal and professional life, and necessitates a range of coping strategies that allow the maintenance of a sense of stability and contentment, while at the same time undergoing constant disruptions to routines and social networks. Identifying the pressures and challenges in the lives of globals, Elliott and Urry note that "whatever the more positive aspects heralded by mobile lives (and we do not deny that they are many and varied), we emphasize that life 'on the move' is also bumpy, full of the unexpected and unpredictable, involving considerable ambivalence" (34). Today, these comments seem particularly prophetic.

The mobility turn in performance is a response to this global condition and some work sets out deliberately to challenge and draw attention to some of the more problematic aspects of contemporary mobility, as in many of the texts gathered in this book. However, performance is not immune to the problems of globalisation, and is just as susceptible to the very inequalities and irresponsibilities of contemporary mobility that have fuelled the climate crisis and the spread of COVID-19. As predicted in a now decade-old report by the environmental arts charity Julie's Bicycle (2010), this increasingly mobile sector has approached a crisis of sustainability. The environmental impact of large-scale international travel is wide-ranging and severe, and the pandemic has necessitated a period of reassessment (Cresswell 2020). It is also likely that we have reached a peak in dominant mobility systems with global oil supplies in decline and radical new transport infrastructures in development (Urry 2007, 278-285; Urry 2013). Baz Kershaw argues that theatre has generally remained ambivalent towards the potential for ecological disaster and its place within the systems that contribute to climate change, global inequality and environmental instability (2007, 10). International touring theatre can easily be accused of such ambivalence – the product of a "compulsion to *mis-perform* ecologically" that may result from an increasingly uncritical position in relation to our climate (Kershaw 2012, 5).

Performance moves; often irresponsibly with disregard for its environmental impact, and with little relationship to the local cultures and practices that it comes into contact with. This prompts a concern

with the making of *roots* as well as *routes*. While Nicolas Bourriaud suggests that the modern question *par excellence* is now about destination rather than origin ("where should we go?", rather than *where have we come from?*) (2009, 40), this does not mean a complete separation from the culturally determined contexts of local culture and tradition. Such 'rootedness' now has to be significantly reconfigured in the context of capitalist globalisation and the related impact of the pandemic. In response to the conditions we currently find ourselves living within, we cannot afford to be rooted inflexibly to a solid foundation, but nor can we travel in the same way any more.

Excursions and visitations

Rather than presenting these posts chronologically, we have grouped them into six themes, which very loosely correspond to different moments or focusses in our research journey. The majority of them are written by Laura or David, occasionally reflecting on our joint research projects. But our own posts are supplemented by contributions from others. The authorship of this volume is therefore shared with Helen Billinghurst, Nic Green, Lewis Hetherington, Sarah Hopfinger, Adrian Howells, Jamie Lorimer, Ishbel McFarlane, Sofie Narbed, Laura A. Ogden, Phil Smith, Filipa F. Soares, Jenny Swingler and Scott Twynholm. At different points over the last ten years, these friends, colleagues and collaborators have travelled with us and contributed to the evolution of the project in various ways. Making Routes only exists in dialogue with others.

First, steps: The opening section gathers together our writing on our creative walking experiments, all of which took place in the first half of the decade. We consider ourselves to be aligned with the loose collation of exploratory walkers, pedestrian geographers, and drifting groups identified by Phil Smith (2010) in his book on *Mythogeography*. Phil presented a paper on his work at the Making Routes launch event and has remained a collaborator on various projects ever since. This section includes an account of his 'misguided tour' of the Scottish coastal town of Ayr, which details some of his tactics and offers an insight into the ways in which, through walking, places can be productively reimagined and reperformed. It also includes our documentation of a series of experimental commuting journeys in the west of Scotland in 2014. These were mainly walked,

but also cycled, swum and sailed. In these posts, we capture something of the potential of slowing down our daily travel to engage with the landscapes that we routinely pass through and over. Creative walking is now a hugely popular pursuit, which we continue to practice in various different contexts – particularly through our forays into the wild. But we have also been concerned with the creative potential of other forms of mobility, and much of our work over the next few years took us into the global spaces of international travel.

Further afield: As we secured permanent academic jobs and enjoyed success with our theatre productions, we found that our network capital was increasing exponentially. As we approached the middle of the decade, we were invited to travel more, or able to find funding for our international trips. The journeys in this section take place in Finland, France, the USA, Brazil and India. These privileged journeys into other cultural contexts are discussed critically in the posts in this section, which capture a sense of unease at the cultural and environmental clumsiness of some of this globe-trotting, even as they celebrate the opportunities that were afforded. Alongside these critical travel diaries, more careful and thoughtful encounters with unfamiliar people and places are recounted, particularly in the piece that the performance-maker Nic Green contributed to our launch event. Working within this expanded realm helped us understand the global performances of mobility, and to shift our focus towards the spaces and routes that connect us to those with whom we are not proximate, but may yet feel close to.

The sea, the sea, the sea: Many of our reimaginings of our journeys involved substituting a mode of travel – David cycling his usual car journey to Ayr, Laura walking the 27 miles from Gourock to Glasgow, usually undertaken by train. The aspect of Laura's commute that proved most challenging to revise was swimming her usual ferry journey across the Clyde estuary. This embodied experience provoked some wider reflections on the differences between moving through landscapes and attempting to journey through seascapes. While terrestrial spaces frequently bear the marks of human activity – the desire path walked often enough that it becomes a track, then a road, then a motorway – the traces of a boat crossing the surface of the water only leave white foam momentarily in its wake. This is deceptive, as the damage human activity is wreaking on the world's oceans is vast

but largely imperceptible as it is less visible than marks on the earth. Laura began researching the sea in performance, looking at site-responsive works that happened on coastlines or on boats, including Selina Thompson's transatlantic journey *Salt*. The materiality of the sea, its inaccessibility and its hidden depths all provided a counterpoint to other 'landscape' studies. Journeys over water, site-responsive creative practices on coastlines and wild-swimming in the sea provided a different perspective to our travels by plane or train. Rather than being moved through the landscape, when you are in the sea, you are of it, embodied and immersed.

Into the wild: After years of touring the world, or looking out over oceans, we reached a point (incidentally coinciding with the arrival of our respective children) when we felt the need to slow down and occasionally stop. This section opens with Laura's "dawn to dusk solo in a wilderness setting", where a "rare experience of stillness and contemplation" is found in Knoydart in the Western Highlands of Scotland. A major shift in our work in the last part of the decade took us into such wild places, where mobility was less the focus but remained an important part of our methodology. The posts in this section document our shared interest in rewilding, and what has become a hugely rewarding collaboration with the geographer, Jamie Lorimer. This ongoing project begins with David and Jamie's walk in the Chilterns, visits Knepp Castle Estate in West Sussex and Bamff Estate in Perthshire and leads us to swim into lochs and climb through undergrowth, as we engage with non-human inhabitations and journeys.

Performances, artworks and exhibitions: While we have always said that it is the process of travelling together that has been the most valuable part of this work, as practice-based researchers we have inevitably created artworks along the way. This section includes an early contribution from performance-maker Ishbel McFarlane. There is also a short reflection from Adrian Howells, who was there with us at the beginning of this journey. We have then included documents of some of the poetic texts, exhibitions and performances that we have created over the years. Other outputs include a number of academic publications, which we reference throughout. It is difficult to see how this project could ever come to a satisfactory end point, so all these artworks and articles – and indeed the entire publication – are conceived as stopping off points, rather than destinations.

(Im)mobility: For the final section of this book, some of our collaborators help us think into the future of this project. Responding to the experience of the pandemic and the limits and transformations that this crisis has brought about, these texts look forward as well as back, and suggest some of the ways in which mobile performance will need to reorientate. First, Helen Billinghurst and Phil Smith reflect on "an inexorable web of entanglement between story and place" that has been informed by their creative research projects during the time of COVID. Second, Sarah Hopfinger addresses life and practice with chronic pain in a time of precarity. Finally, Laura thinks back to the sea, which she can no longer visit, to consider themes of isolation, connection, communication and community. These are valuable additions to our decade of journeys. They bring us up to date, and they look forward to new beginnings.

Moving on

Where next for Making Routes? We have always resisted formalising this project, allowing it to remain light on its feet and free from the institutional contexts in which we spend so much of our time. Nonetheless, with a ten-year history and a growing international reach, it seems like the right time to ask how we can ensure longevity and keep this show on the road. In a post-COVID world, the way that we exchange ideas and collaborate over distance will inevitably change. It remains to be seen precisely how, but the new phase of this project will almost certainly involve radically different approaches to travel and connectivity. There are four areas where these developments have already informed our work, and which we want to explore further. These are the performance of *digital journeys*, *migration stories*, the *precarity* of the arts sector, and creative responses to *climate crises*.

Digital journeys: Developments in digitally engaged performance practice over the last decade have opened up new pathways for performance. In some ways these have unexpectedly come to fruition as many artists have been forced to move their work online. This has radically altered the terrain for mobile performance, as many of the journeys that would once have crossed land and oceans now move within digital spaces, bringing people and places into new forms of

virtual proximity. Making Routes now has a close relationship with the Edinburgh Futures Institute at the University of Edinburgh, where arts and humanities connect with leading research in data and digital technology. This affiliation will allow us to trace developments in digital theatre, broadening our focus on physical journeys to understand how journeys are performed in virtual realms.

Migration stories: At the time of writing, the Louise Michel – a bright pink yacht funded by the British street artist Banksy – is controversially stranded at sea in the central Mediterranean, safeguarding more than 200 migrants. The boat is a performance of "solidarity and resistance" at a time when European states are instructing their Coastguards to ignore distress calls from 'non-Europeans'. It is also enacting a direct intervention into migrant mobilities, saving lives and assisting people on perilous journeys across the ocean. Banksy's yacht is an example of the sort of mobile performance practice that we are interested in following. Making Routes has not yet paid adequate attention to the journeys of those who are forced to travel, or indeed to those who are unable to do so. While we have critiqued the practices of excessive or irresponsible travel, we also need to acknowledge the situations of those without the freedom to choose where or when to travel. We intend to develop ethical methodologies for conducting this research.

Precarity: Theatre has often been perceived in relation to various crises (Delgado and Svich 2002; Angelaki 2017). Political, environmental and economic concerns have impacted on the artform in various ways, often testing the relevance and endurance of live performance. However, COVID-19 has created an unprecedented situation, in which live theatre has not been able to continue for most of 2020-21, and the majority of work has moved into the digital sphere. The sector is now facing another crisis in which theatres have closed with thousands of job losses (Bectu 2020). Meanwhile, as the journeys of migrants and low-paid key workers have continued during this time, the international travel of hyper mobile 'globals' has significantly reduced, and in many cases stopped all together. Mobile theatre and performance are now in a double bind. As theatre rebuilds itself amongst reduced mobilities systems, we want to address the precarity of new work as it reaches out to connect from unstable departure points, through disrupted networks.

Climate crises: We also need to consider what the aspiration of this work should be, now that we have belatedly come to acknowledge our arrival in the Anthropocene – our current, contested, geological epoch. While challenges arising from the pandemic took centre stage in 2020, many have pointed out that the major crisis of climate disaster has not gone away, and in some cases has been amplified by the lack of regulation and law enforcement exacerbated by the lockdown (Solnit 2020). This enquiry has already informed much of our work. But we feel the need to go much further than tentative self-criticism to think carefully about how Making Routes can adapt and evolve to respond to, and operate within, a damaged biosphere.

The texts that follow chart a journey through the first ten years of Making Routes and point forward to future trajectories. This disparate collection will hopefully be of value for artists and academics interested in the possibilities of moving (and not moving) as a cultural strategy. These short essays, notes and reflections follow some routes and practice others, aiming to develop a model for artistic movement in a precarious cultural environment. The guiding conviction is that in these uncertain times we need to move in politically, culturally and environmentally sensitive and considered ways, and to recognise when it is better not to move at all.

First, Steps

David Overend Walks Route 77

March 25, 2014 [1]

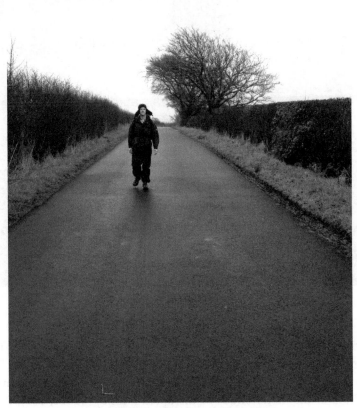

On foot from Eaglesham to Stewarton

[1] See Bissell, L. and D. Overend. 2015. 'Regular Routes: Deep mapping a performative counterpractice for the daily commute', *Humanities* 4 (3), 476-499.

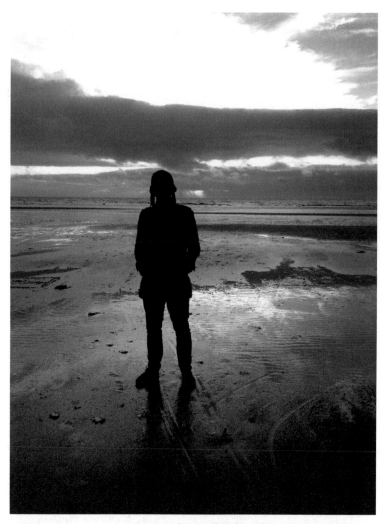

On arrival at Ayr beach

Driving between Glasgow and Ayr several times a week, I was in danger of becoming Tim Edensor's stereotypical commuter; "a frustrated, passive and bored figure, patiently suffering the anomic tedium of the monotonous or disrupted journey" (2011, 189). But like Edensor, I knew that commuting was potentially a far more open and creative activity than popular representations suggest. I set out to enact a series of interventions into my regular journey in order to reimagine my daily commute as a space of creative, or even transgressive, possibility. I wanted to spend more time than my

allocated fifty minutes exploring the "rich variety of pleasures and frustrations" that commuting affords (189). As such, setting off from my home on Friday 14ᵗʰ March 2014, I endeavoured to walk the route.

I planned to weave around the motorways and dual carriageways to inhabit some of the places that I regularly see from the road. I would walk for 48 miles over three days, staying at hotels along the way. The majority of the journey would be undertaken on my own, but I would be joined by Gary – my friend and regular long-distance walking companion – for the second day.

It was important to me that this was a genuine commute, so I planned to arrive at the University of the West of Scotland's Ayr campus on the Monday morning for a day of teaching and administration, before returning home by public transport.

*

Setting off after lunch, I immediately enjoy the sense of the familiar made strange. Travelling through the area where I have lived for the last fourteen years, I feel like a visitor in my own city, walking with an entirely different purpose to the typical rhythms and patterns through which I usually inhabit these spaces. Wearing heavy hiking boots, a deerstalker hat and a large rucksack, I feel conspicuous as I pass joggers, office workers, and pupils on their way back for afternoon classes. I am immediately daunted by the prospect of walking through various unwelcoming places – the industrial estates, road junctions and towns that lie ahead of me.

My route soon follows the River Kelvin and my proximity to the natural force of the water reassures me. Like Phil Smith's 'mythogeographer', I aim to actively seek information, "perceiving not objects, but differences" (2010, 113). Here, they are between natural and man-made, old and new: the Kelvin and its concrete embankments; the nineteenth century ruins of North Woodside Flint Mill set against the glass-fronted architecture of the exclusive Glasgow Academy Preparatory School. I walk from private to public and, along with the children of Hillhead Primary, watch a fisherman knee-deep in the water.

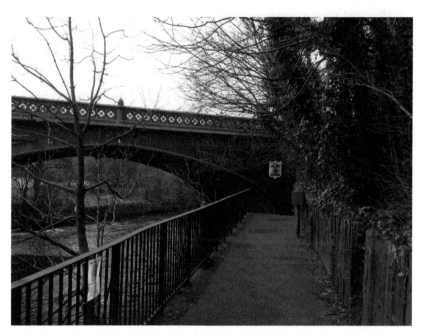

Along the Kelvin in the West End of Glasgow

As I follow the river, I begin to realise how much of the city is cut up and divided by fixed routes and paths. This grid of different boundaries and trajectories comprises bridges, footpaths, cycle lanes, roads, railways, canals and flight paths. And then there are "drainage systems, rivers, electricity cables, telephone wires, and mobile phone masts [...] bearing forms of energy and matter" (Edensor 2003, 156). This is what Gilles Deleuze and Félix Guattari (1988) refer to as *striated space*, as opposed to the *smooth*, open, nomadic spaces of steppes and deserts. But as I walk from point to point, following some routes and crossing others, I do not feel hemmed in or constrained. There is a freedom in this journey and an exhilarating sense of moving beyond the prescribed uses of urban space.

At this point my route leaves the river and the park and cuts through Finnieston, north of the River Clyde. This complex, dynamic part of Glasgow is on the edge of my familiar territory and I walk through a mix of well-known cafés and bars and a less familiar post-industrial landscape presided over by the iconic Finnieston Crane. Here, the offices and fast-food restaurants sit uneasily against the weathered

brickwork of the converted factories and the North Rotunda, the gateway to the old tunnels under the river. And in the midst of all this, the newly opened Hydro arena is parked like a vast futuristic spacecraft on the banks of the Clyde.

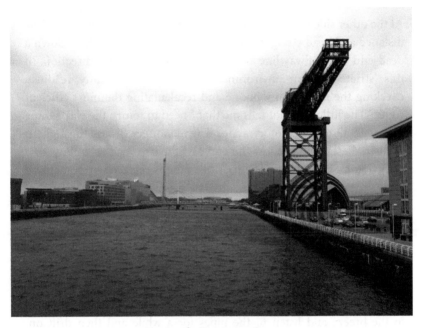

Passing the Finnieston Crane

Crossing the water on the stylish Clyde Arc Bridge is a symbolic moment as I leave my comfort zone, entering an unfamiliar part of the city as warehouses and motorways replace restaurants and shops. I feel strikingly out of place here and a feeling of paranoia sets in as two men cross the road in front of me and eye me suspiciously. The dirtier streets, heavier traffic and thicker accents play on my prejudices and set me on edge. I feel vulnerable and naive but not unsafe.

The M8 is the major artery through this area of Glasgow and I cross the dozen lanes on the footbridge by Cessnock Underground Station. I look out over the tremendous flow of people and goods and recognise the point where the M77 branches off from the larger motorway. This is a surreal and unsettling vantage point from which to meditate on the carbon-guzzling, excessive consumption of a society "held in thrall to instant gratification, continual self-reinvention, superficiality and

addictive, short-term 'highs'" (Elliott and Urry 2010, 23). Paradoxically, the motorway has the same calming effect as the River Kelvin did an hour earlier. I know that the hum of traffic will be a constant companion over the next three days and that it will eventually guide me to my destination. I will simply follow the road.

At the other side of the motorway, I see the trees of Pollok Park in the distance and head straight towards them. I immediately turn down a dead-end by a railway line and can go no further in this direction. In this 'striated' urban environment, I have to constantly readjust, checking the map on my phone and recalculating the most efficient route. The little blue dot tells me that I need to return the way I came and walk along the motorway for a while longer. I pass through an industrial estate and follow the curve of the slip road to emerge in a leafy South Side suburb. The roar of traffic is replaced by something else – a faint melodic drone which I soon realise is the sound of bagpipes.

I remember Smith's advice to use my senses as 'tentacles' and to move in a way "that allows the thinker to ride the senses" (2010, 113). For now, music will be my guide and I allow the sound to pull me in its general direction. I arrive at Sherbrooke Castle and watch wedding guests hurry inside, presumably for the ceremony. I watch the saltire flag fluttering in the breeze and listen to the pipes for a while and then drift on, imagining myself living in this part of town and exploring the tree-lined streets and old Edwardian merchants' houses.

Following a sign for a cycle lane to Pollok Park, I find a path which runs directly alongside the motorway. A chain link fence separates the dog walkers and cyclists from the busy traffic. Walls, barriers and boundaries have featured heavily in my journey so far and I look forward to breaking out into the open Ayrshire countryside. These fences act as grids that break up lines of perception and frame spaces as cordoned off, out of bounds, dangerous or inaccessible. For Smith, grids denote homogenisation (2010, 13).

Walking with him in Ayr two years ago, I was struck by the frequency with which these patterns presented themselves – in wire fences, metal gates and squared paving (see 'David Overend is Misguided in Ayr' later in this book). I felt an impulse to break through, climb over and dismantle some of these physical barriers over the next few days, but this particular installation seemed to serve a valuable function, so

conscious of safety, I allowed it to determine my direction for now. I had never really noticed the life of the minor roads and footpaths that run parallel to the motorway before: the hundreds of thousands of people who live and work within earshot of the perpetual rumble of the roads of my commute. Usually, I would be part of that relentless noise, which was not unpleasant, only ever-present.

Following Route 77

Eventually, I reach the edge of 360 acres of Pollok Park. The section that I choose to walk through is a huge golf course which is currently almost completely empty. It disappoints me that so much of this public space has been rendered so exclusive, but I revel in the open skies and huge green spaces that I have to myself. In the 1990s the park was occupied by the Pollok Free State who opposed the destruction of public woodland to make way for the M77 (Yuill 2012). The battle was lost before I moved to Glasgow at the turn of the millennium, and I started using the motorway for my commute to Ayr over a decade later. Nonetheless, I feel a sense of guilt and loss as I walk across the perfectly kept greens, conscious that on the other side of the wooded embankment is miles of road rather than the thousands of trees that used to be there.

I check my phone only to find that the battery is dead. This is concerning as I haven't worked out precisely how to get to my first port of call at Newton Mearns without my map application, but fortunately I have the constant hum and occasional glimpse of the road to keep me right. I haven't realised it until now, but from the moment I crossed the Clyde, I have been constantly checking and rechecking my position. Along with the catalogue of photographs that I have assembled along the way, this has used up my phone's energy faster than I noticed and now, I find myself without the reassuring companionship of mobile technology. I soon reach White Cart Water, one of the Clyde's tributaries which runs from Eaglesham Moor west through the park and underneath the motorway. I follow the flow of the water to the underpass before realising that I should be heading in the other direction. I am sure there will be a bridge soon but once I have retraced my steps, I walk for longer than I expected. At Pollok House, I find what I need and cross to the south side of the park by way of a stone footbridge.

I head out across more empty golf course, roughly guided by the flow of the traffic in the distance. As the sun shines through the trees, I relax into the rhythm of one foot after another, propelling me slowly forward across the open greens. Here, in the absence of barriers and fences, the space feels smoother than before and the nomadic quality of my journey is more tangible. For Mike Pearson, the nomad is an aspirational figure, "cut free of roots, bonds and fixed identities" (2010, 20). Although this might be too much to claim of a ten-minute walk across a golf course, there is certainly a feeling of freedom here in contrast to the roots, bonds and fixed identities associated with my daily commute. Before I get carried away, I reach a huge metal fence at the edge of the course.

My dilemma is whether to add more miles to my journey by trailing the perimeter looking for an exit, or to attempt to cross into the adjoining field. The solution presents itself as I notice a missing railing which I suspect has been removed deliberately to open up a walking route. I make my way through woodland and clamber over another lower fence and land in squelchy mud. Following the high wire fencing that separates the field from the M77, I enjoy a feeling of subversion and recall Rosi Braidotti's vision of nomadism as "the intense desire to go trespassing" (2011, 66). Whether or not this is strictly

trespassing, it is a moment that embodies the spirit of this journey, moving against prescribed uses of space and reimagining my route as a space of creativity and transgression. However, just as I cast myself as the heroic psychogeographer, I come face to face with a large highland cow. Its menacing stare, sharp horns and slow, deliberate movement towards me make me nervous and I look around for an exit route in case things turn nasty. Unfortunately, I am now too far from my entry point to retreat, and the section of fence that I am beside is too high to easily climb over. The cow lunges forward and a surge of adrenaline catapults me over the fence before I have time to think. On my way over, I scratch my shin and slightly cut my finger. Writing up my notes almost exactly a week later, the cut is still faintly visible – a corporeal document of this encounter.

Emboldened by my successful escape, I wander through scraggy woodland until I emerge through the trees onto Barrhead Road. I had been relying on using my phone for navigation at this point so my only option is to head in the vague direction of the M77. I walk along pavements by busy roads and struggle with the lack of pedestrian crossings at a junction. Soon, I emerge in the suburb of Thornliebank. Here, the motorway cuts loudly and unsympathetically through a residential area. I follow a footpath round the back of the houses to a large primary school and resolve to cross the motorway again over a footbridge. I had planned to stay on this side today but I see a large supermarket and some fast-food restaurants in the distance and decide to take the opportunity to find somewhere to recharge both my phone and my body. In a soulless KFC on Nitshill Road, I buy a large cup of tea and plug in my phone.

Now that I am able to access the map again I am pleased to see how much progress I have made, and that my hotel is now only two miles away. The final stage of my first day's walking takes me underneath the motorway at the slip road that I have often used when driving between UWS's Paisley and Ayr campuses. I then walk between another golf course and a new housing development, past Patterton railway station and on to Newton Mearns. Many new houses are being built in this area but arriving in the early evening sunshine, most of the construction work has stopped. In this brand new space, there are fences everywhere. I am at the edge of the suburbs and passing by cordoned off gardens and driveways, I see trees and fields beyond the

scaffolding and roundabouts. As I approach the Premier Inn, I can also see Junction 4 of the M77.

The hotel exudes functionality and convenience. I check in much earlier than I anticipated and lie on the clean white bed wondering how on earth I will spend the next few hours. I take a bath and soak my aching muscles, reflecting on the bizarre prospect of sitting in a cheap hotel room, only fifteen minutes' drive away from my flat, with nothing to do. From my window, I can see the motorway carrying people home to their families and friends. It is all faintly depressing so I decide to phone a taxi. I leave my rucksack and boots in the hotel room and return to spend the rest of the evening at home eating take away food and watching television with my fiancée, Victoria.

<div align="center">*</div>

At half past ten the following morning, Victoria drives me through the grey, drizzly city to collect Gary from his flat, and then drops us both off in the car park back at the Premier Inn. Travelling here in the back of my car feels like cheating, but it has also been a valuable opportunity for a return from the *détournement* of the walk. After all, as Smith points out, "the permanent drift disappears the drifter" (2010, 139). An evening at home has provided "the periodic abjection provided by domestic life in order to be disrupted as well as disrupt"; the ultimate prevention of assuming the role of the 'star psychogeographer'. This brief return to the domestic also shows that I am already thinking of my commute differently, pointing out places I walked through the day before and noticing features of the route, of which I had previously been unaware. Cessnock Underground, Sherbrooke Castle and Pollok Park are all visible from the road and they have now become part of the web of associations that comprise my regular journey.

Gary smokes a cigarette outside while I return to my hotel room, prepare myself for a day's walking, and check out. We start the second phase of the journey by walking in the opposite direction to the motorway, through the centre of Newton Mearns. I am thankful for the company, as I have never fully embraced the role of the solo wanderer. We have been walking together for ten years now, usually up and down the Scottish Munros. Over the years we have developed a shared ambulatory language, comprised of moments of silent progression, swapping the lead, stopping and waiting for the other to catch up, and walking beside each other in conversation. It is in this

last mode that we move through the residential streets of the town until we reach an affluent leafy street lined with gated mansions. At the end of the road, the threshold to the countryside is marked by three bollards, beyond which the vista opens up to wide grey skies, soggy fields and damp country roads which we follow until we reach the village of Eaglesham.

Arriving at the Eaglesham Arms

This close to the largest city in the country, it is surprising to find a village that has maintained the trappings of rural tranquillity: a village green, a row of cottages, a country pub. Without the need to speak it, we both head straight into the lounge bar of the Eaglesham Arms for a late morning pint of lager. Inside, the decor is unexpectedly chic with leather seating and polished surfaces. It seems we are not the intended clientele and we both feel slightly out of place as we tramp in with dirty wet boots, taking off backpacks and slumping down to enjoy a drink and a rest.

As tempting as it is to stay for another pint, we plough on, leaving the village on the B764 through fields and farmland. The weather has taken a turn for the worse and we pull on waterproof jackets and continue in silent single file as cars race past us kicking up water. We are still the only walkers, but we are now joined by a steady stream of

cyclists following the welcoming signs towards Eaglesham moor along the 'cycle lanes' demarked by white lines notionally cordoning off slices of the road. The impersonality of speeding cars and vans is offset by brief moments of co-presence as the cyclists nod to us or we share a friendly greeting. On foot, we are also aware of the vast amount of rubbish and notice how much the sides of roads around large population centres are "littered with the vestiges of previous journeys: [...] evidence of previous events" (Edensor 2003, 156-157). It is depressing to realise how many people must simply throw litter from their car windows, unaware or unconcerned with the destructive impact on the environments that they pass through. I wonder whether they would do the same if they walked this route and saw close-hand this accumulation of drinks cans, takeaway boxes and plastic bags.

We trek on through the incessant rain along this unwelcoming stretch of road for a while and my legs start to ache. This is perhaps the lowest point of the journey so far and I wish we could have stayed in the warmth of the pub. Then, just as my enthusiasm for this venture takes a nosedive, we are rewarded by the eerie shapes of the Whitelee wind turbines looming through the fog. We are at the edge of the largest onshore wind farm in the UK. I always see the turbines from the road as I drive between Glasgow and Ayr and while I have often desired it, I have never broken from my commute in order to visit. Turbines are an intriguing mixture of lightness and strength, stasis and motion, in which Fabienne Collignon (2011) sees "the graceful movements of a *ballet mécanique*". Their cold, seamless design forms part of "the rhetoric and aesthetic of a (white-washed) future". Emerging now from the foggy moorland, they are an alien presence in the mundane landscape, exerting a gravitational pull on the interloper.

We surrender to the hypnotic quality of the turbines, which offer a regularity and rhythm approximating the effect of music. Our ambulatory rhythms sync up with the rotations of the blades and we adjust our pace accordingly. One foot after the other meets one rotation after the other. At the same time, in this exposed location, rain beats into our bodies and blasts our faces with icy water. The wind is blowing in tremendous gusts, which drown out all other noises, but in the occasional dip, our ears tune into another constant sound – the faint, humming drone of the turbines as they 'farm' the wind and convert it into electricity.

Crossing Eaglesham Moor

Walking through this futuristic landscape is a disorientating and unusual experience but the surrealism is amplified when we arrive at the visitor centre and tearoom. Here, a varied demographic has arrived by car to wander round the small exhibition space and pass the time in the cafe. It strikes me as ironic that the only way to visit this bastion of carbon-free energy in the middle of the moor is to drive for miles, and the electric car charging point looks like it has rarely, if ever, been used. We join the other visitors, ordering tea, paninis and cake and setting up camp by the heater where we arrange our hats, gloves and jackets to dry out while we eat.

I also take the opportunity to plug in and recharge my increasingly useless phone, which has again run out of power despite far less usage than the previous day. I am pleased to know that I will now be carrying some of the Whitelee wind power with me on my journey.

Warmed and recharged, the onward journey across the weather-beaten moor holds little appeal but on we walk until we reach the far side of the wind farm. At this point, the road markings stop abruptly and the previously smooth road surface becomes riddled with potholes. I presume that the upkeep of the roadway up to this point is the responsibility of the wind farm, but later I discover that we have

passed through the boundary between East Renfrewshire and East Ayrshire, so it may be that the latter sees cycle safety and road maintenance as lower priorities.

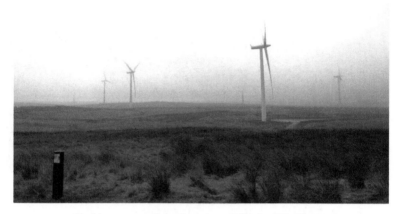

Turbines emerge from the mist at Whitelee Windfarm

From the motorway, I often notice sections of coniferous forest and we walk through one of these now; nature contained within regulated patterns and bordered by roads and burns. As we return towards the motorway, the amount of roadside litter increases proportionally and the roar of the wind is replaced with the steady hum of traffic. We reach the A77 first, which ducks underneath the newer motorway and runs alongside it for a couple of miles until the M77 comes to an end and hands over to the old route again. Before the construction of the new route, the A77 was the major road to the southwest. All the way from Glasgow to its end at Fenwick, it tightly hugs its replacement, weaving over and under bridges and paralleling the frenetic speed of motorway traffic with a slightly slower, quieter flow of people. A wide cycle lane is protected from the road by a raised concrete division. Inexplicably, as we walk south, tens of cyclists ignore the designated lane in favour of the main road, forcing the overtaking vehicles into the opposite lane to avoid them.

Crossed lines in South Ayrshire

Walking so close to the road for the next half hour is a tedious and bleak part of the journey. Our vision is constrained by straight markings and we are realigned with the perspective of the commuter as the view ahead is dominated by "the shifting rectangles and hexagons of the rear end of vehicles, hemmed in by the homogenous green lateral strips of the verge and embankment" (Edensor 2003, 156). The going is tough and I am relieved when we eventually turn off the A77 onto the country lanes that lead to Stewarton, our destination for today. Here, birds dance through the still-autumnal hedgerow and tractors wind their way along single-track roads between fields. We pass under telephone lines and wires connecting vast electricity pylons, buzzing and crackling with the transportation of raw power.

Before long, Stewarton appears before us. From our vantage point we can see the whole town as the first sunshine of the day heralds our arrival. We walk through the streets and arrive at the Millhouse Hotel where I will spend the night. We find a seat in the crowded snug and order two pints. Later that evening, after I have checked into my room, we are joined by

Gary's flatmate, James, who has driven from Glasgow to collect him. We eat a meal together and reflect on the day's walking. After dinner they return home, leaving me alone. I head upstairs to my bed and immediately fall into a deep sleep.

*

I wake early the next morning and leave the room just before my arranged breakfast time at 8am. A sign on the door to the restaurant and bar warns guests that an alarm is set until 7am but as it is well past then by now, I wander through to the snug bar. As soon as I open the door, the shrill warning sound of the alarm is triggered. I freeze and scan the room for a sign of the staff but nobody is around. Unsure what to do, I sheepishly retreat to my room and wait it out, but the alarm has developed into a full-blown siren. I sit at the desk and write some notes on yesterday's walk. Five minutes, ten minutes, and still the alarm can be heard. When 8am has passed, I return to investigate but I can see nobody and the alarm is apparently being ignored by anybody who happens to be in the vicinity. It is possible that I am the only person in the hotel. I check the sign on the door again and read an instruction that if guests are leaving early, they should use the fire escape on the first floor. I am not keen on waiting around to find out if someone will come to turn off the alarm and make my breakfast so I leave the room key on the desk, push the bar to escape the building and head out onto the sleepy Stewarton high street.

I buy an apple breakfast bar and a carton of milk from a local store and enjoy the feeling of the early morning sun as I walk through the empty streets. I reach the Lainshaw railway viaduct and pass underneath the nineteenth century structure enabling twenty-first century journeys. The road meanders on through farmland and the sunshine shows off wide vistas across fields and towns. I fall into a fast rhythm and briefly jog through the East Ayrshire countryside. The wind is behind me and I feel full of life – a stark contrast to the grey monotony of yesterday's trudge along the A77.

My journey takes me through a series of villages – Kilmaurs, Knockentiber, Crosshouse, Gatehead and Symington. I am far enough away from the motorway to avoid the sound of the traffic and I enjoy the peace and relative seclusion of these places as they gradually wake up to a quiet Sunday morning. As I move through the villages, my presence seems to hardly be noticed and only a goat, in a farmyard to

the south of Kilmaurs, is interested enough to break from its usual business and wander over to say hello. For now, I am happy to be walking on my own. This is a privileged insight into other peoples' worlds that I have previously passed by in seconds, unaware that they were even here. However brief and cursory it may be, walking this route on my own at my own pace allows me a sense of inhabitation of the places that I usually drive straight past.

From the viaduct at Stewarton to the A77 at Symington, I pass over, under and across a series of other paths. Rivers, roads and railways intersect my route and carry others on different paths to other destinations. All of these have their own distinct rhythms and functions. As Edensor acknowledges, "all spaces are dynamic and continually pulse with a multitude of co-existing rhythms and flows" (2011, 200). In my car, the rhythm of the road takes precedence as my "insulated mobile body" remains oblivious to everything else, but this walk allows me to seek out, sense and immerse myself in multiple rhythms including weather, seasons, animals and people who use and inhabit the landscape that the road cuts through. As I approach Symington, there is a brief moment when I can see the A77, the Firth of Clyde and a Ryanair plane taking off from Prestwick – routes and rhythms coexisting.

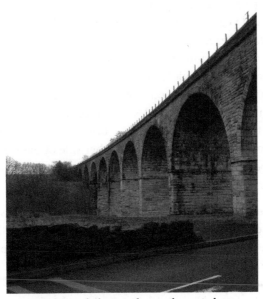

Underneath the Lainshaw railway viaduct

45

I emerge back on my commuting route at the point where some large-scale road works are taking place. While a new bridge and junction are constructed, the northbound traffic has been filtered into a single lane and this creates a curious slow procession of cars allowing drivers and passengers to make eye contact with me – a quick succession of unexpectedly intimate connections. On my countless drives back from Ayr, I have often seen pedestrians on this long stretch of road and I have speculated about who they are and where they are going. I would like to be able to talk with some of these people and tell them how far I have walked, but we are only able to exchange brief smiles or nods.

To my right, I can see the Isle of Arran, which I have never noticed from the road at this point. A little further on, the distinctive mound of Ailsa Craig rises from the sea; an "axis of orientation" that I have come to look out for to mark the final stage of my commute (Edensor 2003, 156). In the field next to me, a tractor scores grooves in the soil, ploughing the terrain in preparation for the spring crop. It has a clear, steady rhythm and leaves a definite mark of its progress. My own journey is lighter and leaves fewer perceptible traces, but in my own way I am also marking a route along which I will return time and time again.

I stop at the Brewers Fayre restaurant at Dutch House Roundabout and, while my phone charges, I eat a greasy beef burger. Children excitedly leap around the impressive play complex and families devour roast meat and vegetables from the carvery. I feel uncomfortable and out of place, so I leave half of my meal and continue on my journey. I avoid the busy road and walk towards Monkton, past an old tower standing alone in the middle of a field. As I reach the centre of the village, an aeroplane passes overhead with an unavoidable omnipresent roar. The timetables of budget airlines must have an impact on the patterns of life here – brief pauses in conversation, interruptions to daily routines. At the other side of the village, I walk along the perimeter of the airport, observing the stationary aircraft through the high fencing with its prohibitory signage.

At the entrance to Prestwick airport, multiple rhythms converge as an enclosed footbridge crosses the A79 from the railway station to the airport. The routes of pedestrians, drivers, car, rail and air passengers, weave together into a complex web of convergence and divergence, stasis and motion. As a walker, passing through this place on foot, I am one of the few who arrive here and leave by the same mode of

transport. Most transfer from train to aeroplane, or from foot to car, shifting the speed and scale of their mobilities.

Crossing routes

I follow the road south through the town of Prestwick and I am soon firmly within the second urban bookend of my journey. I have walked fifteen miles in five hours, and I am getting tired, but my proximity to my destination spurs me on and I pick up the pace as I follow the A79 through the centre of Prestwick and into Ayr. I experience the same sense of conspicuousness as I did back in Glasgow and several people

double take as they notice my outfit and pace is out of sync with the drivers and shoppers who inhabit the high street. Not for the first time during this journey, my intention to explore the multiple textures and stories of the places I walk through comes into conflict with the simple desire to move on. I am nearing the end of my journey, moving faster and noticing less, being folded back into the pattern of the commute.

Prestwick segues into Ayr and I am not sure where one ends and the other begins, but there comes a point when I am definitely in the latter. I expect a moment of relief or catharsis but I still have a mile or so to travel and I am locked into a focussed progression towards the bridge across the River Ayr. I pause here for a moment and look up the river towards the university and down towards the sea. After miles of walking through areas with sparse population, the town streets feel crowded, busy and unwelcoming. I hurry along High Street to Burns Statue Square. When Phil Smith led us on a walk round Ayr in 2012, we stopped here to read aloud the names of the Royal Scots Fusiliers. Today, I walk straight past the statue and on to Carrick Road and the Carrick Lodge Hotel where I check in, shower and fall asleep.

A couple of hours later, I am joined by Victoria, who has driven to join me from Glasgow. There are still a few hours left of the day so we wander round Alloway and down onto the Ayr Beach. It is an evening of beautiful sunshine reflecting from the wet sand. Back at the hotel, we eat a delicious meal and enjoy the chance to be tourists in the town where we both work. We talk about the practicalities and possibilities of moving here one day. We are under the spell of a perfect spring evening.

*

Victoria departs before me with my rucksack and boots in the car and I check out and leave the way I arrive – alone on foot. On my walk to the university, my feet throb with blisters and my legs ache. For the first time on this trip, I open the email application on my phone and I read the deluge of messages that have flooded in over the weekend. I walk and read at the same time, crossing back over the river and absent-mindedly passing the turn off to the river path to work. I back track and pass Ayrshire College and the last fence of the journey, which borders the college's race track. Finally, I arrive at work. I nod to colleagues across the canteen and deposit my bag in the office. Then, I gather my papers, buy a coffee from the machine, and head down to the Performance Studio for a morning's teaching.

Reimagining My Commute:
The journey in signs

Laura Bissell

April 9, 2014

GOUROCK
COVE ROAD
GREENOCK
PLEASE DRIVE CAREFULLY
FUNLAND
BRIDGING THE GAP
RESTRICTED AREA
WATERFRONT
TESCO EXTRA
CONTAINER WAY
POLICE
SPEED CAMERAS
PORT GLASGOW ROAD
GREENOCK ROAD
PORT GLASGOW
PLEASE DRIVE CAREFULLY
NEW ROUNDABOUT AHEAD
GLASGOW ROAD
LANGBANK
SNACK BAR 2ND EXIT
LANGBANK
HOUSTON
LANGBANK
HIDDEN DIP
FARM TRAFFIC
OLD GREENOCK ROAD
CHESTNUT ROUNDABOUT

BISHOPTON
WELCOME TO BISHOPTON
GREENOCK ROAD
BARRANGARY ROUNDABOUT
INDIA DRIVE
PLEASE DRIVE CAREFULLY
OLD GREENOCK ROAD
BLACK CART WATER
ARGYLE STONE
A FAIRTRADE TOWN
WELCOME TO GLASGOW
PLEASE GRAFFITI
ARTIFICIAL GRASS
CAR WASH
RED LION
GRAND OLE OPRY
QUAY
AUTHORISED VEHICLES
ROYAL CONSERVATOIRE OF SCOTLAND

Walking Gourock to Glasgow: Reimagining my commute

Laura Bissell

April 9, 2014 [1]

(Be)Coming to Glasgow

*One must start by leaving open spaces of experimentation, search,
transition: becoming-nomads.* (Rosi Braidotti)

The idea of reimagining my commute was initially driven by the desire
to propel myself from the starting point of my home in Innellan,
Argyll, to my place of work, the Royal Conservatoire of Scotland in
Glasgow. Since September 2013, David and I have been working on a
collaborative research project exploring commuting as a performative
practice. While commuting is often a repeated journey for a particular
purpose (normally to travel between home and work), as Tim Edensor
asserts, "commuting time is not dead or neutral time that simply links
more meaningful spatial contexts" (2011, 194). Rather, it can provide
a time and space for creative possibility. By completing the journey
that makes up my commute (a 10-minute drive, a 25-minute ferry
journey, a 45-minute train journey and a 10-minute walk) using only
my own physical means, I hope to reimagine this familiar and
repetitive journey and experience anew the landscape through which
I commute on a daily basis. I want to move through these spaces rather
than be moved.

My methodological approach is practice-as-research and is informed by
Rosi Braidotti's (2011) theories of nomadic subjectivity and Henri

[1] See Bissell, L. and D. Overend. 2015. 'Regular Routes: Deep mapping a
performative counterpractice for the daily commute', *Humanities* 4 (3), 476-499.

Lefebvre's (2004) discussion of *Rhythmanalysis*. I am interested in how the repeated rhythms of the everyday journey (the commute) relate to the wider critical discourse around nomadism. Braidotti claims that "the point of nomadic subjectivity is to identify lines of flight, that is to say, a creative alternative space of becoming that would fall not between the mobile/immobile, the resident/the foreigner distinction, but within all these categories" (2011, 7). The etymology of the word 'commute' is from the Latin *commutare* which means "to change, transform, exchange" (OED) and it is this process of 'becoming', through the change in time and space that a journey permits, that I hope to explore through my alternative commute.

My original plan – to walk the 5.5 miles from my home to Dunoon, swim across the two nautical miles of the Clyde Estuary between Dunoon and Gourock and then walk the 27 miles from Gourock to Glasgow – has been postponed due to inclement weather and the need to train sufficiently for the sea swim. On the 26th March 2014 I undertook a walk which represents the final two stages of my commute: the train journey from Gourock to Glasgow and the walk from Glasgow Central station to 100 Renfrew Street. By altering the pace of this two-hour commute to take place between 7am and 7pm – the hours of my usual working day – I intend to open this journey up to creative possibility, diversion and interruption. I hope to 'become' something different through this process of journeying, and employ Braidotti's 'myth' of the nomadic subject to "move across established categories and levels of experience: blurring boundaries without burning bridges" (2011, 26). I hope to learn something about my journey by undertaking this task, and for it to become something other than a functional and transitory commute through the spaces between home and work.

I leave my house at 7am, the usual time, and drive to my parents' house on the West Bay of Dunoon near the ferry terminal. I had intended to cycle this leg of the journey, but a flat tyre means that I have to make the decision to forgo the cycle to Dunoon or risk having to get a later ferry and starting the main walking leg of the journey behind schedule. I decide to take the car and console myself with the fact that I have walked, run and cycled this part of the route many times before, and will be able to complete this when I do the sea swim later in the year. I have a cup of tea with my parents and we discuss my plans for the day. They try to dissuade me from undertaking the entire journey and I

placate them by telling them I will hop on public transport if I am tired (although I have no intention of doing this). I board the Argyll Ferry at 8:20am with a nod to the regular crew.

On the ferry I sit inside for a moment and then climb up the stairs on to the top deck. It is very blowy and no-one else has chosen to be outside. I think of Kathleen Jamie's reflection in *Sightlines* about the temporal nature of the world and the enduring nature of the elements I am encountering: "The wind and sea. Everything else is provisional. A wing beat and it is gone" (2012, 242). I am aware that the boat crew have greeted me with quizzical glances as my normal work attire has been replaced with walking trousers, a turquoise waterproof jacket, a woolly hat and a backpack. My garments suggest 'hillwalker' rather than 'commuter'. I take some photos of the landscape as the boat speeds away from Dunoon and across the water towards Gourock. The Cowal Peninsula has a larger area of coastline than France and the intricate weaving of the shoreline around the various crags of land framed by the mountains behind makes for a stunning view, even in the early morning half-light. On my right I can see the Cloch Lighthouse, from where I will swim in June, and I am aware of how I have looked slightly differently at the body of water I travel on every day since I decided to make the attempt. The triangular roofing of the new Gourock train station comes into view as the boat passes the outdoor swimming pool and the boat engine cuts out as the crew prepare to dock. On my usual morning commute there is little time to travel from the ferry to the train and often the rhythm of these moments is frantic and hurried as the commuters rush up the ramp and towards the station. Today, I head away from the station, and as I am about to walk around the cordoned section to allow me to move towards Gourock, the woman in front of me undoes the catch on one of the metal gates, opens it and walks through. Channelling Phil Smith's (2012) renegade attitude to site as explicated in *Counter-Tourism*, I follow her lead, glad of this minor transgression of the authoritative paths and designated walkways that the area by the water assigns.

In the short walk from the ferry towards the main street of Gourock, I find myself taking numerous pictures of the sea, the vessels on the water, the dilapidated pier and the row of boats lined up against the sea wall. I try to take a photograph of the Gourock sign but the sun is too strong and the sign keeps appearing as a black square against a

luminous sky. The urge to record this experience is strong and I have to remind myself to allow the journey, rather than its documentation, to take priority.

Throughout the walk, the road signs and names of places signal the specificity of a recognisable place, but are often surprising in terms of my perception of the boundary or my expectation of where the area began and ended. I realise my usual journey is demarcated by the train stations, and it is these place names that act as what Deleuze and Guattari (1988) would term 'points' which punctuate the route. I find myself looking out for the train stations as signifiers of the progress I have made. I am reminded of Henri Lefebvre's description of a day in *Rhythmanalysis*:

> The use of time fragments it, parcels it out. A certain realism is constituted by the minute description of these parcels; it studies activities related to food, dress, cleaning, transport, etc. [...] Such a description will appear scientific; yet it passes by the object itself, which is not the sequence of lapses of time passed in this way, but their linking together in time, therefore their rhythm. (2004, 85)

The rhythm of my usual commute is determined by the four stages of travel, the different modes of transport and the associated pace/rhythm/environment, but within its four distinct sections there are sub-rhythms. For the train journey, the stations demarcate the rhythm of the journey in terms of the time and space between stops (initially long periods of travel and infrequent stops and then towards the end syncopated with short bursts of travel and frequent stops). While the pace of my walking remains largely constant, I still look to the road and rail signifiers to assert my sense of rhythm.

Another key element that I encounter is the textual signage that provides information on location and direction along the route. Braidotti's focus on process and 'becoming nomad' is analogous to looking for a marker on a road or path: "the nomadic subject is not a utopian concept, but more like a road sign" (2011, 14). For much of my early route, particularly in the Argyll and Inverclyde stages, the road signs are supplemented by another with the Gaelic version of the town name. Often there are four signs which read as a list: district, town, PLEASE DRIVE CAREFULLY, and the Gaelic version of the town name. I notice that a large number of the signs also have stickers on

them, added by people. Signs are objects that invite us to look at them for information or guidance, but these have been augmented by the public, creating an alternative meaning to that which was intended. What the signs are signifying is also in a state of becoming, the meaning malleable and open to interpretation, obliteration, and subversion.

A road sign signalling arrival at Greenock

The journey from Gourock to Greenock is familiar, as the road on which I am walking is the vehicular route to the ferry. Although I have travelled it many times before, the pace of walking allows me to notice details such as street names that I have not previously discerned. COVE ROAD and CONTAINER WAY are new, while the familiar FUNWORLD sign on the side of an old warehouse seems bleak and ironic against the industrial brick façade. I am enjoying the act of solo walking through this area, although I feel conspicuous in my hiking gear – an interloper, a trespasser on these normative streets; a usurper of the everyday rhythm of this commute. My awareness is heightened as I notice intricacies and details that I have previously missed and become aware of the specificity of this journey. A forlorn balloon (HAPPY ANNIVERSARY) in a bush catches my eye, the first of many manmade objects in the landscape that seems dissonant, the juxtaposition of colours and textures jarring yet not unpleasant. Moving through Greenock, the landscape is industrial and there are

numerous decaying buildings, wastelands and areas fenced off (RESTRICTED AREA). There are multiple pieces of public art in Greenock, as well as further on in Port Glasgow, and I reflect on the choices that have been made in terms of the objects created for these sites and their relationship to the town and community. As though offered as a salve to the numerous Tesco outlets that permeate the area (four within five miles, two of which are superstores), the metallic sculptures of Andy Scott's 'wood nymph' and 'Ginger' the horse seem somewhat incongruous alongside the other street fixtures and mixtures of architecture. I am struck by the sense of being able to see the sea at the end of every street that runs perpendicular to the main street of Greenock – this makes the journey more appealing than the public art that purports to 'improve' the Inverclyde town centres.

Street signs in Greenock that indicate the location and purpose of the place

I make good progress and pass Fort Matilda, Greenock West and Greenock Central rail stations. At the large roundabout at Ocean Terminal, there are signs to Wemyss Bay and the Rothesay ferry and I notice how frequently the place names in this area reflect the presence of the nearby water. The large Greenock spire is visible above the roundabout and the squat buildings that house Carpetright, KFC and SCS sit in stark contrast to the decaying and decadent Victorian architecture on the opposite side of the road. There are two lone daffodils in the wasteland next to the Tesco superstore: nature persevering in this urban landscape. In Greenock there are many fences that separate the pavement area and derelict space. Signs read RESTRICTED AREA and DANGER OF DEATH and the metal bars are topped with barbed wire. The intention – to keep people out – is clear, but what goes on in these desolate spaces is less so, in these metallic containers discordant against the backdrop of sea and sky. As

well as the constant presence of the sea throughout this stage of the journey, the large metal structures of the Greenock cranes remain visible in the distance for the first hour of my walk.

FUNWORLD building – a repurposed warehouse in Fort Matilda Industrial Estate

My partner Callum had intended to meet me off the boat but is running late and we have a number of phone calls and text exchanges as we try to synchronise my walking time with his train travel time. I thought I would probably arrive at Greenock Central at the same time as him, but I realise I am making speedier progress than anticipated. Callum disembarks at Cartsdyke and I walk up to the roundabout to meet him. He waves to me from across the roundabout and I wave back. He is on the phone and I walk in silence, holding his hand looking at the large steel-blue crane and yellow McDonald's arches against the sky.

McDonald's in Cartsdyke with crane of Ferguson's shipbuilders in the background

Callum is surprised how far I have come in the first hour and I feel pleased with my progress. We walk along by the noisy road passing car dealerships and Cappielow football ground, where we watched a Greenock Morton versus Hamilton game last weekend. We notice the simplicity of the street names here: PORT GLASGOW ROAD and OLD GREENOCK ROAD (the old road to Greenock which is now the A8, running alongside the busy M8, which I will follow almost all the way to Glasgow).

The waterside at Greenock

We arrive in Port Glasgow via a backstreet behind another Tesco superstore and find ourselves in the town centre. I recognise this as where the McGill's bus from Dunoon to Glasgow stops. We pause at a circular bench for a sandwich (Callum has had no breakfast) and to use the public toilets. PORT GLASGOW TOWN CENTRE adorns a pebbledash wall with a Farmfoods shop underneath. I comment on what an ugly town centre it is. Callum reckons Motherwell is worse and I say Cumbernauld is officially the worst in Scotland – all examples of 'new' town centres, built in the latter half of the twentieth century. Ahead, there is another piece of public art. This sculpture denotes a ship, a nod to Port Glasgow's ship building heritage; now declined to almost nothing while the area surrounding the water is littered with the detritus of the era.

As we leave Port Glasgow, the next roundabout (NEW ROUNDABOUT AHEAD) offers the first point at which we have a choice of route to take – either along the A8 with no visible walkway, or along Glasgow Road. I am tempted by the shoreline and see a cyclist

disappear along a makeshift path by Newark Castle. In *A Field Guide to Getting Lost*, Rebecca Solnit (2006) claims that "NEVER TO GET LOST IS NOT TO LIVE", but I am mindful of our time restriction as Callum has to work in Glasgow later. A look at the map reminds me that at this point we are supposed to cut up Glasgow Road towards Langbank. I resist the temptation of the waters by the 'long bank' and we move away from the shore for the first time. Glasgow Road is very quiet and leads us away from the noise of the traffic and into a more residential area. There are a series of tenement buildings along this road and Callum and I are struck by how the clean and presentable red sandstone facings contrast with the open back close areas that are desolate, derelict and littered with rubbish, white walls streaked with dirt. What should be hidden is exposed, both to the road and the train line.

Backs of tenement buildings in Port Glasgow

As we walk, I realise that a property I viewed when I was house-hunting lies between Glasgow Road and the water. I point this out to Callum. People pass walking their dogs and the sun beats down, reflecting on the water. Although this street is quiet and residential, many of the houses look uninhabited. We can see the train line and we soon pass Woodhall Station, another marker on the railway route between Glasgow and Gourock. Across from this, there is a cemetery behind a high wall that must be hidden from the train, as I have never noticed it before. The sign reads PORT GLASGOW CEMETERY and it is peaceful – we are the only people here. Next to the cemetery is an abandoned housing estate where the windows of all the buildings are boarded up. The place is desolate. A sign to LANGBANK indicates that it is three miles away and we move

on, excited by the prospect of lunch and a rest. As Glasgow Road rejoins the main A8, the noise of traffic is reintroduced as we walk along a narrow path that runs closely parallel. This area of the Clyde Estuary has some of the most beautiful views when travelling by car, but on foot the road is the dominant visual element and our conversation is hampered by the loud and incessant traffic. There is a sheer black cliff face along our right-hand side, on our left the busy A8. This part of the journey is oppressive. The rock face is covered in a wire fence, assumedly to stop small rock falls landing on the path or road, but the impression is of the rock face as caged in, and the natural landscape as contained by a manmade metal grid. The rock formation is fascinating, with a smooth area of rock stretching horizontally along the jagged face. I wonder what natural processes over the years led to this striking aesthetic effect. There are a number of waterfalls and hundreds of almost open daffodils on the grassy verge beneath the rock face. It is very beautiful, although the noisy environment makes this part of the route more stressful and the traffic makes the rhythm of this section feel frantic.

Waterfall near Findlaystone

We walk past Findlaystone tree nursery with multiple conifer trees in various sizes, as well as cherry blossoms and fruit trees. At the end of the field there is a beautiful cherry tree, flowering early, the pale pink becoming more vibrant as we move towards it. This stretch of the A8 is long, and it is a relief when we pass under the bridge at the final corner and can see the pretty village of Langbank on our right. We cut

inland, moving away from the busy dual carriageway, past picturesque houses and well-kept gardens, through quiet streets away from the busy A-road. This street also offers a slight elevation and there is a beautiful view of the Clyde estuary in the sunlight. Dumbarton Rock as a visible landmark is in sight now and Callum and I reflect on when we had driven there for a football match a few weeks ago.

Langbank village

We can see Langbank train station and I point out a number of other houses I considered buying when I was relocating to the West Coast. I eventually moved much further out of Glasgow than I had intended and my current commute is substantially longer than the 36-minute train journey to Langbank and includes crossing the body of water visible now. As we walk through the village, I consider how much of my personal history is entwined in this route and how many autobiographical moments and memories have come to me at various points along this journey. Mike Pearson (2006) discusses this relationship between site and memory in 'In Comes I': *Performance, Memory and Landscape*. I think about this now as I show Callum a home that almost was: my offer was rejected. There is an empty space in the garden; the asbestos garage I intended to tear down has been removed by someone else.

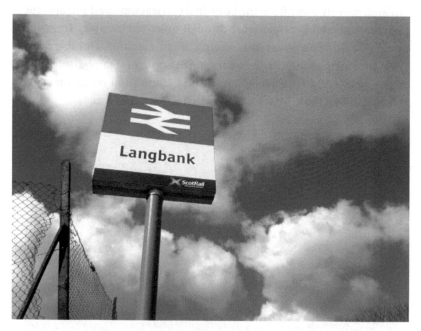

Langbank train station

We stop for lunch at the Wheelhouse in Langbank. Callum and I have a burger and a pint and enjoy resting our legs after the morning's walk. We check the next stage of the journey online and discuss Callum's departure at Bishopton; he is working in Glasgow city centre at 4pm. We set off refreshed for the hour-and-20-minute walk to the next railway station. The road begins to move away from the water and up an incline, elevating us above the estuary. The views are lovely and we walk above the train line now, the cables at our eyeline as we look back towards Dumbarton Rock. It has been a landmark for so long that as the image of the rock recedes and we move further inland, there is a sense of making progress as we move towards Bishopton. This section of OLD GREENOCK ROAD is very quiet and pleasant and signs for FARM TRAFFIC punctuate the quiet road nestled amongst rolling green fields. Approaching CHESTNUT ROUNDABOUT, I can see Bishopton in the distance, as the fields transform into residential areas. The walk to Bishopton seems long, as we try to second guess where the railway station is, checking my phone (Callum's ran out of battery in Langbank) and looking for electric cabling. We are both aware that Callum will be leaving soon and I will be continuing the walk to Glasgow on my own. When we find the pretty Victorian train station

at Bishopton there is a 15-minute wait for the next train to Glasgow Central, so we sit on a bench and I take my boots off to give my feet a breather and organise the rest of our snacks for Callum to take to work. Callum asks how I am feeling about the next stage of the journey and I say I am fine. The morning has been pleasant and I have been glad of the company. I wave him off at the station and with trepidation put my hiking boots back on, ready for the next stage of the journey. My blisters are already making me wince and I regret wearing my heavy hiking boots, as most of the journey so far has been on pavements and tarmacked surfaces. Trainers would probably have sufficed for the mainly urban terrain.

I hobble down from the station and back on to OLD GREENOCK ROAD to continue my journey towards Glasgow. Passing a FILLING STATION, I walk towards the open road. I glance back and see a sign behind me that says GREENOCK 11 and I am incredibly disheartened. I had estimated that I was over halfway along the 27-mile route, but this sign has made me doubt and I start to worry about the next stage of my journey. My feet are already very painful and as I begin to walk along the next long stage of the A8, the endless road yawning in front of me does nothing to allay my fears about the four or five hours of walking I still have ahead. This stretch of road is particularly brutal, with only a very small track next to the A8 that is often encroached on by branches and hedgerow. There is only a path on the left side of the road which means that traffic is coming from behind me and the whizz of vehicles means that I cannot listen to music for fear of being caught off-guard by an articulated lorry. Along this route there is also a lot of debris from car accidents and as I negotiate a path through broken wing mirrors, hubcaps and smashed glass along the grassy verge, my sister texts me, trying to convince me to hop on the next train and meet her for a beer in the sun. It would have been easy to get on the train to Glasgow with Callum, having completed around half of my usual commute by foot. This is the lowest point of the journey so far and I begin to doubt if I can complete the task I have set myself. Prior to doing this alternative commute, I had tried to convince myself that if I attempted the journey and failed it still would have been interesting in terms of my research and useful for our project, however I know I have also not really considered the possibility of failure until this moment. As I limp around the BARRANGARY ROUNDABOUT I decide not to stop again until I can't go any further and I persevere

along the route. Fields stretch into the distance on both sides of the narrow road and I notice how different this landscape is to the seaside towns and hilly vistas through which I have passed so far. A blue traffic cone seems incongruous against the landscape, but I am noticing these things less as my physical tiredness and discomfort become more pressing. Walking on the grassy verge is easier than walking on the hard surface and for the rest of my journey I travel on natural surfaces where I can, avoiding pavements and designated tarmacked areas for the sake of my tattered feet.

India Drive, Inchinnan

The road rises above the M8 and I am struck by the familiarity of this section of the route, which had, moments before, seemed alien. Feeling like I have got my bearings I try to move forward with more gusto, telling myself that I must be near the airport. Sure enough, I see a plane taking off to my right and the road veers away from the M8, across country, towards Renfrew. Callum phones to see how I am getting on and I jokingly tell him I am packing it in, although I am sorely missing the company and my morale is low. His words of encouragement and claims that I am nearly at Inchinnan spur me on and I continue along the long straight road. Signs indicate I am at INDIA DRIVE and the landscape retains the fields on one side, while the other becomes an

industrial estate with clean, white buildings running alongside the A8. At the end of one of the fields there is a large barn that looks like a church, enormous diamonds of stained glass glistening in the sun, which is still high in the sky. I can see a bus depot in the distance and even from far away I can tell that it is the McGill's bus depot. McGill's run a service from Dunoon to Glasgow; the bus picks up passengers in the town centre and then embarks on the Western vehicle ferry, before driving along the M8 from Gourock to Glasgow.

En route to Renfrew

When I told my dad about my intention to reimagine my commute, he suggested I walk for a bit and then get the McGill's bus the rest of the way as he felt the journey was too long. I have inadvertently followed the bus to its depot on OLD GREENOCK ROAD. As I move through Inchinnan, there is more of a sense of the industrial and residential becoming visible within the landscape, as large buildings appear beyond fields and I notice the first shops and pubs I have seen since the Wheelhouse in Langbank many hours ago. I check my phone and realise that I am near Black Cart Water, a subsidiary of the Clyde and I feel a sense of achievement as I cross over first this river, and then another to enter Renfrew.

Fields by the roadside in Inchinnan

Arriving in Renfrew gives me a false sense of being near completion, as the sudden presence of pedestrians, shops, eateries and homes makes me feel as though I have reached my destination. I ponder at a queue of around 40 people outside a chip shop in the town square and move towards the pretty Alexandra Park, past some lovely floral scents and well-kept gardens. The residential area gradually recedes and the railings I pass have more rust than paint.

Railings in Renfrew

All of a sudden, I realise I am in Braehead, and the large PORSCHE showroom glistens in the waning sunshine. Manoeuvring around the multiple roundabouts at Braehead makes me contemplate how this area is designed for vehicles and not pedestrians.

Rocep business park in Renfrew

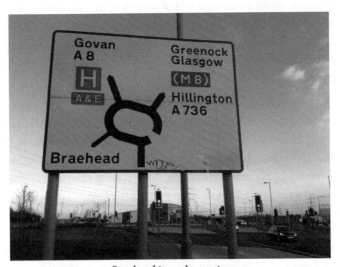

Braehead in early evening

As I wait at the traffic lights, I realise that I have not seen another walker since Callum and I left Langbank. The A8 does not lend itself to ramblers but I have encountered multiple cyclists all along the route. Braehead jars after sleepy Renfrew, as the rush hour traffic becomes noticeable and the concrete and metal of the environment permeate the landscape. There is also a considerable amount of rubbish in the areas around and between the roundabouts and the evidence of human existence and waste is much more noticeable than it has been at any other point. As I tramp past the DIAGEO factory, I

become aware that I have rejoined the path of the M8 and the familiar motorway from which I had diverted after Bishopton has reappeared and is heavy with early evening traffic.

After passing a sign for Govan and Drumoyne, where my mother was born, a sign in the middle of a roundabout announces WELCOME TO GLASGOW. I photograph this, as I have many of the signs, but this one feels important as I have travelled through Argyll, Inverclyde and Renfrewshire to reach this point. As I walk around the roundabout, a WELCOME TO RENFREWSHIRE sign sits at the mouth of one of the exit lanes. These intangible and unknowable boundaries divide one section of paved ground from another. I think about Braidotti's claim about nomadism:

> Nomadism, therefore, is not fluidity without borders, but rather an acute awareness of the nonfixity of boundaries. It is the intense desire to go trespassing, transgressing. As a figuration of contemporary subjectivity, therefore, the nomad is a post-metaphysical, intensive, multiple entity, functioning in a net of interconnections. (2011, 66)

I have enjoyed noticing the "non-fixity of boundaries" and experiencing the small moments of transgression during this journey. I have also been aware of a sense of fluidity of time and space as I have manoeuvred through the landscape and along the route differently than I would in my usual commute. My relief at reaching Glasgow is short lived as I realise I am still not even at the Clyde Tunnel and have many miles to go before reaching my workplace at 100 Renfrew Street in the city centre. I recall living in the West End when I was younger, and how impossibly far the walk into town seemed. Having already travelled around 22 miles the last section seems as though it may be the part that proves impossible. I am physically exhausted and the adrenalin that has kept me going for the last few hours is starting to wane. Callum continues to send encouraging texts and ensures that he phones on the hour, while my sister texts saying that since I am in Glasgow now, I should just hop on the bus and come to her house for dinner. I message her back, saying I would be disappointed not to finish, and continue my walk; a lone pedestrian alongside the multiple motorway lanes, busy with traffic.

I can see Ibrox football ground in the distance and Callum and I had been joking earlier that Ibrox signalled the 'home straight', however,

it seems to take me forever to reach it and my feet are not only blistered, but my left heel seems to have burst open and the pain is excruciating. I am scared that if I stop to look at it then I will not be able to continue and so I keep going as the sun sets behind me. It has been such a beautiful day and the sunshine on my face has been lovely as I have made my long journey towards the RCS. I finally reach Paisley Road West and begin a staggering run, as I find this seems marginally less painful than a walk. A look at my map indicates that this road is a lot longer than I remember and as I jog past the food shops and pubs, the smells and sounds of the city infiltrate my nose and ears. I consider a bus, a taxi, and feigning completion, only to realise that I need to finish it on foot. Passing the GRAND OLE OPRY, I know I am close and approaching the waterway that I have followed for 25 miles. Sure enough, I pass Springfield Quay and cross the Clyde via the 'squiggly bridge', illuminated in the dusky light. I walk towards the town centre and past my sister's flat on Argyle Street (where I used to live) and head up Waterloo Street. Once again, I start to run as I push myself through the final stage of the journey. People have finished work and are going home as I manoeuvre my tired body up the grid-like streets of Glasgow towards my destination.

Ibrox at dusk

Breaking out on to Sauchiehall Street in front of Marks & Spencer, I turn the corner onto Hope Street, past Jack McPhees and across the traffic lights to reach the Conservatoire. It is 7:30pm and I have arrived at my place of work after a day of walking. My journey has taken just over the duration of my normal working day and I have stopped three times to rest.

Braidotti claims that "hope deconstructs the future in that it opens spaces onto which to project active desires: it gives us the force to process the negativity and emancipate ourselves from the inertia of everyday routines" (2011, 90). I had hoped that the physical challenge of enduring a day of walking to re-experience my commute in an active and embodied way would emancipate me from the "inertia of everyday routines". As I reflect on my journey and the new sights and sounds I have encountered, the moments of autobiographical connection and memory, and the ideas I have about processing this, writing about this, talking about this, I know that the "transformative and inspirational" power of the imagination that Braidotti acknowledges (14), has been made visible through the experience of walking my commute during the course of my working day.

Argyle Street, Glasgow

David Overend is Misguided in Ayr

November 28, 2012

Phil Smith's 'misguided' tour of Ayr

Eight walkers assembled behind the train station for the second walk of the day. A smaller group than earlier, but all eager and willing to be misguided by Phil Smith, who had never visited Ayr before. Phil selected three walkers to carry unidentified objects, wrapped in tea towels, and over the course of the afternoon three rocks were revealed. The first was shaped like the sole of a foot and we passed it round the group, weighing it and feeling the smooth texture and the heat generated by previous hands.

We moved inside the station and explored the rich layering of nineteenth century architecture, twentieth century metal work and twenty-first century technology. And strangely, just behind the ticket barrier, was a garden shed. Attentive to anomalies in the environment and hyper-sensitive to the physical and social textures of the spaces we passed through, we departed in a different direction to the trains.

Phil introduced his work on Counter-Tourism and we set off with some of his tactics in mind: "intensifying and sharpening [our] perceptions – seeing what's behind the scenes, what's just outside the site, what's just offstage" (Smith, n.d.). Outside the station we noticed a picket fence and a grass verge, which reminded Phil of Dallas and the assassination of JFK. This was a 'worm-hole', a portal to another place, and when it had been pointed out we realised that there were many, many other places present in the car park, such as the vehicles manufactured in different continents, and the origin of the petrol in their tanks, which perhaps brought this place closer to Dallas that we had originally realised.

Ascending the steps towards Station Bridge, we paused to contemplate a patch of ground behind a metal fence (a grid pattern that we would encounter time and time again throughout the afternoon). Some landscaping work had been done here, but it was half-hearted or incomplete and the place had now been left to grow wild. Hundreds of people must pass by this spot every day, but it seems unlikely that many of them stop to notice such abandoned, cordoned off areas of the city.

We crossed the bridge to Burns Statue Square (named after the statue, not the man) and here we read the signs and displays of shops and bars, treating the faux-Irish paraphernalia in the window of O'Brien's as a genuine museum exhibition. We examined the statue from several angles and attempted to find the exact spot where we could capture his gaze. Tracing the route later on, using Google Street View, I noticed that the face of the statue was blurred out. Impossible to recapture the stare without physically returning. Before moving on, we stood there, reading aloud the names of the Royal Scots Fusiliers who had died fighting in South Africa. Names that had possibly not been spoken for decades.

After following a narrow path between Burns House and the Odeon Cinema, by which two dated buildings maintained a close separation from each other, we paired up and tried out a counter-tourism tactic as one of us closed our eyes while the other led the way back across Station Bridge, lying about the route as we walked. Leading my new friend, Lianne, I turned the Esso garage into a Neolithic farm building and the train line into a mountain stream, and later realised that we were actually passing through the old cattle market on our way to the River Ayr. Sometimes truth and fiction are closer than we realise.

The group meet the gaze of Burns Statue

We arrived at something like a fenced-off smoking area behind the Market Inn, by the Morrisons car park. A rotten gate lay on the ground next to a plastic chair and two beer crates. Phil offered reflections on the social impact of the smoking ban and the spatial relationships of twenty-first century towns. One of the other walkers emailed me the following day, "there were some really amazing moments of seeing the everyday in a new light – who would have thought that observing a smoking pass out at the back of an Ayr pub could become a lesson in anthropology/sociology?!"

The fallen gate prompted us to search for other portals and we headed up Holmston Road feeling the textures of the various gates as we walked. At Holmston Primary, we examined the outline of a road junction in the playground, presumably for cycling proficiency training – streets without pavements. Across the road, we passed through the grounds of a public building, speculating about its many histories and uses. Here, we encountered our old friend, the grid. A network of crude lines was marked on the pathway, framing the ground as an area of special interest and guiding routes across it.

Phil had originally planned this route by searching for unusual shapes in the streets and paths via Google Earth. He had been particularly drawn to a bare patch of land to the east of the station. Visiting the site

in person on the morning of the walks, it transpired that new flats had been built. This was a clear reminder that space is constantly under construction, an idea developed in Doreen Massey's (2005) influential book, *For Space*.

Aerial views of Mill Brae, before and after development

From the new buildings of Mill Brae, we wandered down to the River Ayr, following a pathway that traced the route of Holmston Road along to the cemetery. Here we found yet another grid – a wire fence separating the path from an overgrown piece of land, once concreted over but now returning to nature. We spoke of 'edgelands', a term coined by the environmentalist Marion Shoard (2000), and adopted more recently by the poets, Paul Farley and Michael Symmons Roberts (2011). *Edgelands* are those places where "overspill housing estates break into scrubland, wasteland", the edges of "underdeveloped, unwatched territories" (Farley and Symmons Roberts 2011, 5). This particular edgeland was small and inaccessible, but for now it lacked a clear function and we spent some time examining its hidden details and imagining its story.

We emerged on a grass verge opposite the cemetery. Due to an impending closing time, we remained on the periphery of the site – another counter-tourist strategy. From above, Phil had seen geometric shapes, which he had traced on foot earlier that day. He urged us to return on another occasion to walk them ourselves, noticing the way that different sections of the cemetery are arranged with different patterns, inviting different modes of engagement. And here the walk ended. As we all went our separate ways, Ayr became something else: more familiar, more quotidian, but somehow changed.

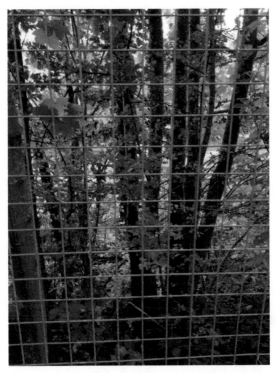

The 'edgelands' framed by a grid

The tour ends at the periphery of Ayr Cemetery

Further Afield

Reflections on a Mobile Train Conference from Helsinki to Rovaniemi

Laura Bissell and David Overend

February 19, 2015 [1]

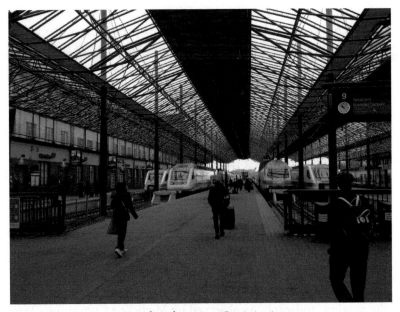

Boarding the train to Rovaniemi

As long-distance commuters in the west of Scotland, we have attempted a variety of strategies to use our travel time productively, creatively and

[1] Originally published as Bissell, L. and D. Overend. 2015a. 'Reflections on a Mobile Train Conference from Helsinki to Rovaniemi'. *Cultural Geographies* 22 (4), 731–735.

as far as possible, transgressively (Bissell and Overend 2015b). We are interested in the performance of journeys and the imaginative processes that they engender. Searching for an appropriate forum to share and develop these ideas, we discovered a 'mobile train conference' with a call for papers exploring ideas around theatre and nomadism en route from the Finnish capital, Helsinki, to the University of Lapland in Rovaniemi (International Federation for Theatre Research 2013). Here, we present an account of the journey, which took place on 8 April 2014, in order to reflect on the opportunities, affordances and limitations of mobilising knowledge exchange in this way.

The conference took place over five days with the train journey on the second day. This day was programmed with panels of two or three papers delivered on a range of related topics, with the chair taking questions from the floor at the end of each session. The thirty delegates were seated along a table that ran the length of the train's 'conference carriage' with a small space for presenting at the top of the table and a portable projector for presentations to be shown on a small screen on the end wall. While the format was similar to a conventional conference, with three panels over the course of the day, we were constantly aware of our mobility as presenters were challenged to stay steady on their feet with the train in almost constant motion.

We have often found that the experience of being in transit leads to critical insight and a productive work ethic. Laura Watts and Glenn Lyons account for this, as movement – in their case the daily journeys of rail commuters – leads to an "ambiguity of place", a "liminality" that can foster "a valued sense of creativity, possibility and transition" (2011, 116). Nonetheless, travelling north through Finland by train, the academic practice of paper presentations, debate and networking often seemed strikingly disconnected from the moving landscape. As observed by Michel de Certeau in a brief passage about train travel, we were "immobile inside the train [...] independent of local roots" (1988, 111). In the comfort of the train's conference carriage, with our coffees, laptops and PowerPoint presentations, we were some way from the nomadic forms of mobility that we discussed during our timetabled, privileged journey north.

Helsinki Station

Helsinki to Rovaniemi

As the 10:06 train to Rovaniemi departs from Helsinki Central Station, the first speaker announces "I have been working here – there!" pointing in the direction we have just come from, referring to the city of Helsinki. This shift between the site as where we are situated (here) and then somewhere elsewhere (there) immediately draws attention to the speed with which our own situatedness in the place where we had begun the conference (and our journey) is becoming dislocated and reconstituted. This moment highlights the fluid relationship between time and space: 'now' and 'here' very quickly become 'then' and 'there' as the train speeds from the urban landscape into the Finnish countryside.

Occasionally, the route exerts its materiality on the academics' performances. A castle, a lake and a theme park divert attention from the speakers to the landscape, interrupting arguments and challenging the status of the work. Later in the journey, as the low, bright sun shines directly into the carriage, curtains are drawn to prevent glare on the projection screen. When the train pulls into stations, stillness and silence serve to randomly emphasise sections of the presentations. Contours in the landscape cause the train to lurch from one side to the other and presenters lose their balance, pausing to recover from their

physical displacement and breaks to their intellectual flow, before tentatively returning to the development of their argument.

At other points in the journey, there is a more productive and formative relationship between the delivery of the papers and the mobility of the conference. A sense of spatial advancement accompanies the chronological succession of the presentations, breaks and discussions. This is a literal mobility that enhances the intellectual progression of the day's work. Furthermore, there are moments when the content of the papers directly relates to the places and landscapes that we move through and past: we learn about the summer theatre traditions of Finno-Ugric cultures just as the sun frames the locations referred to in the paper; we consider performances that use and respond to transport systems and network capital as we stop in a train station, dwelling in connection points and experiencing a brief glimpse of other peoples' journeys.

One of the presenters, Fiona Wilkie, cites de Certeau and points out that we (the passengers on the train) are immobile and seated while the landscape also remains static outside. It is the mode of transport (the train) that is active and moving and allows us to progress through the countryside on our journey. This often has the effect of providing a moving scenery to the event; the bright blue skies and fluffy clouds over the idyllic pine forests emphasising this impression.

Our recent performative interventions into our commutes led us to attempt to reimagine these repetitive and everyday journeys by walking them (See 'David Overend walks Route 77' and 'Walking Gourock to Glasgow: Reimagining my commute', Laura Bissell, elsewhere in this book). By employing an embodied mobile practice rather than the bodily stasis that the use of both public and private transport creates, we attempted to reengage with the landscapes of our commutes. As Wilkie draws attention to the simultaneous stasis of both our bodies and the landscape as we whizz past the dense pine forests of Finland, the disconnection between us and the sites we move through is palpable. The immobility of our bodies on this 'mobile' train conference is emphasised further by the cosy train carriage where there is little room to move.

At 13:15, we pause at Seinajoki just before lunch and Stephen Wilmer, one of the conference organisers, leaves the train to exchange flowers for a box of pastries on the platform. His sister-in-law owns a pastry stop in

this town and Wilmer has arranged for her to provide buns for the delegates on the train. This moment of personal connection and autobiography, in a landscape that is unfamiliar to many of us, serves as a reminder of the personal connections we have with sites and their inhabitants. We witness this momentary and fleeting personal exchange through the glass of the train windows.

The journey is punctuated and syncopated by the stops at stations. At 17:35, we reach Oulu and many delegates use this pause to leave the train and take some air on the platform. Already, the journey to this point has instigated conversations and connections and, through the course of the 10½-hour train ride, has created the sense of a unique relationship shared. We have almost arrived somewhere together. But as de Certeau reminds us, the 'paradise' of train travel has to come to an end and, ultimately, "one has to get out" (1988, 114). Our arrival in Rovaniemi at 20:40 seems sudden and abrupt as the length of the journey has allowed for a leisurely pace of conference papers and conversations. De Certeau's closing remarks resonate as we replace the stasis of the train carriage with the motion of onward travel by foot, and "in the mobile world of the train station, the immobile machine suddenly seems monumental and almost incongruous in its mute, idol-like inertia, a sort of god undone" (114). Our "incarceration-vacation is over", and we glance back at the train before we disperse into the snow-covered city.

Train line over the frozen Ounasjoki River in Rovaniemi

World Wide Wandering

David Overend

December 2, 2012 [1]

E found that early attempts at wandering through Paris and London were frequently thwarted by the irresistible pull of the iPhone Maps app. How could e follow the psychogeographical contours of the city when the multinational data gatherers had been there already, rendering the streets and boulevards hopelessly knowable and searchable? Leaving the technology at home seemed disingenuous: a desperate nostalgic hankering for a bygone age before mobile internet. The city was no longer accessed through physical routes alone, and e had to find a way to embrace this pandemic augmentation of the urban landscape.

Attempting to find the epicentre of the predictable city, e types "places to go in London" into Google and picks the first unfamiliar location – Little Venice, where the Grand Union and Regent's Canals meet north of Paddington. Alighting from the underground at Warwick Avenue, e wanders along the leafy streets and, as the sun sets, the sound of a six-piece blues band heralds the final hours of the Canalway Cavalcade festival – a fortuitously celebratory opening to a week's e-drifting.

E drinks overpriced lager from a plastic glass and watches Chinese lanterns float away into the clear sky. Over a Tannoy, the wry compère announces a procession of illuminated narrowboats; an annual tradition that is cynically undercut by e's judgmental use of a Rightmove application to ascertain local property and boat prices. Now, with the knowledge that e's Glasgow flat is worth little more than the smallest of these vessels, the whole affair takes on a new light and a charming pageant becomes a grotesque parade of affluence.

Later, in a far less glamorous flat in Willesden Green, e trawls the internet for other Little Venices and stumbles across the website for

[1] See Overend, D. 2013b. World Wide Wandering: E-drifting in Paris and London. *Scottish Journal of Performance* 1 (1), 31–52.

the Department of Architecture at Berkeley University of California, where Professor Charles C. Benton blogs about his foray into kite aerial photography. E uses Benton's photographs of the 'Little Venice' of Parc de la Villette in Paris as a real-world hyperlink and two weeks later finds the exact spot where the kite camera captured a freight boat passing one of Bernard Tschumi's follies on the Canal de l'Ourcq.

Searching the web for information about the follies, e mostly finds drawings and plans, strikingly detached from the landscape, alongside photographs of the bright red structures taken from below, framed by nothing but clear blue sky. On foot, sauntering along the canal on the warmest day of the year so far, the park feels very different. The follies are distinct from their environment, but they also have a clear relationship with it. E moves over bridges, across well-kept greens and up stairs – the whole site is a huge adventure playground. At the same time, e has never been in a place that feels so tangibly designed. People literally flow along the pathways, parallel and perpendicular to the waterway. This is the architecture of human behaviour as much as landscape; a clear reminder that most of the wandering that is done in the city was planned in an architect's studio.

The same is true of the nineteenth-century shopping arcades made famous by Walter Benjamin. E walks the length of one of these – Le Passage Choiseul – the next day and finds locked doors, boarded windows and 'to let' signs. Perhaps this is a more direct example of the impact of the internet on the urban environment, as the explosion of e-commerce draws its strength from the closure of local, independent businesses?

Leaving the manmade waterways of the Canal de l'Ourcq behind, e traces the route of the Canal St Martin above ground towards the Seine. Surrounded by monumental architecture and urban order, the river offers a very different experience of wandering through the city. Here, the gothic splendour of Notre Dame and the vast architectural grandeur of the Louvre are juxtaposed with something more mysterious and untameable in the murky depths of a defiantly natural entity: the urban river, containing both "the real and imagined threats which unruly natural features represent to the civilised contemporary city" (Donald 2012, 222).

Standing on a bridge over the Seine, e uses an augmented reality programme to display information overlaid on the physical city. Recognising the shapes of buildings and monuments, a series of labels

are generated that indicate the location of various tourist attractions. E is looking for an indication of where to go next, but there are no clear signs. Under foot, the river ripples in the sunlight. It is notably absent from the virtual data. This is the first point in e's journey that the real seems to shut out the virtual. Perhaps that is why this whole e-drift has continually been drawn to water and guided by its routes. E stays on the bridge for a long time, trying to get a sense of the life of the river. The need to walk diminishes as the water moves things and people past this vantage point.

Returning to London, e spends some time on a houseboat in a floating community near Tower Bridge. For better or worse, e has missed the spectacular flotilla organised for the Queen's Diamond Jubilee, but there is still plenty of evidence of celebration in the days after the event. In the mornings, e sits at a picnic table that was hauled out of the River Thames and given a new home on the bow of the boat. No online furniture store could have provided such an efficient delivery service.

Drifting along the South Bank, e stumbles across a world food market behind the Queen Elizabeth Hall. Eating a delicious Serbian kebab, e reflects on the global marketplace that has contained and defined this entire summer excursion: Google's multinational corporation, operating from data centres in America, Finland and Belgium; cultural exchange of traditions and products – the Chinese lanterns; London's allusion to Italy's grand canals; the passage to France afforded by the Eurotunnel; the Jubilee celebrations of the commonwealth. Clearly, the global spaces of London and Paris extend far beyond their geographical boundaries.

Moving through virtual and physical realms over the course of these e-drifts, another realm had moved into focus, located in the prevalent processes of cosmopolitanism and globalisation. Beyond the intersection between the internet and the city, the rest of the world had asserted its constant presence. Journeys through this worldwide space could now take place both electronically (via kite aerial photography) and corporeally (via a delicious kebab). While these drifts raised far more questions than they ever could have hoped to answer, this seemed to validate this line of enquiry: to explore the connections between the physical and the virtual, to ask how we can work with and through them both to better understand the world in which we live. The next phase of the e-drift might have to reach further into this global realm.

David Overend Attends the Launch of 'Community Spirit'

August 22, 2012 [1]

The crew of Community Spirit at the launch event in Emsworth, Hampshire

I was drawn to this project from the beginning. Following progress online, I watched the collection and selection of hundreds of wooden objects, the design of the vessel, and the collective construction process taking place in a boat shed in Hampshire. The ambition and scale of

[1] Originally published in Overend, D. (ed.). 2012. *Making Routes: Journeys in live art*. London: Live Art Development Agency. See also Overend, D. 2013a. Making Routes: Relational journeys in contemporary performance. *Studies in Theatre and Performance* 33 (3), 365-381.

Lone Twin's plans was admirable. Residents of South East England were invited to tell their stories and donate items that would be turned into a seaworthy yacht. After its maiden voyage along the south coast and inland to Milton Keynes, the boat would be made available for public use as a sailing and arts resource. I felt left out and decided to be there for the launch.

On Monday 7th May 2012, I took the train from London Victoria to Emsworth and arrived in a downpour. Huddling by the station wall, a crowd of people waited for a bus to arrive. Some of them lived nearby and wanted to know what all the fuss was about, and others had travelled from elsewhere in the UK - artists, students, producers, as well as those who had donated their own objects and were seeing the boat for the first time. Soon, 'I' became 'we' as the weather provided a valuable way into conversation.

After a short, damp journey, we arrived at the marina. The rain was not showing any signs of relenting and, as is so often the case in outdoor events in this country, we arrived to find that the vast majority of people had crammed themselves into the food and drink tents, cowering under the tarpaulin. The event had all the trappings of a quintessential English country fair - a bar run by the local publicans, an art exhibition, roast meat in bread rolls and a selection of produce available to sample and purchase. David Williams's (2012) book about *The Lone Twin Boat Project* was also on sale - a series of essays appended with a comprehensive catalogue of all the objects and stories that went into the construction of the boat.

Eventually, we were coaxed out of our shelters by the compère. As the rain gradually relented, a local choir and a sea-shanty group provided the entertainment. The music was interspersed by short interviews with the people who had made this project happen as the compère introduced Mark Covell, the chief builder and project manager; the captain and members of the crew; Gregg Whelan and Gary Winters from Lone Twin; and several of the hundreds of volunteers and donors.

Each had their own stories to tell about their individual contributions and experiences, but more importantly, all of them knew they were part of something much bigger - a sense of community formed around an idea and a belief that working together on something would make it possible. As Whelan and Winters assembled the team and found their builder, they were driven by "enthusiasm for stories, adventure, humour and music, as well as a convivial ease with other people" as much as by the specialist knowledge and technical skill that the build required (Williams 2012, 23).

Detail from the rain-covered hull of Community Spirit

And at the centre of it all was the beautiful boat. Close up, the intricacy of the design was impressive; an apparently delicate surface but hardy enough for a voyage along the south coast:

> *A tiny elephant stands in the shadow of a bleached horse's head between a tree and a spirit level. A helicopter hovers over a minute hillside house and a violin. A clothes hanger, clothes peg and rolling pin float in orbit around a miniscule train. A tiny cat stands transfixed with its back to two overlaid electric guitars. And an aardvark trundles stoically along beneath a tennis racket and a cricket bat.* (Williams 2012, 29)

The final result of years of planning, collecting, listening and building is a remarkable travelling museum of people's lives and stories represented by an archive of personal possessions that have been generously donated

to make something new. The layers and structures of individual and collective histories is tangible and it brings together international superstardom (a shard from Jimi Hendrix's guitar), maritime icons (a piece of the Mary Rose) and personal biographies (toys, tools and hundreds of other personal possessions).

'Community Spirit' is lowered into the water at Emsworth Marina

It would be possible to examine the fabric of the boat for hours but mid afternoon, as the sun crept out from behind the clouds, the crowd surrounding the boat parted to make way for the launch. This was the moment the assembled TV crews and photographers had been waiting for. A huge crane hoisted the vessel into the air and a slightly mistimed countdown preceded a confetti canon and a huge cheer as the boat was carefully and slowly lowered into the water.

As I stood amongst the jubilant onlookers, each stretching over each other's heads to take their own photographs of the floating vessel, the thing I was really struck by was the palpable sense of community that had developed throughout the afternoon. The craftsmanship in the boat was outstanding and the technical and management skills that

realised Lone Twin's original idea was staggering. But more than that, it was the announcements to find the lost child, and later the lost old woman; the enthusiasm and anecdotes of the bar staff; the song by the daughter of the project manager. All this created a memorable event with the boat at the centre of it all.

In the lead up to the launch, a competition had been running to name the boat and earlier that week, it had been christened 'Community Spirit'. The name captures the ethos, the methodology and the outcome of *the Boat Project*. Not only was the boat assembled through the contributions and time volunteered by the people of South East England, it will continue to encounter communities on its maiden voyage which includes stops in Brighton, Portsmouth, Suffolk and even landlocked Milton Keynes (Lone Twin 2012).

'Community Spirit' also reveals something about journey-based live art in the general. Like Pointed Arrow's Yorkshire Onland Boating Club and Kieran Hurley's journey to L'Aquila, Lone Twin's boat is ultimately created through ongoing meetings and encounters with people and communities. It is about working together to create something beautiful in the shared space of the live encounter. When that moment of interaction is at a point in a journey, it has a future. Community Spirit will touch the lives of many more communities as it takes on a new life as a public art and sailing resource. It was a privilege to be there at its launch.

Imagining Travel

David Overend

February 17, 2014 [1]

My journey begins with what Laura Watts (2008) calls "imagined desire" – a vision of flying across the Atlantic Ocean, exploring a new city in temperatures down to the minus 20s. I am travelling as co-director of *Bullet Catch* by Rob Drummond; a touring theatre show produced by the Arches Theatre Company. Together with Rob and our Stage Manager, Deanne Jones, I have visited several new places in the last couple of years, from Edinburgh to America, Brighton to Brazil. This is the last time I will travel with the show. But I couldn't miss out on Michigan. I have always been drawn to the snow-capped mountains and icy lakes of North America.

In the days leading up to my departure, there are reports of a 'polar vortex' gripping large parts of the north-eastern states in an 'ice storm'. I have never heard these phrases before. I reconsider the trip. I phone Mary, the producer in Michigan, and she reassures me. "It will be fine", she says. "This happens every year. We're used to it."

We fly over the north Atlantic, the tip of Greenland and South-Eastern Canada, arriving in Newark Liberty International Airport with only an hour's delay. It feels good to be travelling – somehow an affirmation of the success of our theatre show or a way of proving to myself that I am literally *going somewhere*. We sit in the lounge, waiting for our connecting flight to Detroit, reading, drinking coffee and chatting about our work. As we do so, we patiently watch the delay time on the computer display stretching out into the evening until we know that there is no chance of reaching our destination that night.

[1] This paper was first presented at the Into the New Symposium, Royal Conservatoire of Scotland and the Arches, Glasgow, January 2014.

The inevitable cancellation of the Detroit flight instigates a frenzy of phone calls, emails, queuing and rebooking. Between ourselves, the United Airways staff at Newark, our producer in Glasgow and Mary in Ann Arbor, we arrange to spend the night at the Double Tree Hotel near to the airport, and we are rebooked onto a flight the following evening. "There is no way you are getting your bags any time soon", we are told at Baggage Reclaim. This is our main concern now. Without the props in Deanne's suitcase, there will be no performances this week. "It's not happening. We're not pulling any bags."

We take a taxi to the hotel and over the next few hours, various efforts are made to reroute our luggage. We allow ourselves a moment of respite and I enjoy two cold glasses of Samuel Adams Boston lager and a medium-rare cheese and bacon burger - one of the best meals I have had in a while.

The next day, we return to the airport in plenty of time to attempt to retrieve our bags. Covering all bases, I wait at the check-in desk while Deanne and Rob return to Baggage Reclaim. Both queues are long and slow moving. While I wait, I receive a text from Deanne, "Our flight is cancelled". The process repeats itself – phone calls, emails, queuing and rebooking. The plan is to travel thirty miles across the city to JFK airport, where we can all be booked onto a flight to Detroit that leaves that evening.

But I have just read something about 'frost quakes' and I am no longer keen to reach Michigan. As the co-director of a relatively straightforward show that has been performed and stage-managed over a hundred times by my colleagues, I am an expendable member of the team at this point in the tour. Would it be possible, I wonder, to simply go home. My 'imagined desire' has turned on its head and I think about returning to my fiancé and my warm, familiar flat. It takes a while - an hour to be exact - but when I return to the desk, a tremendously helpful and persistent member of the airline check-in staff somehow manages to find me a seat on the evening's flight back to Glasgow. I ignore a latent feeling of guilt about deserting my friends and we say our farewells.

On the flight home, I have three seats to myself and I lie across them, sleeping comfortably for most of the journey and watching half of *Star Trek Into Darkness* before we land in a dark and drizzly city. On the way home, my taxi driver asks if I have had a good trip.

Over fifty hours, in the mode of Marc Augé's (2009) *Non-places*, I have taken a taxi, a plane, a train, a second taxi, then after a night in a hotel, a bus, a second train, a second plane and a third taxi. I arrive back at my flat with nothing to show for my misadventure save for an irresponsibly large carbon footprint and the loss of two days, $250 and my suitcase, which, I am reliably informed, is somewhere in the company of 10,000 other bags stranded in airport limbo.

This will teach me to romanticise travel, I think. This will teach me to ignore weather warnings. This will teach me to *imagine*.

<p style="text-align:center">*</p>

So, what have I learnt from this experience? In transit, this journey was tangible, corporeal, at times exhausting and uncomfortable. But the present of travel is continually deferred, moved on and erased, and the passage of time is marked by the progress of miles and the shifting land and seascapes below aeroplanes.

Beforehand, and retrospectively, travel exists as an imagined space and time. Looking back, recalling the journey in memory, I am engaged in imaginative reconstruction: selective editing, a reduction of details identified by Alain de Botton as creative process of omission and compression (2003, 15). However, this creative translation of my journey is problematic for two reasons. First, the omission and compression of artistic imaginations can exclude the most important features of international travel. The commas in my list of planes, trains and automobiles reduce significant time periods into single punctuation marks. However, as Monika Büscher and John Urry point out, a lot happens between transit, while we are "temporarily immobilised - within lounges, waiting rooms, cafes, amusement arcades, parks, hotels, airports, stations, motels, harbours and so on" (2009, 108). Between 'train' and 'second taxi' we arranged a night in a Newark hotel, corresponded with our producers to book us on the next available flight to Detroit, and tried in vain to retrieve our luggage.

These mundane details often involve problem solving - a necessarily *relational* practice that relies on a range of technologies, networks and systems. They are the reality of international travel, but in our memories, diaries and stories, we routinely gloss over them, forget the people who have helped or hindered us, and reduce significant experiences to commas in lists.

Second, I am aware that my 'imaginative desire' partly arises from a fetishisation of mobility. At its worst, this impulse to travel and my desire to physically 'go somewhere' is a form of excessive consumption – which Anthony Elliott and John Urry criticise as "the internationalisation of a consumer culture held in thrall to instant gratification, continual self-reinvention, superficiality and addictive, short-term 'highs'" (2010, 23). As we enter a new phase of mobilities, in which climate change exerts its influence, oil supplies are in decline and transport systems buckle under the pressure, it is necessary to imagine alternative futures. The main question to address is whether to maintain an uncritical position in relation to our touring practices, maintaining current patterns of behaviour because *that's just the way it is,* or rather to imagine alternative models of touring, aspiring towards an ecologically responsible, culturally sensitive approach to mobility.

In many ways, the choice may not be ours to make. If we have now passed the peak of global oil supply, the transport infrastructure that facilitates our international travel will necessarily change (Urry 2013). Concurrently (and interrelatedly), climate change is leading to a new form of capitalism and the prospect of a culture of *decarbonisation* is becoming a reality. While the exact nature of these changes is not yet clear, the mobilities system as we know it is clearly unsustainable. There are many different ways in which touring theatre could change in the relatively near future and we need to start to imagine these possible scenarios. *Bullet Catch* will continue to tour without me in 2014 as the production visits Wellington, Sydney, Toronto and Hong Kong. This model of frenetic intercontinental touring is arguably irresponsible and may not be sustainable for much longer, but it will almost certainly change. Perhaps some of these issues will therefore come to be seen as more important in performance research and practice in coming years, and perhaps more work will start to pre-empt this shift? I am hopeful that others will take up this line of enquiry in productive and imaginative ways.

São Paulo, June 2013

David Overend

September 25, 2013 [1]

Protestors outside São Paulo Cathedral, Brazil

After a particularly uncomfortable and severely delayed two-day journey from Charleston to São Paulo, we slump down with a beer in a hotel bar and attempt to wind down. This is the reality of touring

[1] See Overend, D. 2015. 'Dramaturgies of Mobility: On the road with Rob Drummond's *Bullet Catch*', *Studies in Theatre and Performance* 35 (1), 36-51.

theatre – far from home, exhausted and disoriented, desperate for a drink. We have been travelling from place to place for almost three months now. For a few weeks in May I returned to Scotland to direct another play but Rob and Deanne have been on tour the whole time. As we adjust to our new surroundings, a television screen above our heads plays footage of police in riot gear closing in on a group of protestors. It looks like a scary and volatile situation.

Picking up on a few familiar phrases and recognisable images – we soon realise that these scenes are unfolding as we watch and only a few streets away. Nobody in the bar speaks English well enough to explain what is happening and our beginners' Portuguese is limited to asking for directions and ordering food. Thankfully, smart phone technology brings Google to our aid. We learn that a few days before our arrival, the municipal government raised metro fares to 3.20 Brazilian reals – a raise of twenty cents (around five pence). This seemingly innocuous decision fuelled an emerging protest movement that rapidly spread across the country becoming one of Brazil's largest protests in decades. From the clinical universality of airport lounges and hotel foyers, we have unwittingly stumbled into something real and urgent.

Later, from the safety of a hotel room with views over concrete tower blocks and building sites to Ibirapuera Park, I watch hundreds of people drift by on their way to the centre of the action. I decide to follow them but I soon feel out of place – an imposter in somebody else's revolution. I see nothing of the burning cars and police brutality that is currently being streamed across the globe. Instead, there is a tangible optimism driving this mass gathering. Alongside political slogans and chanting, I see samba bands and dancers, balloons, costumes and masks. And everywhere, on walls, pavements, banners and clothes, the phrase "320 não!". Someone holds up a sign, "Brazil Woke Up".

At the Teatro Cultura Inglesa for the next few nights our potential audience is noticeably depleted. The theatre is not empty and our performance is well received but this is a very different experience to the tour so far. As millions take to the streets in a historically significant movement against the corruption of their government, we diligently plough on with a theatre show that we have performed countless times before in venues from London to New York. For now, we are culturally and politically disconnected from our environment. The real theatre is not happening in this building.

Ice and Sapphire Conjure Flame

Nic Green

15 May, 2012 [1]

This is a performance about journeys.

Or perhaps this is a reflection on some of the journeys I have taken within the last 18 months, which have had a significant impact on me, that have influenced my work, my value systems, my beliefs and my practices.

Or perhaps this is a kind of journey in itself.

May 2010, Southwest Scotland

I decide I am going to walk from the house I am living in at the time, to the sea and back again, following the river Annick, which runs close to the house I am renting. I decide that I should leave before sunrise, and make this journey in silence, and without food. I pack water, some extra socks, a jumper, a tent and sleeping bag, and that's about it. The evening before I leave, I make a small circle of stones in the garden, where I will stand at dawn for a moment before I set off, to try to identify some meaning relating to why I am embarking on this small journey of mine.

Originally I had planned to do this walk as part of a process which would culminate in a paper which I would submit for my Ecopsychology module as part of the MSc I was studying in Human Ecology, but I didn't write about this in the end, as my journey became about other things, which somehow weren't conducive to assessment,

[1] A version of this paper was presented at the Arches, Glasgow, September 2011 at the Making Routes launch event. It was subsequently published in Overend, D. (ed.). 2012. *Making Routes: Journeys in live art.* London: Live Art Development Agency. pp. 20-25.

academic referencing, and the standard structures of an essay. So I kept it just for me, as something else. A secret journey, for which I was mostly alone, except for of course, the animals and animate world that I passed by and through. Having never really spoken of this journey with anyone, I thought today's event would be a good place to do so.

May 2010, Southwest Scotland

I close my eyes and listen to the wind passing over my ears.

Without food you get a little more tired, more quickly than normal and I stop for a rest, and fall asleep for a while by the side of the river. It is a nice spot, where the water is shallow, and it makes a satisfying, comforting noise as it passes over the stones on the river bed. When I wake up, it is warm and the sun is shining and making the pebbles around me radiate with heat. I stand up slowly and put on my pack, and there, completely to my surprise and absolute delight, is an otter standing next to me. It stops dead still for a moment, and then dashes into the water, causing a great deal of splashing and noisiness as its velvety shape escapes from my gaze. I wonder how long it was there, checking me out and watching me as I slept. This is the first and only time I have ever seen an otter. I wonder for a moment if this is the first time the otter has ever seen a woman, but I doubt this very much.

No one walks here. There are no paths, no means of easily and leisurely meandering along the riverbank. Everything is a mix of clambering through shoulder high brambles and thorns, scaling the sides of river banks, tentatively crossing water on the stones, cautiously climbing the fences of cattle fields, and nervously crossing a single, dilapidated beam – all that is left standing of a once-used bridge. I try not to look down, and to concentrate on all those balancing poses I've been practicing in yoga.

A note about crossing rivers:

For my whole life, I have always looked for a combination of stones dotted width ways across the river, which would allow me to hop straight across the water, directly from bank to bank. On this particular journey, I realised the shortcomings of this method of finding a route across the waterway. Very rarely did such a convenient arrangement of stones appear – especially given that my legs are quite short, and the water level was quite high. So when looking for

crossings I began to widen my scope, extend my field of vision. I would look down the river lengthways, and plot a divergent path of stones which snaked left and right across the water, eventually arriving safely at the other side. This meant I was on the water for a much longer time and distance, but it was well worth it, as there was far less danger of falling in and getting very wet.

In the end, it turned out that the best way was to think of my journeys across the river with longitude, and to resist the urge to look for the fastest, shortest route.

During this realisation, I wondered if this urge of mine, this instinctual shortcutting, is/was part of my post-industrial, 21st-century upbringing.

Eventually, I was able to stop charting the paths at all and step onto a rock in the river, knowing that somewhere downstream, I would come safely to the other side.

Later on my journey, I see a flash of blue dash upstream as I plod slowly toward the river's end. This is the first time I have ever seen a kingfisher.

- An idea about a performance for the birds.

- An idea about a performance where a chorus of children leads an audience through a landfill, and into a forest. There is a deer on the way, picking through the remains of all our mess.

- An idea about a performance, where I can pack down and carry the parts of the dwelling I am living in, on a wheeled cart from place to place. I can have a series of housemates in each place I go to and we can help each other live here. These people are the audience.

February 2011, Central North India

I have been in an ashram where I have eaten the same meal, three times a day, for one month. Everyone from the West is either constipated or has diarrhoea. I am faced with the ludicrous realisation that I have travelled 7000 miles to try to understand what it means to find stillness. They tell me in this ashram – a lonely Jain temple among rice fields – that shortcutting is an aspect of the Tamas Guna, which is the Guna of darkness. They emphasise the value of long, thorough,

authentic process. They feel things that matter should be worthy of lifelong engagement and focus.

The monks here pull out all of their hair as an act of austerity, and walk naked, with their only possession – a brush made of peacock feathers, which they use to gently move aside any floor dwelling, living creatures which may be in their path, so that they will cause them no harm. They believe in the fundamental notion of Ahimsa (non-violence), and absolutely no killing. They believe in a general principle letting things live, wherever possible. They believe your soul lives through 108 different bodies. A vegetable is a different category of body to the beetle, as the second one feels more, and can feel when you cause harm, or traumatically take its life. The Jains see souls in rocks, in bacteria, in plants and in mosquitoes. They see souls alive everywhere, in everything, moving through an epic journey of lifetimes. You never know where you or another is, on this journey through lifetimes. So according to the Jains, we are always in the unknown midst of a voyage spanning 108 different bodies. Next you might be a dung beetle, and you may have just been a tree. The important thing for them is to respect the journeys of the souls around them, and to try to do the best job you can, on whatever part of the journey you are on.

February 2011, Northeast India

I am in the Himalayas and it is minus twenty degrees. At four thousand meters we come across a dog, alone, as if he is waiting for our arrival. In the evening I throw him the leftovers of our meal and he spends all the entire night on the top of the hill, howling into the darkness. I cannot think what this means and why he might be doing this.

The next morning, I am so ill with altitude sickness that my head has swollen up to resemble a beetroot-coloured rugby ball and it feels like my eyes are going to ping out of my head like ball bearings from an air rifle. The official line as my guide tells me, is that the ice and snow are too bad to go the extra 1000m to the summit, but I know already, that regardless of the weather, I could go no further.

I have always naïvely thought that you can always go beyond where you are, that no journey is ever finished, but this time, I really could go no further.

February 2011, Northeast India

Having descended from the mountains with a now normal shaped head, I have arrived in the oven-like Varanasi, a busy town, on the banks of the sacred river Ganges, full of pilgrims and tourists. On the ghats I see a man with a cage, which contains a kingfisher, who despite her attempts, is unable to open her wings in the cramped and tiny space she has been enclosed in. I remembered that a man once told me they are also known as the jewel of the river. My companion and I rush over to the man and I hear the words "On no, the poor kingfisher". We ask what the birds are for. The man tells us that if we pay him, he will release the bird, and this will mean good karma for us on our journey. I say, "Surely this is your karma, not mine?"

Everything is confusing and difficult about this situation to me.

I really remember that bird, I think of it all the time.

- An idea for a performance in Scotland, where I try to swim in every loch.
- An idea for a performance delivered to taxi drivers whilst they drive you home.
- An idea for a performance on the A1 motorway, walking super slowly, up the hard shoulder, against the flow of the traffic.

June 2011, a small island off the West Coast of Ireland

I am staying with a woman, who is teaching me a course in advanced Yoga and meditation. Lots of things I thought I knew about these practices are challenged and transformed by her ideas and experience. I am grateful for this woman and all that she knows. We really get on well and like each other very much. The night before I leave she asks me if I would like a starter. I say yes, absolutely.

A 'starter' or levain, is essentially an ancestral and natural form of pre-ferment used in bread-making processes. Bread made using this method is called sourdough, which in comparison with yeast-based breads, produces a distinctively tangy or sour taste. This is because of the lactic acid produced by the lactobacilli; a natural culture, bred in symbiotic combination with yeasts, allowing you to bake bread with it.

In short, it is a raising agent – dough mixture which has been cultivated over a period of time, picking up the natural yeasts from the

environment and air around it. It uses no artificially produced or dried yeasts, and you only ever need flour, water and salt to make bread using a starter.

She shows me how to make the bread, and how to maintain the starter, and siphons off some extra for me to take home in a glass jar. This starter was initiated in Ireland 30 years ago, and is as old as I am. Once you receive a starter, you have to keep it alive and take care of it. Ciara, the woman I am with, explains to me that if she is away for a while, she takes her starter with her, so that it won't die. I wrap mine in a jumper and a plastic bag, and as I make my journey back to Scotland, my starter in my bag in the luggage hold of the ferry, my mind worries for the safety of my starter, and hopes it hasn't been broken, or smashed, or shaken too much.

When I get home, I try to make sourdough as Ciara has taught me and it doesn't work. A friend laughs as I compare this process to continually buying bags of flour and throwing them directly in the bin. But I keep trying, keeping the starter alive all the time. The most important thing in this process is the thing that has longitude – the starter. The immediate gratification of a freshly baked loaf is secondary in importance.

Thank goodness, eventually I understand and perfect it. Now I am bound to this process – a lifelong engagement with the act of making daily bread. I am grateful to have this accompaniment on my journey and to keep this starter alive for potentially another 30 years.

- An idea for a performance in which I follow my father (who I have only met once, 12 years ago), continuously at a distance of 30 feet without him knowing. That is one foot for every year we have been strangers.

- An idea for a night-time performance where I work with scientists to understand and discern the nocturnal movement and behaviour of foxes. The audience and I can move through the landscape through the night as a fox does, understanding its journey through the quiet streets of our towns and cities. Perhaps the foxes would watch us, and wonder where we go in the day time.

- An idea for a performance that moves and moves and keeps on going.

I have been thinking of that word a lot recently. *Moves.* That we use the word move for a change in location, or a travelling through environment or space, but we also use it for when we are emotionally affected or engaged in some way.

I suppose this is because we are simply not in the same place afterwards, that somehow we have arrived, without any physical movement necessarily, at a different area of ourselves, perhaps an area which is less travelled to, a more unchartered territory, a place which is only visited occasionally. We are changed.

Perhaps the 'place' we are moved to doesn't have a role in our 'business as usual', or isn't given space in day to day life and activity. In my own experience, it is a place which is often given much less room to breathe, which can become suffocated, ignored, or worse still, forgotten if the space for it to live isn't created.

It matters that we can learn to move to these parts of ourselves, and that things made with love and beauty can give us those precious opportunities.

On the way back from Ireland, I bought a book on *The Poetry of Birds,* which has the picture of a kingfisher on the front. I recall that someone told me that the kingfisher is the symbol of transformation in some cultures. I remember being on a panel with the wonderful Anne Bean, and when talking of transformation she said that she had heard that the body completely renews itself, every seven years. She said she felt she was always changing, always transforming, always moving in some way, and I understood this.

- An idea for a performance where I trace the journey of my starter, and pass on parts of it, following its journey forward.

- An idea for a performance where I bury texts, objects and memories from the last ten years, in a circle within ten miles radius from where I live. In ten years I will uncover them again.

- An idea for a performance where you walk with someone to where they need to get to in that moment in their lives. When you arrive there, you walk another to the place they need to get to, and so on, and on and on.

Kingfisher by Peter Scupham[2]

December took us where the idling water
Rose in a ghost of smoke, its banks hard-thatched
With balancing reeds, the sun in a far quarter.

Short days had struck a bitter chain together
In links of blue and white so closely matched
They made an equipoise we called the weather.

There, the first snowfall grew to carapace,
The pulse beneath it beating slow and blind,
And every kind of absence marked the face

On which we walked as if we were not lost,
As if there was a something there to find
Beneath a sleep of branches grey with frost.

We smiled, and spoke small words which had no hold
Upon the darkness we had carried there,
Our bents and winter dead-things, wisps of cold.

And then, from wastes of stub and nothing came
The Kingfisher, whose instancy laid bare
His proof that ice and sapphire conjure flame.

[2] Reprinted with permission from Carcanet Press

The Sea, the Sea, the Sea

Geology Coastal Walk

Laura Bissell

October 16, 2015

Rocks on the beach at Innellan

On 8th October I attended a coastal geology walk as part of Cowalfest, an annual festival of walking and art which takes place in Dunoon and the surrounding area. The walk was led by retired geologist Julian Hill and began at Innellan pier. Innellan sits on the Highland Boundary Fault and we charted the fault line from the village towards the southerly community of Toward. Julian pointed out Dalradian rock, the oldest rock (around 600 million years old) that makes up much of the landscape of Argyll. The original rocks formed not far from the South Pole as sea sediment in the Iapetus Ocean. Julian explained that crustal collision with North America began around 500 million years ago producing folds in the rock. He described how the plates are still drifting and that Scotland moves away from New York at the rate a human

being's fingernails grow (1cm annually). I was struck by this bodily analogy to help make the global/macro understandable through the locality and physicality of the body.

Rock formation Innellan beach

Julian explained that metamorphism peaked 470 million years ago when the rocks were formed into what is now exposed at the surface. This was called the Grampian Orogeny or 'mountain building' and the ocean floor broke up producing chains of volcanic islands (one of which is Goat Fell in Arran, visible across the firth of Clyde from the village). We looked at examples of schist, phyllite and red sandstone and Julian carefully broke off small pieces of these rocks for us to examine while avoiding the bedrock.

In the last two million years Cowal was severely affected by ice streaming south and southwest cutting deep trenches creating deep glens and scouring bedrock. Julian explained that glacial striations (deep scratches) are visible on many rocks where they were scraped by huge boulders being transported by ice. As we walked along the beach Julian pointed out large rocks which have been carried by ice from Loch Fyne as well as multiple 'dykes' – where two types of rock were fused together when near the mantle producing a striking schism effect in the rock.

Red sandstone on the beach at Innellan

Coastal cave on the Cowal Peninsula

As I walked back along the pavement towards the pier I felt overwhelmed at the sense of age and of history that I had encountered. I looked anew at the familiar landmark stones on my local beach as ancient glacial travellers that have journeyed from lochs to be deposited on Innellan beach.

Rocks deposited on beach by glacial drift

Rocks on beach by Innellan village

"The floor of the deep ocean basins is probably as old as the sea itself. In all the hundreds of millions of years that have intervened since the formation of the abyss, these deeper depressions have never, as far as we can learn, been drained of their covering waters. While the bordering shelves of the continents have known, in alternating geologic ages, now the surge of waves and again the eroding tools of rain and wind and frost, always the abyss has lain under the all-enveloping cover of miles-deep water." (Carson 2014a, 74)

Sound Walk

Laura Bissell

October 21, 2015

I meet Tim at Gourock (I am late).
We travel across the water between Gourock and Dunoon then drive
to my house.
We walk from my house to Sandy Beach.
The water is so still, it is very quiet.
We walk along to the rocks.

Rockpool on the beach in Argyll

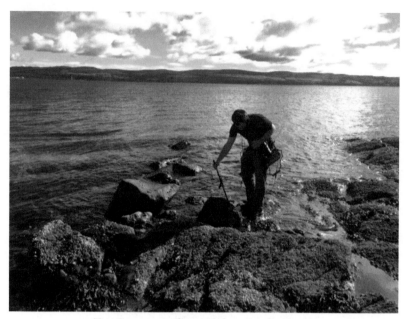

Tim Cooper recording sounds on Innellan beach

We walk back from Sandy Beach, up Fern Lane,
through the woods and along the Velvet Path.
We jump over a fence to a stream that came down from the hills.
Tim records some sounds and I photograph.

Trees block the woodland trail to the Velvet Path

The woods behind Innellan (Sandy Beach)

We get back on the Velvet Path.
We find a memorial bench positioned to look to sea.
The trees and brambles obscure it now. It has the following inscription:

The waves of the sea have spoken to me,
The wild birds have taught me,
The music of many waters has been my master.

Memorial bench on the Velvet Path

We go for lunch then I drive us to Kirn where Tim records the sound of the waves (more frequent than at Sandy Beach because of the boat traffic near the ferry). I photograph some rocks and we talk about our collaboration.

Rocks at Kirn Beach

Slate at Kirn Beach

"Because difference constitutes music, yes. Sound is a difference, is it not? It is the rubbing of notes between two drops of water, the breath between the note and the silence, the sound of thought" (Cixous 1997, 47).

Salt in the Wound

Laura Bissell

September 11, 2020 [1]

Salt, created and performed by Selina Thompson, Arnolfini, Bristol, May 2016.
Image Credit: Bryony Jackson

Black-British performance artist Selina Thompson journeyed across the Atlantic Ocean over forty-two days in February/March 2016 by cargo ship to re-trace the route her birth parents and adoptive grandmother had made from Jamaica to the UK. While on the voyage, she devised her one-woman performance, *Salt*. Retracing routes across the Atlantic Ocean taken between the UK, Ghana, and Jamaica

[1] Originally published as Bissell, L. 2020. 'Salt in the Wound', *PAJ: A Journal of Performance and Art* 42 (3), 64–69.

(known as the Transatlantic Trade Triangle), she followed the shipping course used to transport slaves and goods operating during the Imperial Age from late sixteenth century up to the nineteenth century. Through the retelling of Thompson's experience of journeying across the ocean, *Salt* rubs salt in the wound of colonial trauma, activating history through remembrance and disseminating them through the piece, simultaneously performing both healing and hurting. Since 2016, *Salt* has toured all across the UK and to Brazil, Australia, Canada, and the U.S., including a run in the Public Theater in New York's Under the Radar Festival in January 2020.

As a mineral, salt is perceived to have healing qualities and is frequently used in the treatment of cuts, wounds, and skin irritations. However, the idiom 'to rub salt in the wound' references the painful sensation of its gritty texture when applied to vulnerable, broken skin. This capacity to both heal and hurt can also be considered in relation to the sea itself, often described in terms of its contradictions. The Ancient Greeks conceptualised the sea as having 'two faces', as being polluted but also cleansing, an idea continued by the Victorians who found the sea restorative and beneficial to health while simultaneously evoking sickness. In *The Sea: A Cultural History*, John Mack frames the sea as both a site of forgetting and one of renewed return while acknowledging that "things immersed there change their character", transforming them into something new (2011, 91).

This dual conception of the sea is expanded when considering the slave trade, where passage over the Atlantic made by millions of slaves transformed the sea into a mass grave. The wounding that occurred through the creation of the slave trade is still felt today throughout the diaspora; and as Thompson foregrounds in the performance, upon her return from this journey, she believed that home, as she once knew it, no longer existed. Rather, she returns from her voyage with complex questions about cultural trauma and grief unresolved that are captured in *Salt*.

The performance begins with Thompson dressed in a long white dress and heavy black boots dragging a large bag on a trolley. "I'm an artist, I'm 26. Black, a woman. Grew up in Birmingham, had a brief flirtation with Yorkshire, but now I'm moving back there." She continues, "I'm adopted. Both my birth parents were Rastafarians from Jamaica, who moved to the UK when they were my age. And the parents that

adopted me, were both born here, with parents from Jamaica and Montserrat. On a form, I tick Black-British." Thompson outlines her complex identity in this opening speech, making the autobiographical nature of the work immediately clear. She dons goggles and instructs the first few rows to reach under their seats to find additional pairs placed there, asking us to put them on. Then, Thompson removes a large block of salt from the bag and proceeds to smash it up with a sledgehammer. The fragments of the salt block shatter across the stage, and later 'perform' as objects in her story from commodities, to people, to debris.

The smashing of the salt functions as a device to demonstrate the physicalisation of the violence and trauma embedded in the legacy of colonialism. In the course of an hour, Thompson uses the debris to represent her journey across the Atlantic; at the end of the piece, some of these fragments of salt are dropped into a see-through Perspex box filled with water, and she proceeds to wash her face and hands with the salty liquid—an act of cleansing and renewal after telling a story of pain and suffering. That the sea is complicit in Thompson's own journey and those her ancestors made is crucial to understand as the piece functions as a temporal connector of past and present. After the initial block of salt is broken into much smaller pieces, Thompson lines up the fragments in a line that spans the entire performance space. As she tells her story, the chunks of salt also take on the roles of those people she shared the journey with on the ship, such as the crew and officers. Segments of rhythmic text are integrated and are reminiscent of sea shanties—traditional working songs sung by men on sea vessels to pass the time as they work, characterised by the repetition of phrases and rhythmic patterns. The Master, Union, Company, International Laws and Imperialism also become allegorically embodied by the salt fragments spread across the stage.

According to Paul Gilroy's The Black Atlantic: Modernity and Double Consciousness, ships are "a living, micro-cultural, micro-political system in motion" (1993, 4). He claims that "ships immediately focus attention on the middle passage, on the various projects for redemptive return to an African homeland" (4). The shift in perspectives throughout Salt are key to understanding the role that this autobiographical work has in connecting the personal with universal issues, allowing audiences to figuratively navigate expansive, uncontainable, and complex racial

histories. In *Cities of the Dead: Circum-Atlantic Performance*, Joseph Roach explains how the Transatlantic Trade Triangle saw different cargo brought along each leg of the route: "The Americas (raw materials), Europe (manufactured goods), and Africa (human beings)" (1996, 8). Roach states that "the most revolutionary commodity in this economy was human flesh" (4). The way in which humans were treated as objects, as chattel, created a shared experience of 'terror' felt by black diasporic communities across the world.

In *Salt*, Thompson uses her autobiographical journey to show how the legacy of colonialism and slavery has caused cultural trauma and wounding. A depiction of the Transatlantic Trade Triangle is created in the performance by using different points as references to specific moments on her journey. While Thompson attempts to bring us into her story, at the end she acknowledges, "I could never take you with me". Thompson recounts how she travelled by cargo ship to avoid the luxurious comforts of cruiseliners that make similar journeys. Her spoken text captures the irony of how contemporary shipping prioritises non-human cargo over human passengers, while historically when slaves were treated like commodities the conditions on ships resulted in millions of deaths. Thompson's message is clear: only through self-empowerment can we hope to understand the trauma of the past and the challenge of the future.

Thompson's attempt to heal by visiting sites of historical wounding is evidenced through her retelling of a visit to the famous slave port of Elmina. She compares her experience to that of Saidiya Hartman in *Lose your Mother* (2007), an account of the author's fifty journeys to Elmina to understand the site. When Hartman arrives in Elmina, it is 'empty', devoid of whatever sense of cultural memory she had preconceived of it. But Thompson finds it full: "I stand in there, in the dark and it takes everything in me to not scream, not to bang on the door and scream to be let out. It makes me feel sick." On stage, Thompson builds the walls of the castle of Elmina with chunks of salt and then knocks them down into the ruins.

The contradictory understanding of the sea gives Thompson licence to create a performance exploring colonialism and slavery without relying on stereotypes of the "abject objectified broken black body". Instead she critiques the ways these representations reinscribe trauma and codify imagery around black victimhood and black people as

being without agency, while locating slavery to a specific point in history. The piece frames the sea as a space to grieve, and Thompson's journey across it provides her a way of reflecting on the relationship between the past and the present while journeying over the same body of water as her ancestors. She draws parallels between the historical and contemporary conceptions of black lives as expendable: "No one needs to say 'white lives matter' because they know they do". Thompson has indicated that the piece is a response to her own grief about the numerous recent deaths of black people in both America and elsewhere across time, including the shootings in Ferguson in 2014 and the killings of Freddie Gray in 2015 and twelve-year-old Tamir Rice in 2014.

In the production's final moments, Thompson watches the salt block dissolve as if returning to the sea. The sound of the ocean that plays in the background becomes quieter as Thompson delivers her final speech:

> I am what I am, doing what I came to do.
>
> I can see the place where those that did not cross the chasm, who remained suspended in the transformation –
>
> not human, not yet completed their social death
>
> now reside.
>
> Waiting for me.
>
> Preserved in salt
>
> I am in all three parts of the triangle, and in the centre of it
>
> And really, I've always been here
>
> And really, I could never take you with me.

As well as healing and hurting, Thompson claims that the salt of the title also preserves some of those who did not make it across the ocean, who are figuratively suspended in the process of being transformed. The fusion of past and present, slave journey and post-colonial remembering, come together in Thompson's conclusion. As audiences exit, we are given a fragment of salt from the performance that functions as a memento mori, or reminder of death. Thompson

states this is "a commitment to continue to live, a commitment to the radical space of refusing to move on, and all that it can open, salt to heal, salt to remember, salt for your bath, for your nourishment, but above all, salt for your wounds". Her depiction of the sea as a site of grief and salt as a preserver exposes the process of healing she attempts through re-enacting a historical journey.

In Shakespeare's *The Tempest*, the spirit Ariel sings the following to Ferdinand, prince of Naples, after Ferdinand's father drowns: "Full fathom five thy father lies/ Of his bones are coral made/ Those are pearls that were his eyes/ Nothing of him that doth fade/ But doth suffer a sea-change/ into something rich and strange." A sea-change here is suffered: it marks the bodily transition of life to death, a transformation of human into more-than-human. Just as the sea can be seen as transformative, as a repository for grief, a site for reflecting and healing, it is a symbol of endurance and the connective medium inviting intermingling across time as it dissolves to become part of a wider system. *Salt* is a performance of preservation itself, of holding memories alive so those lost can finally be grieved.

Into the Wild

On Contemplation: A dawn to dusk solo in a wilderness setting

Laura Bissell

January 10, 2015

Knoydart

In March 2013 I attended a weeklong residency in Knoydart in the Western Highlands of Scotland. This area has been called 'Britain's last wilderness' and it is used by the Natural Change Foundation (www.naturalchange.co.uk) as a site for leadership training which "catalyses social change for a fair and sustainable future". The curriculum design of the Contemporary Performance Practice BA (Hons) Programme at the Royal Conservatoire of Scotland has been influenced by Natural Change processes and I travelled to Knoydart to experience an embodied understanding of this approach (Kerr and Key 2013). My pedagogy has been influenced by bell hooks' (2003) vision of *transformative education,* and Rachel Naomi Remen's assertion that "we

must have the courage to educate people to heal this world into what it might become" (1999, 35). I was keen to see how this "reflexive practice" in a natural setting could influence my teaching (Kerr and Kay 2013, 5).

During this cold but bright period in March I spent in the wilderness with colleagues and with strangers, I stepped away from my usual life for a week and found time and space for contemplation. I undertook a 'solo' and sat from dawn until dusk alone on a small isolated beach and for the first time in a long time, stopped. It has taken me until now – almost two years later – to process and contemplate what that rare experience of stillness and contemplation was and how it has affected my practice. Here I attempt to communicate and illustrate this experience through my notebook entries and my more recent reflections on it.

On this process, I thought about:
The world and my place in it
How a day lasts a whole day
The challenges of being still
Home, the sea I see every day and the coastline I am familiar with
How small things can get bigger
The fact I have never spent a whole day from dawn till dusk outside
My family, my friends, my work, my life
How experiences are translated through writing (and sometimes not)
How old the rocks are and the tirelessness of the sea
My body in the landscape
Rocks
Grass
Heather
Slate
Rockpool
Sea
Sky

This experience of being quiet in the landscape of Knoydart was the first time I have maintained stillness and solitude for this long. I reflected that the week before I had been travelling back from Australia and had spent a similar amount of time (around 15hours) in stasis on the plane as I travelled, but that this transitory time of being immobile

while being moved through the air, did not lend itself to contemplation in the same way that this immersion and stillness within the landscape did.

My spot is between three large bits of rock with a large rock sticking up in the middle of the space. There is a small rivulet of stagnant, still water leading to the bay. Seaweed lines the walls of this. The colours are blue, purple, brown, green, sand, rust, white, slate, black, pink and yellow.

My intention is to find/explore stillness and I hope this place will help me to do this.

When I arrived, I built a small pile of stones at the 'entrance' to my site. I touched these and asked the place if I could sit here for a while.

The light was very pink on arrival with cotton wool clouds. The sun is now up but not in my spot yet. As it is so sheltered, I don't think it will be the sunniest spot so this will be different from my experiences over the last few days.

On the train journey to the boat from Mallaig to Knoydart, snow began to fall and the landscape became concealed with white as we travelled north. I thought about being outside in the snow for long periods of time and how frail and vulnerable the human body is and how naturally inept it is to exist within the elements. This experience was about being 'in nature' and I was glad that on arrival the weather was crisp and bright and that my day of stillness from dawn until dusk was about contemplation rather than survival; meditation over endurance.

Beach on Knoydart where I did my 'solo'

Sensations in Stillness
Sound:
Wind, the occasional bird, very distant waves – a single boat engine.
(no tree noises, no animals, no voices, no footsteps)
Taste:
Fresh air
(no flavour, no food, no sweet, no bitter)
Smell:
Fresh air, sea air, hint of acridity from fire.
(no flowers, no perfumes, no fumes, no bodies)
Touch:
Paper, stone, wind on face and fingers, nylon.
(no metal, no skin, no synthetics, no moisture)
See:
Rock, water, weed, stone, shell, heather, snow, hills.
(no people, no boats, no planes, no man-made structures)

Pile of stones at the entrance to my site

At the start of the day I found myself making lists of tasks I had to do on my return and feeling unable to quiet my mind. As the day passed and the light changed, I began to adapt to my situation and to enjoy a feeling of contentedness within my environment. By sitting and thinking and occasionally writing I refused to adhere to my normal processes of productivity and constant thought and found this to be an exhilarating experience that felt very creative and restorative.

Word Association – 'Stillness'
Calmness, peace, not moving, thoughts stopped or paused, contemplative, water, air, static, soft, death, sleep, safety.
It is still snowing which makes me unsure of how to work out the time. I don't feel distressed at not knowing, I am just curious.

Over the course of the day I drift in and out of consciousness and am only aware of the changes in weather and the subtle shifts of the light. This freedom from the constraints of time made it easier to relinquish my thoughts to things other than tasks, work and commitments and have encouraged me to 'observe' myself and my thoughts from a different perspective. At times I do think about work, but more about the ideology behind my practice and my teaching than the minutiae of everyday tasks.

The facilitators on the Natural Change process call these individual experiences of finding a site and spending long periods of time outdoors a 'solo'. I have been thinking about the term and how it seems to be rooted in performance and I reflect on the performative nature of what I did yesterday. The distance from the stone circle, north to the water was 40 of my steps. In the time I was sitting on the rock by the sea I had to move back three steps, then another two to avoid getting wet. I liked the fact that my movement is determined by the tides and I used this as a sequence for East, South and West too. By performing these movements as part of a ritual, a choreography occurs and my 'performance' is observed by the rest of the group at different points. Today on 'solo', thoughts of performance are with me as I look at nature and observe myself on this small beach. Who am I doing this for? How will I take this forward into my own practice? What are the relationships between performance and nature? How can performance practices be sustainable? What are the contradictions/confusions between the live (ephemeral) and the sustainable (that which can be maintained or can regenerate)?

During this period of contemplation, many questions came to mind about many aspects of my life. I did not feel any urgency to respond to these questions on that day, but many of them have lingered with me and have made their mark on my consciousness. My memories of this contemplative and creative time, and my reflections on the questions that this period of stillness encouraged me to ask, have travelled with me. My understanding of my embodied practice and pedagogical approach that aims for 'freedom' (of thought and of educational experience) and 'wholeness' (of life and of people) was allowed to develop while simultaneously considering and contemplating our place within the natural world (hooks 2003, 181). Like the traces of me that I left at the site (a small pile of rocks, an arrangement of shells and glass shards worn soft and opaque by the sea, my shape in the stones) this day of stillness and contemplation has left its mark on me.

Still
It is harder than it looks
To be still
It is not about just doing nothing
It is about stopping
The constant thoughts
Of actions to be done
And allowing the body
To drift while in stasis.

Arrangement of found items left at the site after my 'solo'

The Elephant in the Hedge

David Overend

February 9, 2017

A red kite flies over the Chilterns

I have been spending a lot of time on my own recently, taking a regular journey by air between my home in Glasgow and my workplace in Surrey. This hasn't been entirely unpleasant. Suspended miles above the landscape, or responding to emails in the reassuring universality of airport lounges, it has been easy to detach myself from the succession of personal crises that I am struggling with just now. Nonetheless, I am heartened to receive an invitation from Jamie Lorimer to join him for a morning walking in the Chilterns. We will discuss our new project as we explore the area around Christmas Common, followed by lunch at The Fox and Hounds. We are looking for elephants in birch trees and hedgerow.

We have been thinking about the ghostly presence of past inhabitants of the British countryside. If you know where to look, and what to seek out, there are myriad traces in the fields and woods. Signs of species that are no longer with us. They are there in certain bark colours and features, patterns and fissures that would break off if a large herbivore attempted to remove a strip. They are there in the tough wiriness of smaller trees, resistant to uprooting and snapping. And they are there in the impenetrable tangle of flexible shoots that comprise the quintessential English hedgerow. I first learnt of these hidden clues on reading George Monbiot's work on rewilding. Monbiot (2015) reminds us that "wherever we go, we walk in the shadows of the past".

One of the most successful rewilding projects in this country was the reintroduction of the red kite to this area in the early 90s. Apart from a small pocket of survivors in Wales, these magnificent raptors were hunted to extinction in the nineteenth century, and it took a foreign delegation to re-establish regional populations. Quarter of a century later, these European immigrants, released for several years across this hilly area of Southern England, are thriving. We are walking through red kite country and as we set off from our meeting place in the pub car park, Jamie recounts the brazen theft of his wife's sandwich by one of these majestic opportunists. The intrusion of unpredictable wildness into an innocent family picnic. Today, they are a constant presence on our walk, circling and swooping through the wide-open skies, stirring up the smaller birds to frantic alarm calls, and occasionally dipping below the tree line, perhaps in search of carrion.

Weaving around the theme of our walk, the kites send potential victims diving into the cover of the surrounding woodland, and as we follow roads and pathways into the trees, we note the otherworldly lustre of the silver birch guarding the way into the beechwoods. As we walk we move through places and subjects. A theatre maker and a geographer, searching for parallels and convergences in our fields. We want to explore the potential of creative practice to contribute to rewilding; and to find out what theatre and performance might learn from contemporary approaches to conservation. We will start slowly, inviting a disparate group of artists, scientists and conservationists to think and create together. And in time, we will plan a larger scale project. It will be called The Elephant in the Hedge.

Walking gives way to talking and, on several occasions, I realise that I have stopped looking around me, lost in trains of thought about cultural geography, performance theory and natural history. Most contemporary walkers claim their practice as a way of relating more closely and attentively to the landscape, but I wonder how honest they are about those moments when, walking with a companion (or indeed alone), they tune out and follow some conceptual tangent, periodically travelling inwards rather than gazing outwards. It takes a particular feature of the route to jolt me back into the world again, usually prompted by Jamie's attentive navigation and guidance.

We reach a borderline, where the beech clash with another interloper: the conifer. Planted for timber and spreading quickly throughout the twentieth century, these fast-growing conical trees serve a functional role, but drive back native species such as oak, ash and cherry. A project is now underway to remove conifer from ancient woodland, opening up areas for wildflower growth and encouraging greater biodiversity across the Chilterns. At every turn, I see that wildness is a human decision, and that it is only one possible option. We could walk through annexed monodominant forests, our sandwiches intact, but our lives would be lesser for it.

As we complete our loop, we pause briefly to investigate a circle of chalky mounds, which Jamie suspects may be the work of badgers. Then back to the pub, which is now open and warmed by a welcoming log fire stoked by a friendly proprietor who we had passed earlier, walking his dog in the opposite direction. Here, we eat well and quickly and capture some of our thoughts and plans on paper. Then we bid farewell and leave this remarkable patch of countryside to the collaborative ecologies of the kites, the beechwoods, and the walkers.

I park my car outside my office later that day and as I gather my bags, out of the small strip of protected woodland that borders the carpark, a couple of small skittish deer cautiously watch me from the shade of the collection of rare trees that the University has gathered from all over the world. The rest of the day seems to have been intentionally preparing me to find profundity in this encounter and for several minutes, we simply watch each other. I will a vestigial wildness from my being, and it might be a vast Mesolithic elephant staring back at me from the undergrowth for all the meaning that it conveys.

Performing Wild Geographies

Filipa F. Soares

January 15, 2018 [1]

In October 2017, a transdisciplinary group of sixteen participants met at Knepp Castle Estate (West Sussex, Southeast England) for a two-day creative workshop. The event, entitled *Performing Wild Geographies*, was intended to be a cross-disciplinary experiment in engaging the public with the 'rewilding' movement. By embracing disparate disciplinary perspectives and methods, it explored how scientists, geographers and artists might work together through collaborative performance-making strategies.

Led by Jamie Lorimer (Geography, University of Oxford), David Overend (Drama, Theatre and Dance, Royal Holloway, University of London) and Danielle Schreve (Quaternary Science, Royal Holloway, University of London), the event brought together theatre practitioners and scholars, human geographers, palaeoecologists, conservationists, visual artists and journalists. It entailed a series of presentations, creative walks, workshops and discussions around the meanings and practices of rewilding, as well as cross-disciplinary collaborations and *entanglements*. All the participants stayed at Knepp's campsite for the two nights, which created a stimulating *atmosphere* for rewilding discussions.

[1] See Overend, D. and J. Lorimer. 2018. Wild Performatives: Experiments in rewilding at the Knepp Wildland Project, *GeoHumanities* 4 (2), 527-542; and Overend, D. 2021. Field Works: Wild experiments for performance research, *Studies in Theatre and Performance*. Advance online publication.

DAY 1

After all the participants arrived, we gathered at the Cow Barn, by the campsite. David briefly introduced the workshop. Drawing on the idea of 'learning to be affected', he explained that over the next couple of days we would explore the links between performance and rewilding – not only what the first could offer the latter, but also vice versa. Similar to the rewilding *ethos*, the workshop was also an "unknowable and unpredictable encounter with the other", with scope for disappointments.

Bell tent at Knepp's campsite

Sir Charles Burrell, Knepp Estate's landowner, joined us and introduced the Knepp Wildland Project: a large-scale conservation initiative ('soft rewilding') that was established in 2002, in the Southern Block of the estate, with naturalistic grazing at its core. Herein, free-roaming grazing animals (Old English longhorn cattle, Tamworth pigs, Exmoor ponies, and red, roe and fallow deer) have been the main drivers of physical disturbance and habitat change. Charlie gave us a brief historical overview of the use and management of the three blocks within the estate and, in particular, of the fields in the Southern Block. The latter had gone from intensive farming in the 1980s to rewilding in the early 2000s. This shift towards "work[ing] *with* the land, rather than battling against it" was inspired by the

palaeoecological theory of cyclical vegetation turnover developed by the Dutch ecologist Frans Vera (2000). This theory suggests that the mid-Holocene temperate European landscapes would have been characterised by open wood-pastures driven by grazing animals, and not by closed-canopy forests. According to Charlie, "what you will see [in the fields] is Vera's theory in practice".

Free-roaming grazing animals are at the core of rewilding at Knepp

Since the beginning of the project, Charlie told us, terminology has been a constant challenge. As concepts can mean different things for different people (e.g., meadow, woodland, forest, etc.), it is important to find a language that enables talking among each other. Before the concept of rewilding was in use, for instance, the project was called a "long-term minimum intervention natural process-led area". Although the project focusses more on processes and is open to surprises, rather than the target-led mainstream conservation, it has been praised for its successes, notably the return of endangered species such as purple emperor butterflies ("Tamworth [pigs] have given us emperor butterflies!"). According to Charlie, "life is poured back in here". The project has also inspired many 'pop-up Knepps'. Due to the constant and dynamic interaction between large herbivores and vegetation, landscape is in constant transformation – more than a mosaic, he notes, it is a *kaleidoscope*. For him, rewilding is above all about scale and perpetuity.

By the end of the night, after dinner, David, Jamie and Danielle led one-to-one meetings with all the participants. In these meetings, each of them engaged with an object (a tree trunk, a beaver bark and elephant figures) to either talk about their work or to tell a story related to wild(er)ness and rewilding.

Back in our tents, yurts, and alike, *naturally* illuminated by the bright moon, we could hear deer roaring and acorns falling over a metallic roof. These were the *wild* soundscapes we all remembered the next day. More-than-human collaborations.

DAY 2

The second day started with a series of presentations and Q&A around the broad themes of rewilding and performance from three perspectives: social sciences, natural sciences and arts and performance studies. First, Jamie drew on the example of the Heck Cattle to explore the ontologies, epistemologies and politics of rewilding. According to him, the social sciences can contribute to discussions about rewilding by addressing three main questions: *What is the wild? Who knows the wild? Who decides?* Second, Danielle explored the links between rewilding and temporalities and the contributions of palaeoecological research to conservation and rewilding. Palaeoecology, she argues, allows reconstructing (imagining?) past environments. Her presentation focused in particular on issues around baselines and nativeness, emphasising how fauna and flora have been and are in constant flux. Finally, Baz Kershaw closed this series of presentations by bringing performance into the discussion. Through the example of 'meadow meanders', he proposed meandering as research. As a form of systemic performance of ecology, these meanders allow sensing "the pathway's agencies and energies – like gravitation waves – [that] may be flowing through us".

Equipped with these three distinct but complementary perspectives, the whole group was then divided in two: one group went on a safari, led by Penny Green, Knepp's resident ecologist; the other group did a creative walking exercise, led by Phil Smith. The groups would later switch.

The group I followed was first led by Penny, who explained the rewilding project as the safari vehicle she was driving went through the fields of the Southern Block.

The safari vehicle, from the outside and inside

Penny explained how the fields we were looking at are transitionary, ever-changing, ever-moving. She used the metaphor of *kaleidoscope*, which we had heard about the night before during Charlie's presentation. It is, she mentions, a 'moving feast', where no two consecutive years look alike. We stopped by a tree-platform, which had a panoramic view. Here, we had the opportunity to talk about rewilding and the broader landscape, provided with binoculars.

At the tree-platform

After a Q&A about the rewilding project and animal species, either present or absent, such as the beaver, Penny showed an example that proved Frans Vera's theory, which we had been introduced to the night before: an oak surrounded by holly. This example, we were told, proves the centrality of grazing animals, as holly would protect the growing oaks from being nibbled. She said that "this is a Vera's landscape". On this note, there were some questions about the density of large herbivores and how it is assessed. Penny mentioned that the assessment

entails surveying the available fodder thrice a year and regularly checking the animals' health condition due to welfare and food regulations. As the meat of the animals that are culled is meant to be sold and consumed, at Knepp these regulations have to be followed.

Example of Frans Vera's theory: oak surrounded by holly

Still at the tree-platform, some of us were paying attention to Penny's explanations, whilst others were 'exploring' the site – walking around the platform, picking acorns, looking through the binoculars or taking pictures. Suddenly, we saw a silhouette of two white storks passing by. As storks are rarely seen in Britain, as opposed for instance to Portugal, where I am originally from, Penny asked how this encounter with storks made us feel. Some said it was a special and unexpected sighting. Even for

Stork farm

me, very used to storks in Portugal, it felt indeed special. The storks we encountered are part of a reintroduction project – a joint venture between a number of private landowners in Sussex and surrounding counties. For Penny, the stork is a good example of *thinking big* and rewilding: big animal, big landscape, etc.

Back in the car, we passed by a 'stork farm'. This is a fox- and mink-proof pen inside which storks are held, bred and fed. This captive-bred population of storks, which was provided by the Warsaw Zoo, raised some interesting comments amongst participants about the meanings of wild and rewilding.

As in any wildlife safari, there were more unexpected and uncertain *wild* encounters. This time, we encountered two Tamworth pigs resting. We all left the car and stood in front of them, who seemed to be indifferent to our presence. Many visitors to Knepp, we are told, particularly like the pigs. Penny explained that this breed shares similarities with the wild boar, notably in terms of behaviour, but is less aggressive, hence the choice of introducing the former rather than the latter. When asked whether she had noticed any behavioural changes since the pigs were first introduced, Penny mentioned that, as opportunistic species, the pigs have started to dive and search for mussels in the pond, when it becomes filled. They open the mussels with their tusks. She also pointed out how different it is to have them acting in a *wild* place instead of an area covered in concrete.

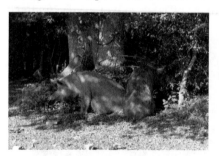

Looking at Tamworth pigs

While we stood in front of the pigs watching or photographing them, they stayed in the exact same place for a while, almost without noticing us. When a noisy truck approached, however, they left. Without more *wildlife spectacles* to witness, we continued the safari in the car.

As the car approached another field, we spotted a red deer stag. Penny took this opportunity to explain that Autumn is the time of deer rut, or mating season. During this season, males (fallow bucks and red deer stags) fight and display for females by roaring, clashing antlers and releasing pungent pheromones. All the participants recalled the soundscapes of the previous night, with deer howling very close to the campsite.

Deer stag camouflaged with the trees, in the centre of the picture

At the end of the safari, before switching groups, all the participants came together and were encouraged by Phil to "listen to the ground". To this end, each of us would pick a place and bring our ear close to the floor, while Phil started to talk about a "cosmic microwave background" and a map of the universe within each of us. We were all either laying down or with the knees on the floor, with the ear by the grass or concrete, listening to the ground in silence.

The butterfly and the 'god of rewilding'

The whole group then split again. This time, my group did the creative walking exercises, each of which began with a story told by Phil. First, each of us was given a different 'persona', mine being a cow with missing

calf. Without having to perform or mimic it, we were asked to experience and interpret the landscape through its eyes, while walking in silence. Some of us followed the path behind Phil, others slightly deviated.

As we approached the camping reception, we gathered by the butterfly made of wood pieces and Phil told another story, related to the next exercise. This time, we were asked to imagine the 'god of rewilding' and to think about its characteristics and how these would physically manifest, either through movement, posture, etc.

After a brief discussion, in which disparate but interrelated themes emerge (e.g., 'butterfly effect', resistance to fixity, baselines, constant movement, hybridity or the role of humans), we agreed that the main characteristic of this god would be interconnectedness or entanglement. To perform it, we used the image and metaphor of an entangled knot, made out of our hands and arms. In a circle, each of us placed both arms in the middle and held someone else's hands. We then tried to undo the human knot, by using our own bodies, arms and legs, until being unable to unknot. Phil called it 'the god of entanglement'. One of the participants said she would consider it more a 'god of interconnected systems', which recalls the idea of different perspectives and terminologies about the same thing.

The next exercise was called 'imagining species'. It was carried out by the arch made of antlers that marks the entrance to the campsite. Standing in front of it, we were asked to imagine an animal walking through the port, such as an extinct animal that would return. Afterwards, we were divided in two groups, each of which was given a can that would act as a pinhole camera, combining all the animals that the group has imagined. After holding it for thirty seconds, we opened the can to find a photograph of a wolf coming from the arch. There were laughs and one of us said that the wolf would be the most obvious one.

Pinhole camera and imagining species exercise

The next exercise entailed using modelling clay to create three figures: a water prey, a predator for that prey and a new sense or organ that would either protect the prey from the predator or help the predator get the prey. This modelling exercise was carried out by the lake, standing on the bridge in silence, with the sound of acorns plopping in the water as background. I noticed that most of us were looking at the lake, instead of the clay we were working with.

Modelling the clay, in silence

As we continued our walk, this time in the direction of the campsite, we were given a bit of soil to hold while walking. We slightly deviated from the path we were following, which would lead us to the campsite kitchen, and stopped by a patch of grass. While standing there, Phil shared with us the dystopic idea of soil disappearing in the near future. He encouraged us to take off one shoe and to feel the "threat of that coming void", by feeling the soil with our bare foot. Afterwards, with our shoes on again, we walked in the direction of the woodland that was at the edge of the open campsite, spatially (and metaphorically) demarcated by trees, vegetation and a bridge. Standing on the latter, Phil talked about liminality and cryptic creatures – the so-called *Anomalous Big Cats* (ABCs). ABCs are allegedly sightings of silhouettes of black cats that are often something else, such as a combination of shapes or a movement that might trigger that idea. Divided in two groups, we were asked to perform/recreate an ABC to each other. One of the groups recreated a landscape instigating fear and the unknown through sounds; the other recreated a hunting scene.

Back to the campsite, the last exercises were focused on sight and the different layers and scales of looking: from a satellite, detached perspective to the finest details, without removing ourselves from the landscape, in line with Tim Ingold's ideas (2000, 209-218). We were

asked first to look at a particular point in the horizon and to take a deep breath, then exhale, move to another point ("blowing the horizon") and repeat it ten times. Second, we would focus our attention on a specific area on the grass, with our hands around the eyes, like binoculars, to experience how colour intensifies as we move closer.

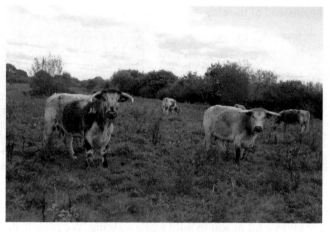

Encounter with longhorn cattle

We were then encouraged to switch between these two 'ways of looking' as we walked back to the Cow Barn, in silence.

From there, we joined the other group in one of the fields, where we gathered for lunch. On our way, we encountered some cows. Over lunch, we shared experiences and encounters with animals during the safari and discussed ideas about walking and looking.

After lunch, we walked back to the Cow Barn for a workshop led by Karen Christopher and sat at the big table. The beginning of the workshop was a meditative exercise, where we were asked to remember the beginning of the day. We were encouraged to think about where we set that beginning (is it when we wake up? Later?) and what happened from that moment until now, and to identify and write down five or six moments. To each of these moments, we added a descriptive element, either a sound, an image, a movement, an idea.

Afterwards, Karen distributed images that she had ripped in half and talked about the metaphor of pollution/contamination – when, for instance, one does a movement without explaining (e.g., moving only the body to imitate grass moved by the wind), it can stay in someone

else's memory and, in another circumstance, could later be understood or made sense of; or when one does a movement and the other imitates. Following this explanation, we were asked to stand in front of someone else who was sitting at the opposite side of the table. Each of us would start by making a gesture related to the image we got, and then switch and imitate the movement that the other has been doing at the same time.

Images from the workshop led by Karen

With these two ideas in mind (memory and 'contamination'), we gathered in pairs. After choosing one of the moments that each of us had written down in the beginning of the workshop, we were asked to think about how we could perform it and to show it to our partner, who would then imitate. Each duet was then aggregated in groups of two or three to create a 'performance fragment', in a short period of time, around the idea of rewilding and tangling. As a background idea for the fragments, Karen talked about tangle and tangling, presenting some definitions and using two quotes: one from a book called *Tangling*, by Japanese architect Akihisa Hirata (2011), the other from *Lines*, by Tim Ingold (2016).

Organised in three groups, we were asked to do the performance fragments. Starting with the individual/duet performances, we would then aggregate them as a collective, with a transition in between (Duet/transition/duet; duet/duet/transition/duet). At the end of the workshop, all participants were encouraged to reflect upon the performative experience. For some, it provided a new way of structuring things, beyond only one intellect or discipline; a conscious way to play around with things, between artists and scientists, where the individual becomes a group. Besides people, it was also a tangling of ideas and materials, following or breaking rules. Other participants also

mentioned the idea of movement ("you set things in motion and let it go"), the importance of non-verbal, embodied clues to communicate as a group, without instructions to work together. This might help, for instance, to overcome verbal difficulties in understanding each other. The idea of soundscapes and sound as another way to reach out to broader audiences was also mentioned.

Example of a performance fragment, in duet

After an hour for personal exploration, the workshop was drawn to a close with a discussion facilitated by Laura Bissell and Sarah Hopfinger. Using Donna Haraway's (2016) metaphor of *Staying with the Trouble*, of staying aligned towards the present, Laura asked: What can this moment and what can this configuration of people and practices offer to the discussion? She also underlined the idea of considering "the more-than-human as a collaborator in creating that performance moment". Sarah, in turn, reflected upon the interconnectedness between rewilding and theatre-making, "as a medium, in its liveness", as a collaboration "with the unintended, with the unpredictable" – an in-between "the intended and unintended, the managing and unmanaging, not necessarily knowing which one we are doing".

All participants were then prompted to talk about what each would take from the workshop. The most consensual themes pertained to the ideas of lack of control and rules, uncertainty, constant movement and mutability of time-spaces and how these can be positive, contrary for

instance to the prevailing epistemologies of scientific knowledge. An increasing consciousness about body and senses was also alluded to, namely in terms of sounds, rhythms, literal and metaphorical listening and also attentiveness to uncanny elements in a familiar landscape. A final point mentioned was transdisciplinarity and what blurring the boundaries might entail.

Examples of performance fragments, in groups

With these ideas in mind, we went for dinner, where the discussion continued. Afterwards, we all went back to our tents. Deer were silent this time, replaced by owls, and the acorns kept falling on the roof, ground and possibly in the pond further away where we had done the exercise with clay – "the acorns are falling in the pond!"

Helen Billinghurst's Sketches and Maps

October 11, 2017

The campsite at Knepp Castle Estate, West Sussex

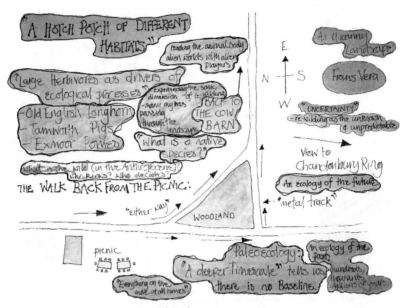

Thought map 1

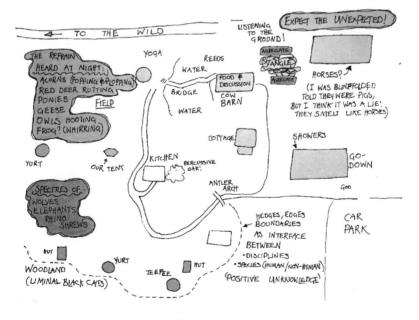

Thought map 2

The Shepherd's hut

Movements of Knepp

Sarah Hopfinger

January 15, 2018

During Phil Smith's workshop, we collaboratively created outdoor performances in response to the idea that wild animals are often thought to have been sighted in places where they feasibly could not have been. Below is my response to one of those performances.

Baz Kershaw lies face down in a woodland, his head between two sticking-out-slanting branches. He seems oddly comfortable. His bodily position is bold yet at ease. Straight arms and legs with subtle bumps of torso and angled feet and hands are all held uniquely by the shape of the earth-stones-sticks-and-other-things-that-I-do-not-know-are-there. The movements of the trees around him, of myself and the others walking past him, are made more certain by his odd-at-ease-antler-human-face-down-stillness.

This image moves me, I am not sure why. It requests my attention. It does not ask for me to make meaning of it as an image of 'an antler man' but asks for a quality of attention. I am not Sarah watching another human being 'a stag': rather, I am part of a performance of attentiveness. This attentiveness is not merely mine nor the 'antler man's' but seems to be an attentiveness that belongs to the ecology of here, of bodies-stillness-sticks-watchers-wood-wind-air-performers-and-more. However fleetingly, this more-than-human performance has opened up a mode of attention - of attending - that is somehow slow, soft, curious, surprising, vulnerable, alert, and, perhaps, wild.

During Karen Christopher's performance workshop, we created collaborative pieces inspired by movements, sounds, images and ideas from our time so far at Knepp.

In one of the group performances Danielle Schreve walks, and at the same time she moves her arms. Her arms are a waving-curving-up-and-down-preciseness. There is an everyday-ness to this performance: she walks on concrete, she is wearing boots, her expression is unforced and open, her walk is certain and relaxed. Yet this is an unusual performance: her arms are moving up and down and there is something more-than this movement in this movement. Her swooshing curvature of bending arms is neat, satisfying, definite. It seems less that she does this movement, and more, that she takes part in it: as if the movement is moving her.

The evening before I had listened to Danielle's presentation on her specialism – palaeoecology. She spoke of ancient ecologies, of the noisy place that the UK would have been due to the intensity of its species. She explored how we might 'see' ecological processes and how do we know when we 'see' them. She talked about how species' behaviour does not get neatly fossilised and she gleefully discussed how hippo remains were found at Trafalgar Square in the 1950s.

Danielle's words and energies that I encountered during her presentation now merge into these walking-arm-wavering movements. Her way of moving seems to be full of a deep history: a palaeoecological knowledge expressing and speaking itself through the simplicity of two arms going up and down. I do not think she could do these movements without the specifics of her embodied intellectual understanding of palaeolithic animals and ecosystems. Earlier on in the workshop, Karen Christopher had said something along the lines of: we cannot fully know what we are doing, what the effect of something we do might have, what knowledge is carried in the movements of our bodies.

In another group performance, David Overend is sitting on a chair at a distance from us (the "audience"). He is out there towards the field where there are grasses-hedges-horizon-and-what-I-cannot-fully-see. His far away-ness feels important. David, sitting on his chair, faces us with a stare that arrests me closely, yet I cannot make out his expression or bodily position: he is not fully clear. I am drawn to this far-away-close-David-chair. He watches us watching him. After some time, he slowly brings his arms up towards his head, his hands carrying two long sticks that end up resting on his head and protruding out-upward into the sky, echoing a knowledge of long antlers. He does not change his

continued looking at us, even as he is changed by this simple movement and collaboration with two sticks.

I overhear a conversation later and I learn that David was attempting, in this performance, to recreate the experience he had had of watching a half-hidden stag watching him. Later in that performance, David walks towards us, lessening the distance between us, coming into view more and more. Yet even as I see him more fully, I cannot help but feel that he is not fully see-able, and neither is the 'stag' that he was performing. I sense something worthwhile in this not-fully-knowable-not-fully-graspable way of experiencing things. There is an openness to partiality in this David-stag performance: I experience a sense that it is OK not to view things in full. David's physical distance from us spoke to me of a significant partiality, a half-hidden and not-fully-see-able wildness.

Perhaps animals, environments, people and ecosystems need to not be fully seen, grasped, understood, in order for them to be what they are, where what they are always contains something unknowable. This brings me to the thought that if we are part of environmental ecologies, as opposed to somehow separated or separable from them, then we cannot ever see them in full view, we can only ever participate in ecologies and 'see' and 'do' from the partiality of our entangled perspectives. What matters, then, is how we participate in environmental ecologies: what our ethics, aesthetics and practices are of participation. Experimental performance practice, with its methods of openness to the unpredicted and unknown, may be a particularly unique way in which to not only communicate but to phenomenologically experience rewilding processes.

Under the Surface of Knepp

Laura Bissell

December 12, 2017

Under the Surface of Knepp

An arch of ghostly manta rays
Entrance to a wild place
Petrified and stacked
Bleached brown coral reef
Signalling death and end
Palimpsests
of lasts

Although the Knepp Estate is around fifteen miles from the sea, with no coast visible, under the surface of this wild place I could feel the sea. Not only through water which I encountered at times, on the dawn walk by the Millpond and at the Oak-lined stream, but also in flashes of images, fragments of conversations, and through the experiences of my body. As oceanographer Rachel Carson reminds us, our bodies hold ancestral residues: "our inheritance from the day, untold millions of years ago, when a remote ancestor, having progressed from the one-celled to the many-celled stage, first developed a circulatory system in which the fluid was merely the water of the sea" (2014, 20).

Penny Green, Knepp's conservationist, told our group when we were on a wildlife safari that there was a hope to connect Knepp to the sea in the future. This made me think about how the acres of wild, green space, bustling with wildlife, provide clear, visual evidence of the success of Knepp's rewilding programme. The ecology of the sea and its decline, however, seems invisible to us, the collapse happening under the surface of the water.

In *This Changes Everything*, Naomi Klein writes that unlike the visible damage of pollution to species such as seabirds and mammals, the effect

on larvae and aquatic eggs are unseen: "Rather than some camera-ready mass die-off, there would just be... nothing. An absence. A hole in the life-cycle" (2014, 426). This damage to sea environments after a large-scale pollution event might not be perceptible in marine life until two or three years after the episode, when, instead of usual volumes of fish and aquatic wildlife, a "handful of nothing" will be the only evidence of the harm that has been done (431). Rather than a mass-extinction event, or a decline of species over time, some of the human-caused stresses to marine environments can result in swift, huge depletions in sea-life with little media coverage or most people even realising. My time at Knepp made me consider how approaches to rewilding could be translated to other environments. How could the successful rewilding processes used at Knepp be applied to other (potentially more expansive, difficult and unwieldy) spaces? What does an underwater Knepp look like? How do we *rewild* the sea?

The predominant Western view of the sea might be characterised as that of a quintessential wilderness. According to John Mack: "the sea... was empty: a space not a place. The sea is not somewhere with 'history', at least not recorded history. There are no footprints left upon it" (2011, 16). The sea differs from other landscapes due to its expansiveness (70% of the Earth's surface is covered in water) but also due to its materiality: humans cannot access ocean landscapes in the same way that they might a field, mountain, or forest, and the wetness and depth of the seas allow for human engagement only from its edges or its surface. Mack says there are two alternative cultural views of the sea, "one which constructs it as an unwelcome and unwelcoming wilderness where the land is a reassuring point of reference; the other which sees it as entirely familiar and unthreatening. These are, however, only characterisations of two extremes" (74). Our inability to reach ocean environments has exacerbated a reluctance to care for or conserve them. While there are some Marine Protected Areas and marine conservation areas, across the world the health of our seas is in crisis. In 2017 global warming caused the worst coral bleaching to date, and overfishing and marine pollution (both plastic and chemical) is devastating marine species.

Sam Trubridge states that humans "may require a boat, a swimmer or a figure of some kind in order to encompass its vastness, to provide human scale or to somehow traverse it conceptually or geographically"

(2016, 1). As well as the physical engagement with the sea that shapes our experience and relationship with it, there are also emotional or metaphysical aspects and frequently the sea has been portrayed as a mirror to human consciousness (as depicted in Joseph Conrad's *The Mirror of the Sea*, 1906). Is it only through self-identification and 'mirroring' that we can care for the sea, or can humans begin to consider it as a more-than-human environment in itself? Not "as alien 'other'; as featureless wilderness" (Brown and Humberstone 2015), but as Anderson and Peters claim, "our world is a water world. The oceans and seas are intertwined, often invisibly but nonetheless importantly, with our everyday lives" (2014, 3). Can we care for it as a 'vital space' itself as opposed to an anthropomorphised entity?

Knepp seemed to me a liminal space, a place of possibility, an edgeland. I was reminded of Carson's thoughts on tidal areas in the second book of her Sea Trilogy, *The Edge of the Sea*: "The shore is an ancient world, for as long as there has been an earth and sea there has been this place of the meeting of land and water. Yet it is a world that keeps alive the sense of continuing creation and of the relentless drive of life" (2014, 8). Clearly before we attempt to *re*wild marine environments we need to urgently put in place measures to stop *un*wilding them through plastic/chemical pollution and overfishing. Some of the earth's most ancient living inhabitants are sea-dwellers with species of clams, molluscs and turtles dating back millions of years.

Carson says that in the sea nothing lives 'to itself', that the sea water itself is changing due to the creatures that inhabit it: "the present linked with past and future, and each living thing with all that surrounds it" (42). My time at Knepp reinforced and reinvigorated my feeling of kinship and collaboration with our more-than-human world. Under the surface of my time at Knepp I felt sympoiesis – 'collective creation' or 'making with' – my environment; as Haraway says: "we become with each other or not at all" (2016, 4-5).

In the archway of bone and antlers I saw a dead coral reef, an exposed monolith, a warning. I saw the sea in the fields. I saw the struggle of ancient species to survive in this modern world. I saw one environment as a palimpsest of many environments, and I saw myself in it too. I saw this under the surface of the green, wild meadows of Knepp. We need to look under the surface of our seas to see what life is struggling to be witnessed as we inadvertently unwild it. How do we rewild the sea?

Retreating:
Thinking, making, being

Laura Bissell

January 25, 2018

Over the past few years I have undertaken numerous creative residential retreats. This prompted me to think about the benefits of these processes for artists, writers, thinkers and performance-makers.

The word *retreat* implicitly has the promise of a 'treat' within it, referring to the notion of a treat as "anything that affords pleasure". Treat comes from the Latin *trahere* (to draw or pull), through resonances of the Middle English 'negotiate' (for example treatise) and *retreat* as a pull away from something. From these etymological roots, we can see some of the ways in which the word 'retreat' has come to have its current meanings. If we are *to retreat*, the word suggests that we are moving away, we are withdrawing, recoiling or fleeing something or someone. Antithetically, *a retreat* (or more recently to be *on retreat*) holds connotations of a place that offers seclusion, withdrawal, solitude, isolation, privacy, and sanctuary (to move away from something to find peace, space and time). 'Retreating' explores the ways in which retreating from our everyday lives can have profound benefits in terms of what Cal Newport (2016) calls *Deep Work*, and how these practices can improve thinking, writing and being.

Newport defines deep work as "professional activities performed in a state of distraction-free concentration that push your cognitive capabilities to their limit" (3). He uses the example of Carl Jung retreating to Bollingen, a tower in the woods, "not to escape his professional; life, but instead to advance it", and argues that many great thinkers and writers such as sixteenth-century essayist Michel de Montaigne and writer Mark Twain all removed themselves from their

everyday, urban lives and retreated to a more rural, natural environment, in order to undertake deep work, thinking and writing (2). Newport's hypothesis can be applied to a range of fields and these processes of retreating, of withdrawing from our technological and (largely) urban lives, in order to find solitude and sanctuary, can be of particular relevance and interest to artists and creative practitioners.

Knepp Castle Estate in the morning

What are we retreating from?

[withdraw, retire, draw back, give way, give ground, recoil, flee, take flight, beat a retreat]

Newport argues that our contemporary lives and constant need for connectivity is eroding our ability to think deeply. He argues that deep work is necessary in order to fulfil human intellectual capacity and that "this state of fragmented attention cannot accommodate deep work, which requires long periods of uninterrupted thinking" (6). Author of *The Shallows: How the Internet Is Changing the Way We Think, Read and Remember*, Nicholas Carr (2009), agrees: "What the Net

seems to be doing is chipping away my capacity for concentration and contemplation". Newport's Deep Work Hypothesis is as follows:

> The ability to perform deep work is becoming increasingly *rare* at exactly the same time it is becoming increasingly *valuable* in our economy. As a consequence, the few who cultivate this skill, and then make it the core of their working life, will thrive. (2016, 14)

How can we think deeply about the issues facing our lives and our planet if we are perpetually distracted, engaging in superficial and self-generating tasks such as emails and social media? How can we find time and space for contemplation and deep thought? We *must* retreat.

How to retreat

[seclusion, withdrawal, retirement, solitude, isolation, ebb, recede, privacy, sanctuary]

A *retreat* can happen in many ways. For most people, it is difficult to justify long periods of time away from work, family or study, but there are some small changes in focus and attention that can allow for a deepening of your life (and as a consequence, your work). The first (and most desirable) is a literal removal from your 'usual' life to another environment, in natural surroundings, where you can be alone (or with a group of like-minded others) away from the anxieties and demands of everyday life. This withdrawal from your usual routine and immersion in natural surroundings is perceived to be the best way to embark on a period of deep work. As this is not always practical, Newport and others suggest strategies for retreating to a state of deep work within existing patterns of labour. An internet 'Sabbath' (one day of no internet connection) or an internet 'sabbatical' (abstaining from the internet for periods of time – only checking at assigned times if you need to do this for your job or practice) are some of the options that Newport suggests. What these strategies do not offer that a physical retreat does is the experience of

being outdoors, and recent evidence suggests that this is a vital part of deep work, thinking and being.

What are we drawn to?

Newport argues that in a post-Enlightenment world, we have tasked ourselves to identify what's meaningful and what's not, "an exercise which can seem arbitrary and can induce a creeping nihilism" (2016, 87). How do we decide what is meaningful for our lives? What has value? What should we focus our attention on to think deeply about? What can deep work philosophies offer artistic practices and processes? Behavioural scientist Winifred Gallagher argues that it is focusing our attention on something (anything we choose) that is the key to a happy life: "Like fingers pointing to the moon, other diverse disciplines from anthropology to education, behavioural economics to family counselling, similarly suggest that the skilful management of attention is the *sine qua non* of the good life and the key to improving virtually every aspect of your experience." As she summarises: "Who you are, what you think, feel and do, what you love – is the sum of what you focus on" (cited in Newport 2016, 77). By paying absolute attention to the thing that we are doing at any given moment; cooking a meal, taking a walk, writing a poem, creating a performance, spending time with a friend; the focus of this allows us a mental retreat from the distractions of our everyday lives. That focus and attention can be achieved more fully out with usual patterns of work/family life and in a natural environment is supported by numerous studies.

This intense focus and concentration on thinking, making, writing and being cultivate a "concentration so intense that there is no attention left over to think about anything irrelevant, or to worry about problems" (79). This may be more difficult in practice than in theory, however, like everything in life, deep work is a practice that must be nurtured and maintained throughout a lifetime. As the yogi Pattabhi Jois said to his students at Mysore: "practice and all is coming" (cited in Shapiro 2013, 132). For Dani Shapiro, "when it comes to the practice of writing, it cannot be distraction that propels us but rather the patience – the openness, the willingness – to meet ourselves" (132). We meet ourselves when we are immersed in natural environments, when we have time and space to think and to engage

with our natural surroundings and to consider our *mirror in the landscape* (Natural Change).

The river at Knepp where the acorns fell into the water

Retreat *into* Nature

"I only went out for a walk, and finally concluded to stay out till sundown, for going out, I found, was really going in" (John Muir)

While the benefits of pressing 'pause' on our normal, busy lives might be evident, recent studies indicate that in order to make the most out of a period of deep work, a natural environment is the most suitable, and as well as being devoid of the usual distractions (assuming we disconnect from the internet) has other effects in terms of health and wellbeing. Payam Dadvand et al. (2017) explore the benefits of green spaces to improving the attention spans of children:

Natural environments provide children with unique opportunities for engagement, discovery, risk-taking, creativity, mastery, and control, and for strengthening the

child's sense of self; in addition, they also may inspire basic emotional states (including a sense of wonder) and enhance psychological restoration, all of which may positively influence cognitive development and attention.

As well as the positive effect on attention described here, discovery, risk-taking and creativity are all essential to developing a creative practice. The benefits of being outdoors are evidenced in recent studies exploring all age ranges. A study by Simone Kühn et al (2017) found healthy brain changes to older residents of urban environments who live near forests and further studies show that even small and brief encounters with something natural can improve overall mood.

As Kathleen Jamie (2003) says in her essay "Into the Dark", it can be easier said than done to remove ourselves from humankind-built structures, buildings, and spaces, and sometimes difficult to find a natural or *wild* place to be. I am reluctant to use the phrase 'being in nature' as it implies that we 'go out' into nature, that it is something outside of us and our normal lives. The binary between natural, rural environments and built-up, *un*natural urban ones feels like an unhelpful dichotomy and perpetuates ideas that we are other than, or even against nature. Admittedly, we have become very disconnected from our natural world and environments in most aspects of our lives and most of the working age population have few regular encounters with natural environments beyond their urban place of work and home. A study by Kayleigh J. Wyles et al. (2017) also indicates that wild natural spaces such as rural areas or coastlines are seen to be more beneficial than urban greenspaces, gardens and parks. To retreat further away from urban centres and more deeply into a natural environment has potentially more benefit to a period of deep work than an urban retreat, for example.

The benefits for all are evidenced, however, particularly for artists, writers and creative practitioners, walking through nature exposes you to what author Marc Berman calls "inherently fascinating stimuli [which] invoke attention modestly, allowing focused-attention mechanisms a chance to replenish" (Newport 2016, 147-8). The process of walking outdoors, particularly in rural and coastal areas allows your directed attention resources time to replenish and can be of benefit to a creative practice.

The majority of the writers I have mentioned have advocated intense periods of retreating from the chaos of our daily working lives in order to have intense concentration and focus on whatever it is they are doing. They also insist that relaxation and time away from work is also as vital. When retreating to his stone tower in Bollingen, Jung would work, deeply, alone in a room every morning without interruption. He would then meditate and walk in the woods in the afternoon to clarify his thinking in preparation for the next day's writing. This break from work, this time *being* in a natural environment was able to support his thinking and writing practice.

When you are on retreat, think about the following questions:

- What are you retreating from?

- What are you drawn to?

- What has value to you?

- What will you focus on, deeply?

Gallagher (2009), author of *Rapt: Attention and the Focused Life*, says: "I'll live the focused life, because it is the best life there is". What kind of life do you want? Is it a deep life?

I offer Wendell Berry's (2012) poem 'The Peace of Wild Things' as a final thought:

When despair for the world grows in me
and I wake in the night at the least sound
in fear of what my life and my children's lives may be,
I go and lie down where the wood drake
rests in his beauty on the water, and the great heron feeds.
I come into the peace of wild things
who do not tax their lives with forethought
of grief. I come into the presence of still water.
And I feel above me the day-blind stars
waiting with their light. For a time
I rest in the grace of the world, and am free.

(Reprinted with permission from the author.)

Reflections on our Latest Visit to Knepp

David Overend and Jamie Lorimer

October 29, 2018

(**DO**) On 14th-17th September 2018, I returned to Knepp Castle Estate for a third time with Jamie Lorimer, along with three new visitors: Sofie Narbed, Jenny Swingler and Scott Twynholm. On previous trips we had scoped out, explored and experimented with this complicated site; learning to read, interpret and work with the wild processes and inhabitants of the Wildland Project. This time, we planned to *make* something: to create a text that tangled together our artistic responses to Knepp with its existing narratives and ecologies. The piece that emerged from this weekend takes several forms, including an audio track and a written document, as well as a podcast about the site and our project.[1] This text gathers together some images and reflections, recording another productive and revealing encounter with this complicated and often inaccessible environment.

Working with wildness at Knepp (JL)

Working with our team at Knepp over the last few days has made me think differently about rewilding. It has given me scope to think philosophically about the wild ways of the site; or the different topologies through which we might conceive of the oak. Learning

[1] See (The) Six Wild Ways of the Oak, Jamie Lorimer, Sofie Narbed, David Overend, Jenny Swingler and Scott Twynholm. Available as an audio track at https://soundcloud.com/user-465055761/the-six-wild-ways-of-the-oak. Jamie Lorimer's section of of the text was later published with illustrations by Rosie Fairfax-Cholmeley: Lorimer, J. and R. Fairfax-Cholmeley. 2020. *The Wild Ways of the Oak*. Oxford: Flagstone Press.

together about the tree, its landscape, and its history open up to a musical understanding of ecologies. We learnt of worlds marked by discordant harmonies: tangled lives, with multiple trajectories and shifting intensities. The oak became more than a simple tree. It was a bending, moving body. It was on the march, surging out of linear hedges to take over abandoned fields. It also became a refugia for myriad oak-loving life forms. The tree was also a node of dissemination – spreading countless acorns. Last time at Knepp we were all taken by the acorn symphony, as nuts pinged off the tin roof and plopped into the pond. This time we saw acorns on the move, carried by jays under scrub and into the rootings of pigs. Oaks opened us to the histories of the site – human and nonhuman. They told us of hunting, of industry and of war. They tell and foretell of climatic fluctuations, storms and diseases, and the intensities of ecological disturbance.

(L-R) Scott Twynholm, Sofie Narbed, Jenny Swingler, David Overend, Jamie Lorimer and Old English Longhorn cows at Knepp Castle Estate, September 2018

Being amongst those attuned to sound taught me to listen. It helped me to sense absences. The roars of the rutting deer were striking, but would have once been subsumed by the bellowing of elephants, the howls of sabre-toothed tigers, and the general chorus of insect and bird abundance. We learned to listen to individual birds and their calls, to try and strike up conversations by mimicry. Tapping stones or cupping hands to simulate alarms or flirtation. Mist nets raised to

catch birds drawn by recorded calls also gave notice to the perils of attraction. Caught birds left unharmed, save for the chunky jewellery of a new ring. The layering of sound files revealed the creative potential of dissonance. Synchronous readings of our lists of highlights made clear common moments of wonder, shock and comedy. The murder of a rabbit by a stoat, signalled by a horrific scream as it was dragged by the throat and asphyxiated, marked us all.

This collaboration has revealed the creative potential of well-choreographed collaboration. David has directed us like a pro, drawing out our strengths, offering sound advice, and making a weekend of work a lot of fun. We hope our leftfield take on rewilding provokes curious encounters with oaks all over the country. Go find yourself some acorns.

Vera Oaks (DO)

Frans Vera is a Dutch palaeoecologist. His influential book, *Grazing Ecology and Forest History* (2000), responds to a prevalent belief that prior to human intervention, Central Europe would have been largely covered with closed canopy forest. Vera argues against this view, instead offering the hypothesis that the grazing behaviour of large, undomesticated herbivores would have created a "park-like landscape consisting of grasslands, scrub, solitary trees and groves bordered by a mantle and fringe vegetation". Vera's thinking has been extremely influential at Knepp. As a scientific advisor to the project, his theories are put to the test at the site. One of Vera's most important – and contested – ideas concerns the mechanisms through which forest regeneration takes place. This is the argument that oak saplings (and those of other hardwood trees) are able to withstand the grazing pressures of large herbivores when acorns fall and germinate in thickets of thorny scrub.

The Vera Oaks are distinctive in that they can only grow in places where gorse and thorns take root, creating an exclosure that prevents grazing destroying new shoots. In this rewilded landscape, which is enclosed from the roads and neighbouring farms beyond the Knepp Estate, there are multiple boundaries – both natural and artificial – that allow wildness to take place. The processes of rewilding play out within carefully protected zones.

Watching Tamworth pigs

The Vera Oaks offered us inspiration and challenge. Literally inaccessible and guarded by unruly, tangled flora, our concern with boundaries and exclusory zones materialised around these trees. There were parts of this site that were inaccessible in all senses of the word. At the same time, they hinted at multiple spheres of influence and connection: reaching out to the interconnected components of the ecosystem; resonating deep into the past and out into the futures; shifting scales and setting off new trajectories. We set out to follow these wild ways, and to attend to the lessons that the oaks might teach us.

A Tamworth pig rooting for acorns

The Gift in the Beaver

Laura A. Ogden

August 20, 2019

A beaver on display at the Kelvingrove Art Gallery and Museum, Glasgow, Scotland

Gift giving may be the most basic form of exchange, though hardly simple. In our hearts, we like to imagine that gifts are given with 'no strings attached'. Of course, this is rarely the case. Instead, gift exchange is weighted by complex, rarely articulated social

expectations. I am reminded of these expectations whenever I find myself staring at a distant relative's wedding registry, calculating how much I should spend so I don't appear uncaring or cheap. Yet, as anthropologists have shown us, a gift is more than a gift. Gifts circulate through practices of reciprocal obligation. When we give a gift, we get something back in return – whether it is an actual gift, social recognition, or just a good feeling. When we receive a gift, we are obliged to reciprocate in some way. I fret over distant relatives' wedding registries because twenty years ago I received wedding gifts from relatives I barely knew. Gifts bind us to others and honour those obligations.

Here, I consider what I learned about our obligations to beavers, while participating in the Landscaping with Beavers Workshop, held at the Bamff Beaver Project on the Ramsay family estate in Perthshire, Scotland.

Beaver sculpture, with additional offerings by Laura Bissell, Laura Ogden and Jamie Lorimer

Beavers transform their worlds by chewing, felling and dragging the trunks and branches of their favourite trees around. In their wake, they leave woody debris, often crafted into fantastic and awe-inspiring forms: hour-glass shaped stumps, curiously upright and balanced, though nearly gnawed through at the middle; pointy spears, honed to a sharp edge; horizontal logs marked by a tracery of teeth. In Scotland,

while spending time at Bamff, I began to think of these forms as artistic offerings – a beaver's version of a sculpture garden.

At the Bamff Beaver Project, I watched tourists photograph each other while standing in front of a fantastic example of beaver art (seen in the photograph). Watching the tourists, I was reminded of Paul Nadasdy's brilliant essay entitled 'The Gift in the Animal'. In it, Nadasdy asks us to take seriously widespread practices of animal-human reciprocity that occur within Indigenous North American hunting societies. In these societies, animals give themselves to hunters as gifts. In exchange, hunters are obliged to perform specific ritual practices. Anthropology's theories of exchange, Nadasdy argues, have been limited by Euro-centric ontologies that treat the gift of the animal as an Indigenous 'belief' rather than a social relationship bound by human-animal reciprocal obligations.

We are so used to viewing beavers as utilitarian workers, the epitome of industry ('busy as a beaver'). Yet, as a thought experiment, what happens if we think of beavers as artists and their statuary as gifts? Taking this a step farther: If beavers are gifting us their art, then what are our obligations to them?

Jamie with his beaver offering. One of the pieces had been chewed up the night before

This proposition, in part, led Laura Bissell, Jamie Lorimer and I to imagine ways of offering reciprocal gifts to Bamff's beavers. Doing so forced us to consider what would please the beavers. Gift exchange, as a social practice, requires us to be empathetic and open to another's needs and desires. One would never bring a copy of *Moby Dick* to a child's birthday party, for example. What we know from beaver behaviour and physiology led us to stage several edible offerings to the Bamff beavers. These beaver offerings had the feel of temple shrines, composed of fresh tree limbs, apples and flowers. We assembled the offerings along the river, with the hope that they would cheer and sustain the beavers as they travelled beyond their homes at the Ramsay estate.

We completed our beaver offerings on the last evening at Bamff. The next morning, knowing our time together was ending, we awoke and wandered off to the river as a group. As we walked, I was nervous to discover if the beavers had accepted our gifts. It turns out, most of the offerings remained undisturbed, like gifts that didn't quite hit their mark. Then, a sweet surprise at our last offering. This one, which Jamie built, was composed of several bendable sticks, like child-sized fishing rods, that arched toward the river bank. At the end of each stick, Jamie affixed a piece of apple. Beavers love apples! It would be hard to overestimate the giddy joy I felt when we figured out that a beaver had nibbled on the sticks and apples. This was a little success, a bright moment of multispecies reciprocity. And that joy was the real gift in the beaver.

Landscaping with Beavers

Laura Bissell

July 29, 2019 [1]

Arriving

"The more beavery the landscape is, the harder it is to find them." This is what Laura Ogden, an environmental anthropologist from the US told us on our first evening in Bamff in Perthshire as we took an evening walk around the land to try to spot some beavers. An interdisciplinary group of ten researchers including artists, cultural geographers, and anthropologists visited the estate for four days to explore 'landscaping with beavers', and the possibility of multispecies collaboration. Building on previous visits to the Knepp Estate in West Sussex (an ongoing project of rewilding discussed by one of the owners of the estate, Isabella Tree [2018], in her book *Wilding*), we hope to find out what has happened in in Bamff since a keystone species has been introduced, and how we might learn from the ecological processes that are taking place here.

Our hosts were Paul and Louise Ramsay who own and run the estate in North-East Perthshire; 1300 acres of land made up of farmland, woodland, wetland and hills, including some ecotourism accommodation open to the public. For the past thirty years they have strived to restore a more natural environment to the estate and have welcomed the arrival of various species of birds and mammals, most notoriously perhaps the return of the Eurasian beaver, which disappeared from Scotland in the 16th Century due to hunting and was reintroduced to the river in Bamff in 2002. Despite only being given protected status by the Scottish government in May of this year, the beavers have been breeding at the site since 2005 and as the community has grown they have extended their territory creating wetlands in

[1] See Bissell, L. 2020. 'Ecologies of Practice: Landscaping with beavers'. *RUUKKU: Studies in Artistic Research* 14.

between the fields and woodlands. The traces of the beavers' activity are visible as soon as we arrive at the Bamff estate on a warm evening in June; capsized trees with disks of roots exposed evidence how the beavers' dams cause flooding which undermines the root structure of the trees. We experience the longest day of the year while we are there, the light, warm evenings allowing for late night encounters with the beavers as they go about their business of swimming, building, playing and eating.

Scanning the beaver ponds in Bamff

I carried Donna Haraway's (2016) ideas of sympoiesis – of 'making with' more-than-human others – with me throughout the weekend. What are we doing when we 'make with' beavers? In viewing them as potential creative collaborators are we simply anthropomorphising them, this time as performance artists rather than architects, water managers or workers of the land? Do they want to 'make with' us? What might the first steps in 'making kin' be?

Attending: 'to be present at'

Some of us stay in the family home of the Ramsays (and are made to feel very much at home by their warm welcome and the sharing of food) and others take turns to stay solo in the 'Hideaway', a wooden building situated across from the beavers' lodge, where their nocturnal activity can be witnessed. Those of us attending this research trip are here to explore the possibilities of collaborating with the beavers through interdisciplinary processes. I think of the word 'attend',

meaning to apply one's mind or energies to, 'to be present at'. It reminds me of Haraway's contention that "staying with the trouble requires learning to be truly present, not as a vanishing pivot between awful or Edenic pasts and apocalyptic or salvific futures, but as mortal critters entwined in myriad unfinished configurations of places, times, matters, meanings" (2016, 1). This focus on present-ness, not just of being in attendance but *attending to* these questions of how to be truly present, how to stay with the trouble – not run from it or ignore it or deny it, but to sit with it and to live with it – feel urgent during our time at Bamff. One of the participants, cultural geographer Clemens Driessen, tells us that "for the animal, only the present exists". As a performance-researcher, I hope that performance-making processes can explore these ideas of present-ness and play a part in research creation in order to more fully understand this site, its landscape and our relationships with more-than-human beings.

Bark gnawed from a tree – signs of beavers at Bamff

Another definition of 'attend' is to deal with, cope with, or see to. This other meaning of attend also feels relevant to our time in Bamff as we try to find ways to take care of and give our attention to the beavers. Staying with the trouble is about attending to where we are now, taking responsibility for it and thinking about our role in 'response-ibility' (i.e. how we respond to what Tim Morton (2018) defines as a period of mass extinction).

On our second day in Bamff I lead the group in some exercises which I hope will help us arrive at this site, attend to our senses and allow for an opening up to this place and what it might have to offer. I ask people to use their animal instinct to find a spot they want to respond to. We start with a very human activity, writing, and from this we abstract a haiku, a short imagistic poem which takes place in the present, originally defined by Japanese poet Shiki as a "sketch from nature" (Ross 2002, 12). These haikus are then translated into a live action, an embodied fragment of performance sited in our chosen spot. I ask people not to view performance as a way of pretending or creating an artifice, instead I ask them to invest in the real time/real effort mode of performance-making.

As the afternoon moves into early evening, theatre director David Overend invites us to think like beavers and to explore the landscape from a beaver's perspective. I sit by the beaver pools for a while and try to get into a beavery frame of mind. I take off my hiking boots and dip my toes in the still water. I feel repelled by the stagnant smell. My hand touches the bark of a tree and I am coated in a sticky resin. I like the smell of this, deep and foresty, but not the feel of it and I place my hands in the water to try to wash it off. We meet back at the hideaway and David returns dripping water from his body after a swim in the beaver pools. He tells us how he lay in the grass and followed a beaver path down to the water before slipping in, his body submerged among the water weeds. As David relayed his aquatic adventures, I felt disappointed that I had let my human sensibilities keep me on dry land. I hadn't been able to put aside my revulsion of the brown brackish water, its icy-coldness, but I was glad to live vicariously through his telling of becoming beaver in those moments. As we share our explorations I have to confess that in my attempts to be beavery, I did have a little nibble of the furled back bark of a tree. It was horrible. Like the stagnant water, I could not move away enough from my human-ness to become beaver and to find it anything other than unpleasant. I am not a beaver. But in attempting some beavery behaviour I do feel I have a different understanding of my own body in relation to theirs, of my own behaviours and drives alongside their activities and the way they have transformed this countryside. I see them everywhere now, not the beavers themselves, but their traces, marked indelibly in the landscape.

Laura Bissell making-with tree roots.

Making With

On the third day we spend the morning thinking about mapping as we explore the landscape of Bamff in more depth. Further traces of the beavers' activity become apparent as do the presence of other mammals, insects and birds. At one point we walk along the road between Bamff and its neighbouring farm. The road acts as a visual divide between two opposing ideas of land management, on the left, the neat, flat, familiar fields of green and yellow of a traditional agricultural farm. To the right of the road, the tall, leafy, dark green trees of the Bamff estate loom above the road, swaying in the wind. The buzzards flying overhead seem to favour the airspace over Bamff.

For the afternoon session on 'Making' we split into groups of three. I worked with human geographer Jamie Lorimer and environmental anthropologist Laura Ogden and we began by talking about building a dam. It was very tempting, but we came to the conclusion that attempting to imitate the beavers in this task was doomed to fail. When it comes to dam-building the beavers know best and who is to say that we wouldn't end up disrupting their landscape or diverting water away from where they intended it to go? Was this genuinely 'making with'? Who says the beavers even want to make with us

anyway? In our midsummer late night glimpses of them they had seemed ambivalent towards us at best.

To the left, the managed agricultural land, to the right, the edge of the Bamff Estate

We started thinking about how we might go about 'making kin' with the beavers. On the first trip we had made to the beaver pools we had noticed beaver 'artworks' around the site. These sculptural forms gnawed from tree trunks and the intricate interweaving of different natural materials within of the structures of the dams had made us consider the beavers' endeavours not only as practical, but as creative and aesthetic too. Perhaps we could collaborate with these existing artworks to 'make with' the beavers, to respond to something they had already produced. Working with Laura for this task provided some context of the idea of gift-giving through the lens of anthropology. We thought that perhaps the first step to making kin could be offering some kind of gift to the beavers to help them with their endeavours. We returned to the path by the beaver pools and realised that a small waterway at the end of the river which ran under the forest was the point of departure for beavers leaving the Bamff estate before moving out into the landscape beyond. We decided to mark this point of transition and decorated this passageway with an arch-shaped garland of the same pink flowers as the rhododendron bush that the beavers' lodge was sited under. Jamie scratched on a slate the message 'GO FORTH AND MULTIPLY' as we hoped the beavers would continue to thrive and breed beyond this boundary line which demarcated the safety of Bamff.

We decided to frame these performative gifts as 'OFFERINGS' and created a range of sited gifts for the beavers to encounter along the waterway. These included: a toolkit of materials that might be used to

make a dam (which we called 'DIY'); some apple attached to various lengths of sticks hanging over the water for beavers to try to reach ('PLAY'); and some slices of apple arranged on a dock leaf under one of the beaver sculptures which we called 'NIBBLES'. These small offerings – to our beaver 'oddkin' (Haraway 2016) – were placed along the river leading to the transition point and we thought of these as gifts they would receive as they made their way towards the passageway which led via water out of the Bamff estate. The signs that accompanied the stations were there for humans, to signify our intention with the specific gift, but the gifts themselves were designed with the beavers in mind (our hosts informed us that apples were a treat for beavers).

Nibbles – one of our offerings to the Bamff beavers

Other performances devised during this 'Making' session included: a film of humans building a dam played on a laptop which was viewed through binoculars from the stairway of the hall in the Ramsay home; a one-to-one sound piece inviting audiences to sing a song to remember the dead; a live performance installation sited in the Steading and a solo guitar performance using a log to hit the strings as an audience member read out a recipe for beaver soup from an ancient tome. Our hosts accompanied us on a promenade performance of these works traversing the estate on our final evening at Bamff. The route ended at the boundary of Bamff with our sign reading GO FORTH AND MULTIPLY. Louise explains to us that this is contentious in this

context, local farmers don't want the beavers to go forth and multiply and the Ramsays themselves fear for the beavers' safety once they are beyond the boundary of the estate. The beavers have no sense of the human division of land or the politics of land management but will instead move dependant on resources, environment and the presence of water. As we return to the house for a final dinner I feel closer to the beavers than I have before. I haven't been physically closer to one than the width of the river, but I feel like I can sense their way of being, their beavery-ness in a more intimate way by spending time in their home.

David Overend and Clemens Driessen in the promenade performance

Traces

We began our journey at Bamff by noticing the impact of the beavers' behaviours and the traces of their actions in the landscape. Mathew Reason (2003) asks how we can create an archive for performance, something that is so ephemeral and live and which exists only in the moment. He says that all that is left behind are 'husks' and proposes a theatrical archive of detritus. Inspired by this, and by the natural materials people had used in their performances, after our first day of making short performances in response to place, I asked participants to create a small archive of the 'husks' that our actions have left behind. This little archive existed for the duration of our time in Bamff then the materials were returned to the site. While the beaver's traces are clear to see, it felt important that the traces we left on this place were not damaging or permanent. On the final morning in Bamff when the group returned to the 'OFFERINGS' installed the night before, some of the apple was gone from one of the lengths of stick hanging over the

water. Our nocturnal kin had (perhaps unknowingly, reluctantly or ambivalently) accepted one of our invitations to play.

Play – an invitation to interact with our offerings for the Bamff beaver

An archive of the 'husks' from the live performances at Bamff

Lewis Hetherington Swims with Beavers

June 17, 2020

Days before the lockdown began, we made it back to Bamff Estate in Perthshire - the site of Scotland's first reintroduced beavers. Moving on from our usual walking methods, we donned neoprene and attempted some creative swimming experiments.

Bamff Estate, Perthshire

1. Song to a Beaver

O Beaver!
How I long to see ya.
I'd like us to be friends,
maybe that is impossible,
I, a human,
You, a beaver.
I marvel at your work, dams, sculptures, waterways, all,
but I fear that you may be indifferent to my writing,
both broadly but also specifically this poem,
yes, even this poem,
which I have written for you
(who is the you? Who is this generic beaver? anyway...).
I, of course, accept your indifference,
or more precisely,
lack of awareness,
of my poem,
for you have already given me gifts,
for example, the inspiration to write this poem.
Thank you Beaver. And Goodnight.

2. Traces of Beavers, Bamff Estate, 14th March 2020.

- gnawed chips of wood

- fallen trees

- caves made of fallen tree roots

- me

- us, trudging through the rain looking for beavers

- sculptures of broken trees

- fallen boughs

- upturned roots

- boggy spread where land and water co-mingle

- spikes of tree stump chewed to a point

- stripped bark leaving trees of gold reclining luxuriously across the soft green banks of moss

- dams

- each individual twig, branch, log and trunk which make up the dams

- the pictures I have taken of all these things

- the list I am making now

- the imagination of beavers which I had in my head this morning

- the imagination of beavers which I have in my head now I have been here and seen their engineering

- the WhatsApp message I sent to my boyfriend Iain with a photo of a beaver gnawed tree trunk

- the individual teeth marks on each individual tree trunk

- the many WhatsApp messages I sent to friends to say "I'm swimming with beavers!" when they asked me what I was doing this weekend

- the tracks, almost like chutes, down to the water's edge, made by beavers

- our footprints on the water's edge, and in the water, how we disturbed the silky sludge and weeds on the bottom of the water, and whatever traces of dirt and microbes from the cities we came from as we waded into the water

- the log fire and its smoke that burns as I write this

- the hope that I will see a beaver tonight

- these, amongst many others that I have thought, and not thought about, are the traces of beavers that I have encountered today.

Notes Towards Becoming Beaver at Bamff Estate in Perthshire

Jamie Lorimer

March 15, 2020

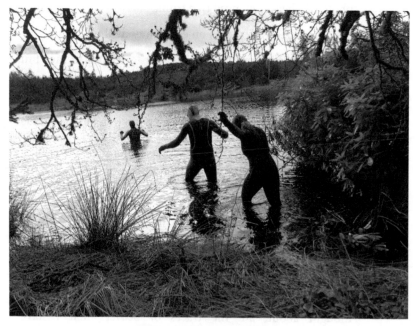

Wild swimming at Bamff Estate

We gathered in Bamff in March to continue our wild experiments in the company of beavers and their terraqueous (or land and water) landscapes. Our primary aim was to develop a creative swimming methodology to address the following questions:

- How do beavers sense and inhabit their watery environment?

- How can wild swimming facilitate a creative engagement with non-human others?

- How can creative walking practices be modified and applied to this specific site, and what can this tell us about multispecies collaboration?

Bamff in March is coming out of a Scottish winter. Although this winter has been mild the water temperature is cold, at about 12 degrees. The day was grey and wet. A moderate drizzle and a cold wind. The landscape looks bleak, Spring is yet to start, and the impact of the beavers is stark. Plenty of fallen trees, raw stumps and vivid pale wood chips. Little is growing.

After lunch in the warmth of the cottage we put on our wetsuits, gloves and boots, under jumpers and jackets. We leave the house and walk the half mile to the beaver pond. Sheltering under trees we pause, eager to enter the water, but apprehensive as to what was in store. Awkward, alien in neon neoprene amidst the forest; like Golems at a triathlon. David has us each remove a boot and place a naked foot on the soil, feeling amongst the pine needles and beaver chips for the ground and a still moment of grounding. He read us Phil Smith on the terrestrial practice of drifting: an attentive curation of distraction, making space for suppressed marks of difference, and a purposeful collecting of experience.

We don headwear, goggles. Our hearing deadened, our vision blurred, and our skin buffered from the cold by 5mm of rubber. We enter the water. The bottom is soft, feet sink into silt. The steading is unfaithful and our gait unsteady. We stagger and waddle drunkenly until deep enough to float. The cold water enters through seams and at cuffs. We gasp and seek to acclimatise. I swim strokes I know that keep my head above water. Initially, aimless I make circles in the pond. I strike out for the opposing shore, get close and ground myself in the mud. Great bubbles of methane are released from decomposing vegetation. A smell of rot, distinct, yet buffered by the rubber. I float toes up, surprised by the buoyancy of the rubber.

Striving to become comfortable in the cold I seek to appreciate the watery nature of my new existence. How should I orientate myself in this landscape? What would be my purpose now if I were a beaver? To start with I reckon I would need to orientate myself in relation to the sensory cues given by the pond and what they tell me about the environment. Deaf to the world and with an untrained and dull nose I decided I would look. I get down to pond level and scan like a crocodile. Then I plunge my head under water. The vision is striking, bewitching and somehow familiar from film footage seen in Laura Ogden's collaborative film and on the BBC (Ogden, Marambio and Gast 2017). But this small comfort was undone by the shock of the cold water on my face, the only naked part of my body. I gasped. I ducked again, caught masochistically between an embrace of the pain and the security of warm air. I felt I should dive, duck under and swim lithesome through the weeds, sliding over the mud with my belly. But my bodily thermostat screamed no, stay up, keep the mind removed from sensory immersion and potential overload.

What then in the absence of sensory affinity? Think about the beavers' purposeful nature. What would a beaver do, here and now? My caricatured book knowledge of beavers suggests they would forage and collect materials for making. I reach down to grab sticks and mud, but the water was too deep to avoid submersion. I experiment with my feet, which, like the beavers, are unaided by opposable thumbs and forefingers. Clad in thick rubber they serve as blunt shovels, stirring up mud but no good for carrying and dam building. I slap the water, remembering the beavers' alarm call: but this is a crass form of communication.

In many ways this experiment was an abject failure to become-beaver. And yet it helps us to calibrate the background conditions required to conduct such an experiment in the future. It offers a first attempt. It tells us a lot about the elemental difference between water and land and about the phenomenology of cold.

Although I am a confident and experienced swimmer and can feel at home in the water, I was lost and confused in the pond. I was reminded of the terrestrial nature of my being. I can walk and breathe, walk and talk, walk and think, walk and not even know I am walking. On a good day, in a warm bath, I can float and do all of these. Sometimes floating

even helps. But swimming in a cold pond at Bamff in March is much more of a challenge than walking the same landscape. I suspect this is not true for beavers: equally at home in one or the other.

I do not know how the beaver senses the world through its fur and skin. I can only assume it has a more nuanced haptic experience than I gained in the pond. The wetsuit rubber made a barrier with the environment. It was snug, but then leaky. And the leakiness bore no direct sensible relationship with the water I was seeing around me, or what my movements through the water suggested the water was like. I could not trust touch as a medium to engage with the water, in the way I could when naked. The rubber also diminished my already diminished senses of smell and hearing, fumes of new wetsuit and ear coverings overwhelmed efforts at multisensory attunement.

The leakiness also introduced the cold. And the cold was uncomfortable, bordering on fearful. In accumulated in the peripheries: the fingers, the nose, the toes. It began to chill the core. It distracted from the cerebral aim to think my way towards beaver. It overrode experimental projects to dive, to forage, or just to float and think. Cold (and pain in general), without training, is a profound barrier to multispecies ethnography. Though perhaps it might enable us to understand animals' experience of environmental disconcertion, of being too hot, too cold, or otherwise in distress.

To become beaver and to understand the elemental characteristics of its terraqueous world I would suggest the following experimental conditions:

- Water warm enough to permit protracted, naked swimming, unrestricted hearing and smelling;

- Flippers or other modes of beaverly propulsion;

- A snorkel to permit extended submersion;

- Darkness or an eye mask to incentivise the other senses;

- A flowing water course to offer audible cues to the passage of water, and the nature and distribution of leaks

None of these prostheses will make me a beaver. Future experiments will also fail. But they will tell us more about the embodied experience of aquatic mammalian being.

Performances, Artworks
and Exhibitions

Even in Edinburgh/Glasgow

Ishbel McFarlane

September 12, 2011

First impressions of things I learned from doing my show *Even in Edinburgh/ Glasgow* on the train between Edinburgh Waverley and Glasgow Queen Street as part of the Edinburgh Fringe Festival 2011:

- if a festival is called after its host city, press like to write about a show which ends in a different city

- large volumes of pre-show press does not equal large volumes of audience/reviews

- working with national organisations means only 6% of the people you will encounter will have any idea of what you are doing

- performing on public transport means you are subject to public transport

- people in the Holytown area love stealing cable

- stolen cable means signal failure

- art is not compulsory

- get a champion in the organisation you are working with

- if you are taking people out of their comfort zone, you are their parent: if you look stressed, they are stressed; if you look relaxed, they are relaxed – what you are actually feeling is irrelevant

This text is a collection of my initial impressions after doing a show which aimed to undermine initial impressions regarding Edinburgh

and Glasgow (and the land between them) among residents and visitors. It was a poetry-tour which began on platform 13 of Edinburgh Waverley, boarded the train with the audience, made anyone who was in the carriage an audience member (if they wanted – more of that later), and then left the audience in Glasgow Central Station at platform 5, with a map of the city marked with My Favourite Places.

I was the only performer: I had a notebook, a battery powered amp and a microphone. I had the poetry of Liz Lochhead, Gael Turnbull, Edwin Morgan, Elaine Webster and William McGonagall. I had my own opinions, I had my own research and I had stereotypes by the tonne. I had the views from the train, the experience of the train, three of my own stewards and the staff of ScotRail and Network Rail, whose workspace I was invading. I had the permission of their superiors, and a hopeful, apologetic, defiant smile.

The journey of *Even in Edinburgh/Glasgow* began in late 2009 as *Even in Glasgow/Edinburgh/Glasgow*. I had recently moved to Glasgow from Edinburgh to study at the Royal Scottish Academy of Music and Drama (RSAMD) and I had been struck that before I moved there I had been to Scotland's largest city, its cultural heart, maybe a dozen times in my whole life. Let's be clear, it was not hard to get to Glasgow – except mentally. I never lived much more than an hour from it physically, but psychologically there is an Iron Curtain which dissects Scotland around Falkirk (in fact, probably slightly to the east of Falkirk). The rivalry between the two sides is jokey, but it's not a joke.

When I moved to Glasgow I was invited to make a pitch to be part of the On the Verge festival run by the RSAMD and the Arches. I wanted to do a show about Edinburgh and Glasgow, and following the advice of a friend, I decided to start by diving into what I already loved and so returned to a long-held idea of a poetry tour. Since the poetry and ideas would be about Glasgow and Edinburgh, it seemed only natural that I should show the audience both places, so they could hear the poems, hear my opinions, but also let what they could see out of the windows reinforce or undermine my words.

As is often the case with site-specific, site-based and general not-in-a-theatre theatre, negotiating between the various mighty, often corporate institutions was a tricky thing both in the development version in 2010 and in 2011 when I did the full version at the Fringe. As the sole writer, producer and performer I quickly found that it is the

writer and performer who miss out in that triumvirate of roles. Deadlines for press releases, or explanations to ScotRail or the Fringe office tended to shout much louder than the nagging whisper of my own knowledge that I needed to think about what I was actually going to say.

A large chunk of my preparation time was spent travelling the line, so that I could learn cues which would warn me of the approach of something I wanted to point out or synchronise with a line or a poem. The concentration it took to be 'present' for the audience, remember my 7,000-word script and 9 poems, and keep an eye out for a specific tree formation, or view of a shale-bing out of the corner of my eye meant that after the show arrived in Glasgow, I tended to eat and then go straight to bed.

The biggest challenge of writing the show was fitting my argument's arc, and the points of the poems, to the narrative of the journey itself. This was to be an intellectual journey which mapped and enhanced the physical journey. I knew I wanted to give people time to think, talk and look without my voice, so I had to work in natural pauses. Another consideration as I wrangled with the dramaturgy of the show, was that approximately one third of my audience would have known about the show before they boarded the train (usually around 25 people). The rest (usually around 50) were just going places, sometimes only boarding the train for a few stops. I had to make the show satisfying as a whole, while also stimulating in chunks.

In many ways, these other travellers were my 'central' audience. On the performance days, my stewards would stand on the platform at each station and explain to those boarding the train that our carriage would include a free poetry event that they were welcome to join, to ignore or to chat through. Alternatively, they could sit in the other carriage which was completely 'Art Free'. Although one man asked the conductor to hold the train while he literally ran away from the literature, there was about a 50/50 split in the number of people who chose the poetry carriage rather than the normal carriage. The 'incidental' audience included a whole selection of people going from A to B on a line with two prisons and a prison store, six stops, a Catholic shrine and two mosques.

With my microphone and my notebook, I looked much more like a tour guide (which I partly was) than a poetry proselytiser (which I partly was). I cultivated this appearance, as it meant that there was less

preciousness about the event. This was not a sacred thing, separate from the world. Neither was it something which wanted to ram itself into a world and explode it from the inside out. I wanted to cultivate the sense of adventure that you can get on a journey, both from those who had chosen to see a play not in an auditorium, and those who chose poetry on their commute. However, I wanted to avoid the sense of fear associated with a military exercise. Some productions aim to shock their audience out of their normal lives with enforced, dare-devil audienceship. But if my audience felt afraid then they would not properly hear the poems. If they were merely excited by the unexpected then they felt and listened more closely to what I had to say and were more keenly attuned to the journey as a whole.

Collating my first impressions of this experience has highlighted that it is problems, challenges and disappointments that present themselves first. Like the form-filling, production side of the creation process, these negatives shout loudly about what needs done and what needs done better next time. However, I have many abiding positive memories of the journeys that people took with me. The first is of a lady who watched my first performance, who got on at Waverley in order to get to Bellshill. At each stop she moved closer so she could hear better and I spoke to her during the breaks in the show. She said she was listening because her son would be interested and it was so long since she'd heard any poems, not since school, and she had never really thought about the journey before, even though she did it all the time. As we approached Bellshill, she decided to stay on the train to Glasgow so she could hear the end of the show, changing her literal journey so she could hear through to the end of the concurrent literary journey.

At the end of the show, before we pulled into the station, I went round those who had listened – pre-planned audience and otherwise – chatted with them and gave them my personal map of Glasgow. After I left the station I kept bumping into people at the places I liked to eat, or heading to my favourite vantage points or museums. By ending in another city, there was no way the audience journey could end when mine ended. My show was just part of their day out, just one journey of many within and between Glasgow and Edinburgh. Fitting the poetry journey within and beside, in front of and behind other journeys that the viewers would make on that day is an idea I take with me to my next show.

Adrian Howells Discusses the Impact of Travelling on his Evolving Arts Practice

October 5, 2011 [1]

Flyer for The Garden of Adrian – a performance in the James Arnott Theatre at the University of Glasgow in 2009

[1] This text is from Adrian's contribution to the Making Routes launch event at the Arches, Glasgow, September 2011.

The impact travelling and making journeys to different countries and locations around the world has had on my evolving arts practice...

This impact has happened in three major ways:

Firstly, by taking my work to a diverse range of countries and cultures, these trips have then directly influenced my thinking and ideas for other, new pieces of work, because of a qualitative and an experiential encounter with that country: meeting its peoples and engaging in its culture, traditions and customs.

Secondly, because it is fundamental to the ethos of my work and my personal philosophy, I IDEALLY create work for everyone and anyone, irrespective of cultural background, race, ethnicity, religion etc., the performance of my work in this eclectic and diverse range of countries and cultures directly informs me about the connection with and responses to it by different audiences from different cultural backgrounds and helps the piece to continue to evolve and develop.

Thirdly, there's a kind of inevitable two-way traffic situation because of the cultural and artistic exchange that frequently takes place. Very often there are orchestrated opportunities for dialogue, learning and skill sharing between different artists and their disciplines, which in turn influences the work created and developed by myself and those artists, who then take that work back into their own communities.

'Reimagined Journeys': Everyday commuting excursions

Laura Bissell

June 23, 2015

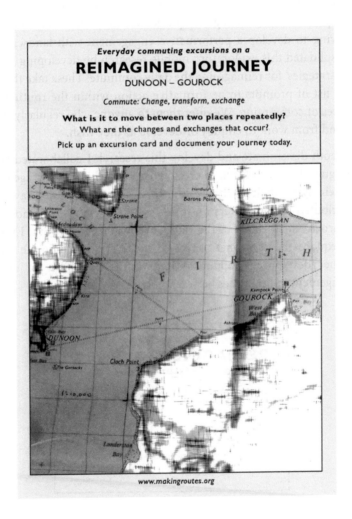

Everyday commuting excursions on a

REIMAGINED JOURNEY

DUNOON – GOUROCK

Commute: Change, transform, exchange

What is it to move between two places repeatedly?
What are the changes and exchanges that occur?

Pick up an excursion card and document your journey today.

www.makingroutes.org

In 2013, David and I began a collaborative research project exploring our everyday journeys between home and work and how the commute (from the Latin word commutare meaning 'to change, transform, exchange') could be conceived as a fertile ground for creativity, productivity and transformation.

Over a period of eighteen months David and I embarked on a series of experimental commutes undertaken in the west of Scotland by foot, bike, boat, train and swimming. Drawing on the nomadic theory of Gilles Deleuze and Félix Guattari, and Rosi Braidotti, our aim was to develop a performative 'counterpractice' that employs the metaphor of nomadism, and the 'creative becoming' the myth of the nomad encapsulates, to reimagine quotidian and functional journeys. Striving to develop a performative engagement with landscape, we consolidated this exploratory mobile research by developing a series of 'strategies' for reimagining the daily commute. These take the form of a list of prompts to performative action within the routines and spaces of commuting. We offer them to anyone who regularly travels to and from work to employ or develop as they wish.

To both disseminate and develop this research I collaborated with a designer, Rachel O'Neill, to create postcards which encourage others to reimagine their everyday journeys. These postcards have been distributed to commuters on the Argyll Ferry between Dunoon and Gourock which is one of the stages of my journey to work. I wanted to explore the relational aspect of the everyday commute and to further develop my understanding of the possibility of creative engagement in the spaces between home and work.

Everyday commuting excursions on a

REIMAGINED JOURNEY

EXCURSION ONE: FIRTH OF CLYDE (DUNOON – GOUROCK)

OUTWARD	a.m.	RETURN	p.m
Dunoon............................		Gourock............................	
Dunoon............................		Gourock............................	
Dunoon............................		Gourock............................	

Commute: Change, transform, exchange
What is it to move between two places repeatedly?
What are the changes and exchanges that occur?

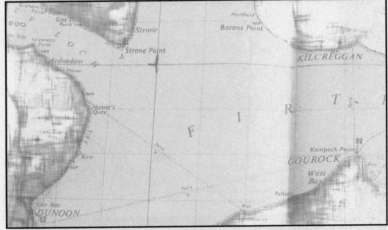

Can you think about your commute in a different way? Write, draw or map your thoughts in the space below and leave this card in the box:

This is part of a creative exploration of everyday journeys: www.makingroutes.org

Here are some of the responses:

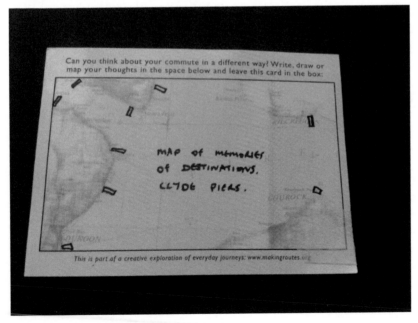

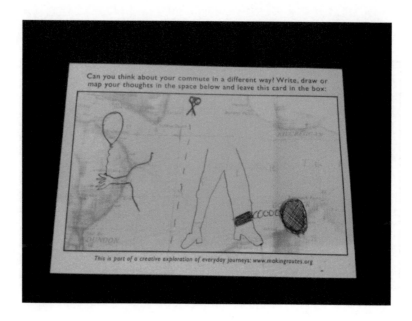

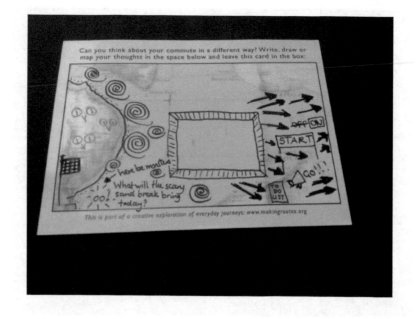

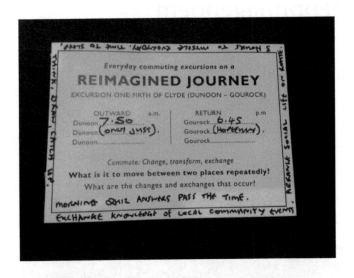

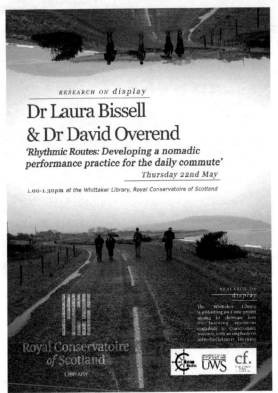

Research on Display at the Royal Conservatoire of Scotland, image: Phoebe Amis

Kneppimagepoem

Laura Bissell

October 27, 2017

Deadcoralarch

Homehearthtable

Dawnbreakingday

Anticipationlight

Blueskyhorizonbreath

Redroofpuddlepaw

Deepgreendivider

Intricatewebworld

Stretchinglimbleaf

Pigpalportrait

Warningkeepinout

Autumnblownleafharvest

Palimpsestlastlife

Acornduetstream

Deadtreestagstick

Stratocumulusdrift

Pathtomantreeman

Feethandsentangling

Gatheringacorngreen

Birdsseekingbirdslook

Dawnwalkingswantrio

Lineboundarypathsky

The Six Wild Ways of the Oak

Jamie Lorimer, Sofie Narbed,
David Overend, Jenny Swingler
and Scott Twynholm

October 8, 2018

The Six Wild Ways of the Oak *is a creative response to the wild ways of Knepp Castle Estate, focussing on the different topologies through which we might conceive of the oak. This project was funded as part of Jamie Lorimer's British Academy Fellowship at the University of Oxford. Thanks to Penny Green, Tom Forward, Rina Quinlan and all the staff at Knepp.*

1. This oak is a tree. It has roots, a trunk, branches and leaves. It is a living body that grows, it sways, and it bends. It is a body that ages, that sheds its leaves, bark and branches. It is a body that splits, rots, and dies.

When I catch the right air and breathe in,
I have the makings of an excellent ship.
Salt water dreams rattle my leaves.

The A24 is a hug;
It lulls me with its safe indifference.

Bitter winds come with icy revenge.
I never did make it back.

My destiny was to birth kings.
To lean on the winds and to sing;
As an army of pigs scatter my strength.

2. This oak is in a refuge. It grows in a hedgerow that enclosed property. Protected by its thorny neighbours: hawthorn, blackthorn, bramble, the oak was not eaten. Now it advances into abandoned fields. Foraging earthworms mend and tend its soil. Roots and their fungal symbionts creep beneath the earth. This oak also *is* a refuge. Little owls live in its hollow trunk, insects flit in its branches, and *we* climb to view, to sleep, and to escape.

Feel your steps along a grassy track
Let your attention wander
Follow a pull towards the edges,
 the dense, thickety hiding spaces
Push your limbs into this scribble of thatch, this thorny seam,
Stretch out amongst the burrows,
 the deep tunnels that birth and swallow life
Come to stillness on this leaf-littered ground,
 the cool dirt at your fingers and knobbles of roots at your back
Close your eyes to the light
And feel your weight sinking into the earth.

Bones releasing,
Flesh spreading,
Head, hips, heels. Heavy.
Breathe here beneath the tangled darkness broken by scattered pinpricks of light.
Lie wrapped in the snaps and rustles,
 the crunches of footsteps, the swish and clatter of wings.
Feel your edges expand as you draw the outside in.
Shelter in this chaotic cocoon of woven veins etched across a shifting, roaring sky.
Lean in to this space.
Rest. Here. Sink. Down. Into this, your body hollow.

3. So this oak is a node in a network. Its roots and rhizomes feel out across once sterile territories. Its acorns are vectors for its movement. Jays bury its seed, too plentiful to be eaten in even the harshest winter. Peregrines perch and surveil. Pigs come to scratch an itch, to wallow in the shade, and to feast on the mast.

human voices
 You just cut away the back of its throat and
 a distant plane
white noise of the road, constant a startled rabbit
in conversation with the
Wind in the Ancient Oak a squirrel running along a
branch
 my breath the first tentative acorn drops of the season,
 joining in plopping into the pond
small birds talking the call of a wood pigeon
horses hooves on a gravel path, from right to left
 the muffled voices of a meeting in progress
a wood pigeon a diving duck
a guided tour the rumble of an engine wind in the reeds

hello textures of bird song
children's voices a distant assertion of engine noises
more voices, adults this time: a door slams
 everything apart from the gravy was cold, and I was like
 a fly by
 a return to the wind in the ancient oak
 a duck diving
a page turning.

rhythmic clicking from a hedge row, like an irregular car indicator
 the door creaks open in the breeze
 a bird? a car pulls up
 a speeding insect as a plane flies by
 a falling acorn and an acorn falls
 an event to break the stillness
The high pitched whir of a cricket a dragon fly's heavy
 passage,
Footsteps and a voice from behind touching the reeds
Is that time up? cracked twigs,
 falling from above
 bird song
 abundance
 Life

4. This oak is in a cycle, part of a shifting mosaic of forest pasture. Acorns cast or buried in scrub find refuge. Like a cuckoo, growing amidst this thorny fortress, they avoid the browse and graze. They poke their crowns above, and grow fast to shade out and kill their nest of thorns. They spread their canopy, claim their space. At length they droop, they decay and fall. Light returns, pasture is created, thorns emerge. And so the cycle continues.

This story was told by a Dutchman who took the oak as his guide to grazing ecology and forest history. He sought oaks in the pollen record, in fables, and in the vestiges of the wild wood. Following how oaks persisted, and how they spread, he was drawn to the jay, a bird with a love of acorns.

The archive of oak love tells us of the man who planted trees. A shepherd, alone in a treeless, abandoned valley who took his stick, made a hole and placed an acorn. A hundred thousand times he did this, all across the pasture. He gave up his sheep as the oaks took root, and tended their resurgence.

Let us follow these men and become Jay.
Find an oak in the autumn.
Select one to six healthy, ripe acorns which have not been affected by parasites and are not too small.
Carry the largest or longest in your beak. The rest can go in your throat or gullet.
Take flight. You may go but a few score metres, or several kilometres. But the more acorns you carry, the further you should travel.

Find a hedge at the edge of an open field. Look for the fringes of thorny scrub. Fly down into the bush and seek some loose soil where you can easily push your acorns into the ground. The rootings of wild boar or pigs are ideal. Bury your acorns separately, a few metres apart.

If the nut will not go in far enough, hammer it into the ground. Cover the hole with a few sideward movements of your beak, and camouflage it with leaves, little lumps of earth and stones. Remember the shape of your hedge. It will be your beacon.

Repeat. At the height of the collection, you will move and bury a thousand acorns in a day.

You can eat your hidden acorns throughout the year. Dig them, peel them *in situ* and eat the contents there, or fly off with the unpeeled acorn in your beak to eat it elsewhere. In June, with your young, look out for seedlings which have grown from the buried seeds. Show them how to find a shoot, take hold of the stem with your beak and lift the plant. Remove the acorn, peel it and feast together.

5. But this oak is different from all the others. Its cycle has its own rhythm, marked by the intensities of history. Its rise is shaped by the wind and the sun. It leans to balance, it reaches for light. Its branching is shaped by storms, droughts, lightning, and fire. It is etched by the munch, the bite, the peck, or the burrow of myriad dryophilus (or oak loving) beasties. The legacies of these different disturbance regimes are written into its rings.

Hammer Rabbit is dead

She is lying in the pond under the branches-
A furry Ophelia.

Hammer Rabbit shares her grave with an industry
That also gnawed and scratched at the surface
And burrowed deep.

But just as Hammer Rabbit tries to catch her last eternal breath
A new industry is moving in.
It is as if the men who battled with this landscape have risen up
From the swampy depths and are reincarnating into microbe form.

This band of microbes has no union,
And has abandoned all workers' rights,
They toil without breaks.

A small community has gathered in her stomach.
They fight hungrily through her kidneys, liver and lungs.

Guided by the light of her eyes
They plough through her retinas
And begin to strip her of her skin.

Hammer Rabbit undulates-
Decaying is ticklish.

Her bones settle on the sludge and she gives in to the suck of the mud.
Beneath she feels the hot breath of what has been and what will be.

Her bones become entangled with the beginnings of a Mammoth.
Her ribs form an arch that shield this impossible baby,
As the Mammoth breathes warm winds,
That melt the boundaries of time.

Its body not yet grown or born,
It leans into a landscape not yet formed.
Imprinting future ground with heavy step,
And drinking from rivers not yet full.

6. And this oak has travelled, marching in sync with sheets of ice.
Retreating in the cold, encroaching in the warmth. Following in
the vanguard of plant pioneers, it moved a few metres a year.
Voyaging up from its Mediterranean refuge, it passed through
the swamps of Doggerland before the ice melted and the
Channel opened up. This time it became British, oh-so-British.
Its relatives sheltered kings, built ships for imperial adventure,
fuelled furnaces for industry, and aged spirits. We sing its
praises.

(Im)mobility

Change and Repair: Trixxy Walking, Place-stories and Recovery in a Time of Virus

Helen Billinghurst and Phil Smith

December 21, 2020

Crab & Bee at Coxside for the Being Human Festival 2020

Over the last two years we have been investigating an inexorable web of entanglement between story and place that has emerged during creative research projects. In the following essay we will recount how our experiences working on two such projects during the time of COVID have informed our understanding of the nature of this entanglement and reflect on their significance for re-wilding projects.

We will recount how we gathered material from a series of lockdown walks around the Tamar River system that connects Devon and Cornwall to create a handbook, *Skulk & Guiser's End Game,* and five micro-films for a subsequent commission, *End Game,* during the first lockdown. This is then followed by a discussion of the challenges involved in placing a story of human/unhuman relationships within the community of a 'forgotten corner' of Plymouth for the Being Human Festival 2020, at a time when embodied contact with humans was increasingly difficult to negotiate due to relaxing and re-tightening of COVID restrictions during Autumn, 2020.

At the moment we are still in the middle of the first project; the primary two phases of which consisted of a time of wandering and gathering information, and then writing this material up into the handbook: *Skulk & Guiser's End Game* (2020), a short and slightly 'unhinged' assemblage of games, paintings, stories and journeys intended 'for a time of virus'. We are just completing the third phase having distributed the handbook (with a list of questions to answer) to fifty volunteers for testing out and we have collected almost all the responses. The fourth and fifth phases are to come: our analysis of the responses and then writing up of our findings in a case study.

At the 'Performing Wild Geographies' weekend in Knepp back in 2017, we responded to a landscape in the process of rewilding by various agents; from aristocrats to pigs and seed-shitting flocks of birds. This year, in lockdown, we have been wandering a landscape, that was briefly being re-wilded by a virus, and in much longer-term processes of turbation, ruin and redundancy; its landscape worked over by oysters, worms, and other agents. The Tamar River system – that includes the rivers Tavy, Tamar, Lynher and Hamoaze – connects South Devon to South Cornwall. The Hamoaze is a ten minute walk away from both our homes in Plymouth.

Shortly before the first lockdown, under dark February skies we drove narrow, winding lanes to the North of the city and parked by a woodland. On foot we followed a path through trees, alongside a small river that snaked through and around the isolated muddy flats of Blaxton Quay, where it joined with the Tavy. Despite Blaxton's now desolate inaccessibility, we noted rotting remnants of a once-busy trading quayside. Lines of wooden posts poking from the mud indicated what was once a jetty, the dark chambers of a large Lime Kiln

are covered in brambles and ivy: elements of a pattern of abandoned, once connected centres of exchange, that we repeatedly explored along the water-fronts during lockdown walks.

Tributary streams carve deep, winding, worm-like trenches through the mud as they flow through estuary mud to join the River Tamar

While the former tin mining industry of Cornwall is well known, along the Tamar, on both banks and under the river bed itself, there was extensive mining for lead, copper, arsenic and silver. Add this to the extensive quarrying for limestone and the movement of granite from quarries on the two abutting moors, Bodmin in Cornwall and Dartmoor in Devon. We have been surprised, even shocked, by just how intensive was this industry; every little creek along the rivers Tamar and Lyhner has the remains of a quayside and stories of arrival and departure; just inland, strange and rather grand stone buildings that have now been redeployed for agricultural use (barns or cattle sheds) have the look of counting houses and customs offices.

The large properties and estates of the area, as well as ornate family tombs in the churches, are testimony to where, and with whom, much of the profits from these enterprises ended up. There is an intense weave of hollow lanes, sunken into the terrain and often passing unnoticed between fields and estates. These days they are washed by the rains;

unrepaired, many have lost any paving long ago and are down to a treacherously slippery limestone or slate bedrock when wet or frosty; yet they are mostly still open and uninterrupted, the odd one or two grown over or ending mysteriously at some private wall. But for the most part the sunken local paths remain, maybe much older than even the first mining, for they connect communities and waterway in a logic that is not entirely determined by mineral extraction.

St George's Lane near Sheviock, Cornwall: site of Dando's descent to the Dandy Hole, accompanied by hounds

The paths are not simply historical; they serve to lead the curious to frost pockets, old wells, and deep riverbed pools. They manifest a geographical logic that makes sense of many of the local folkloric stories; such as the monk Dando who is caught hunting on the Sabbath by an antlered devil on horseback and sent racing down George's Lane pursued by his own hounds until driven into the Dandy Pool beneath the Lynher. Modern river charts are testimony to the physical accuracy of the tale; while in its different tellings 'Dandy' and 'Dando' are applied sometimes to the monk and sometimes to the mounted demon.

Paths, rivers, tunnels and webs of local story form a complex latticework of exchange that can still be traced when walking the old routes repeatedly as we did. Sometimes reconfigured as 'miracles' or cautionary tales, the stories – with their smugglers, saints, sacred springs, holy wells, worms, charms, chapels, devilish dando-dogs, transforming staffs, and corrupt lords (a glass of sherry at their side)

convinced of their own immortality – speak of something older than the theological or the medieval. Even those tales that cite historical events or figures often include elements that suggest an interweaving of 'earthly' (materials, trade, transport) and 'unearthly'. So, a clearly historical figure like Sir Francis Drake often features locally as more of a magician than a privateer and slaver, while tales of late eighteenth and early nineteenth century smuggling include unreal elements like walking skeletons who carry lamps and white horses leading streams from moor to city.

This 'magic realism' fits aptly with some of the contemporary landscape. It was on the beach beside Wearde Quay that we made one of five one-minute films as a Lockdown micro-commission for The Box (the latest manifestation of the city's museum and art gallery) in Plymouth (Crab & Bee, The Box). Sitting on Wearde Quay, on the Cornish side of the meeting of Tamar and Lynher, we gaze across Looking Glass Waters to the Dockyard, where hulks of nuclear submarines (their reactors still in place) are left to rot. Also visible from there is Bull Point, where the Navy game-play various disasters (tsunami, chemical plant explosion and so on) to rehearse their emergency response. Meanwhile from Plymouth, the weird wailing of sirens sound out across the apocalyptic waters every Monday morning at 11.30am, announcing the ever-present imagined nuclear accident.

Perhaps then it is not so surprising, given the weirdness of this place and the oddness of the time of COVID, that our short pamphlet *Dr Skulk & Dr Guiser's End Game*, is slippery and strange; an oddness interwoven with startling and direct material conditions and contexts, which has reappeared in our most recent practice-as-research in this time of virus: the equally watery *Coxside Smoke Signal*.

During the summer, as the first lockdown was relaxing, we participated in a series of Zoom conversations (facilitated by arts organisation Take A Part and by the University of Plymouth) between local residents and artists to explore shifts in the ways we make art in the community in response to challenges posed by COVID. We learnt of a general agreement amongst the four Coxside residents who participated that online activity was a poor replacement for live events and workshops. There was enthusiasm for exploring ways of facilitating hands-on, material engagement even if embodied contact was not possible: local publications (zines and newsletters), use of local residents' windows and

noticeboards as exhibition/display space, and deploying community amenities (when not locked down) such as local shops and cafés as drop off/pick up points and supplying creative activity packs to locked down residents were all discussed as potential ways forward.

Discussing good models for socially-engaged art-practice, one theme that emerged from these research conversations was the importance of dreams, the dreamlives of residents, but also the virtues of helping to articulate the hopes and dreams of local residents for the future, particularly at a time when, for many, expectations and ambitions had been postponed indefinitely.

Informed by the findings emerging from these discussions, in September 2020, Crab & Bee began to work with the waterside community of Coxside, Plymouth, towards a project for the Being Human Festival 2020 in November. Due to the perpetual loosening and re-tightening of lockdown restrictions over the following period, planning for this event continued to shift and adapt. From plans for an outside participatory procession and ritual burning, the project morphed to a series of workshops with limited participant numbers, and finally to the delivery of materials and instructions in activity-packs for Coxside families, with 'drop-off' points for completed artworks in local cafés and shops.

This project was informed by an understanding that had been growing as we wandered around during our permitted lockdown 'exercise' (deploying some trixxy, while responsible, interpretation of the rules); we had become increasingly aware of how the landscapes and the stories told about them and associated with them, were in a very close relationship with each other. The landscapes told and retold their stories. The evolving and eroding and disrupted terrain was all the time changing the reading of the texts sited there, while the texts were simultaneously and continuously eroded by and transformed by their associations with the places. The terrain was never just a backdrop or setting, but places with personality that were characters in and authors of the tales told about them.

We were not new to Coxside, Plymouth's 'forgotten corner'. In 2019 we became aware that the well-known Plymouth story of Gogmagog – the mythical giant whose demise is sited on Plymouth Hoe in view across Cattewater from Coxside – has a late-medieval prequel: the story of the arrival from Greece or Syria of Gogmagog's mother Albina

(and her 33 sisters), set adrift as patriarchal punishment for resisting arranged marriages. During a two week residency at Teats Hill in 2019 we had worked with this heterogenous origin story at the Teats Hill beach in Coxside. We told of how Albina and her sisters had washed up on the slipway (the site of our residency), how they hunted and tended gardens there at Coxside, and coupled with *genii loci* to produce a race of giants; the first inhabitants of 'Albion', a non-Anglo-Saxon origin-story of 'England'. With local children, we drew pictures of the baby Gogs and folded paper boats to remember the thirty three princesses. To celebrate Albina as Magog (mother of Gog), we painted the slipway with 'milk' made from local china clay, and handed out copies of a sixteenth century map of Coxside showing two prominent hills, 'Teats', that have subsequently been quarried away.

In the midst of the pandemic in 2020, we returned to this story of Albina, as a way to look forward and backwards simultaneously, to draw hope for the future from unexpected and multiplicitous origins, from perilous and unchosen journeys, from transgressive relations with animal others, and with materials – milk, water, limestone, paper, white china clay – in a 'healing'-burning ritual and storytelling in which we have sought to engage not just the people of Coxside and their dreams, but also the materials of their living place, in the actions.

'Secret' boat-burning ritual at Teats Hill, Coxside

At times we chose to operate in a playful, skulking manner, partly in response to the limitations of embodied human interaction in lockdown, but partly to flatten our presence into the site itself: leaving small, enigmatic constructs and 'offerings' of ash, china clay 'milk' and paper boats on the beach. We leafleted door to door with the story of Albina and Gogmagog, put posters in windows and post boxes in the shop and café. We distributed workpacks, on request, to individuals and via small community groups; with these the residents could write or draw their hopes and dreams, both for themselves and for Coxside, onto paper and then fold them into boats. The first of these written and drawn hopes and dreams were "sent to the future on the winds" in a recorded but necessarily 'secret' burning ritual on the 21st November (Crab & Bee, Lockdown Boat Burn), and then an account of the burning was distributed in leaflet form door to door. A second, more public, boat-burning, due in January during 'Café Accoustica', a regular outside event held by the local Barbican Theatre on the slipway at Teats Hill beach, was postponed due to a new lockdown and remains an aspiration at the time of writing.

The strangeness of the present circumstances has helped to throw into sharp focus for us certain fundamental questions about the nature of this research and the engagement of artists with communities in a research context (as at Coxside, in contrast to the working with individual volunteers invited for the 'Endgame' testing), which otherwise might have remained as assumptions. This has included ways that practice-as-researchers are expected to engage in quantitative and qualitative assessments of impact, and how those procedures may be looping back into disempowering assumptions about those we engage with, while at the same time privileging human actors over unhuman collaborators. All of which begs, at least for us, a radical rethinking of accepted practices of engagement and assessment in both research and community arts through a prism of unhuman agency.

Our visit to Knepp in 2017 and our introduction to the rewilding project there has continued to play into our subsequent art making and research; adding an increased sensitivity to depredations upon the geology and the local extermination of species (red deer, wolves). At Coxside, we were quickly sensitised to the quarrying away of the 'Teats', to the decay of the concrete slipway (constructed by the US

Army for the D-Day Landings) and the abject state of the little beach, ironically sandwiched between the National Aquarium and the University's Marine Station, strewn with recent plastic trash, and tiny metal detritus from decades, if not centuries, of ship building, trade and fishing. By introducing the story of the 33 Syrian or Greek sisters, we have been experimenting with how the residents might respond to a story that puts their 'forgotten corner' at the heart of an origin-story for the whole country; a story that is diverse in its characters (crossing nationalities, species and human/magical boundaries), places human/unhuman relationships as central to the history of the area, and implicitly proposes that a remaking of the area may not best be done wholly rationally, planned generally, or its future defined anthropocentrically, but at least partly incrementally, cross-species, unhumanly and by fictioning.

While we are far from being ready to present anything close to findings or conclusions from either the 'Endgame' or the 'Smoke Signal' projects, what has emerged from them is a hypothesis: if we fail to tell the stories of places of rewilding, or fail to allow those stories to retell us, we will always be in danger of disenchanting and dislocating both the places and the process. If we allow that disenchanting and dislocating, we risk subjecting rewilding to the same logics of anthropocentric efficiency and exploitation that have created the climate crisis in the first place. If those two propositions are correct, then, alongside scientific assessments of both the human and environmental advantages of rewilding, there is a crucial role for the connective, entangled place-story to play in making rewilding common, widespread and effective.

Living (in) Precarity

Sarah Hopfinger

December 16, 2020

Sarah Hopfinger, resting on a walk in the Peak District.
Photograph by Emily Hopfinger

My name's Sarah, I am 32 years old, and I am in companionship with pain . . .

I am trying to listen to you.
To get to know your qualities, character and atmosphere.
To mark you.
Honour you.
To see what you have to say.
And let you take centre stage.

I have lived with chronic back and neurological pain for over 18 years. Until recently I viewed my pain solely as a barrier to my life and work. During the last two years I have been exploring how to turn towards my pain differently and how to work creatively with it through my arts practice. I am a performance-maker, and I devise movement based live art performances in response to my experiences of being alive in the world today. Through working with, rather than against or in spite of, my pain I am realising that living with pain can provide ongoing lessons in vulnerability, unpredictability, openness and precarity. Arguably, these are key lessons when it comes to the various crises we are living in – the pandemic, the ecological crisis, and more. Many disabled artists and activists have reflected that the realisations many are having during the pandemic are lessons that sick and disabled people have (out of necessity) known about for a long time – for example, how to navigate limitations and unpredictability, and what it means to live in a vulnerable body.

Through reframing living with chronic pain as an experience that has validity and knowledge, what can pain teach us? What kinds of knowledges do people with chronic pain have, where these knowledges might provide particular insights into, and lessons about, what it means to live with, and relate and respond to, wider ecological pain and the pandemic crises? What follows is a critical-creative response to these questions, which includes performance text from a solo performance I created and presented in 2020 at The Work Room (Tramway, Glasgow), *Pain and I,* which explored my relationship to my pain, autoethnographic accounts of my experiences of chronic pain,[1] and wider critical thinking in relation to pain, ecology and precarity.

I am scared of this body.
I am scared of its unpleasant ways,
of its threatening, dizzying, draining and unpredictable ways,
its depleted and loss-of-life ways,
of its troubling and weaker-than-it-was ways.

Donna Haraway argues for the need to "stay with the trouble of damaged worlds" (2016, 150). She proposes that "all of us on Terra - live in disturbing times, mixed-up times, troubling and turbid times",

[1] My personal and performative reflections on living with pain are written in italics.

where the task is to become capable of relating and responding to a damaged and wounded earth (1).

I am scared of what has been worn away and is unrecoverable.
I am scared of this damage.

Haraway explores radical methods, from human-pigeon collaborations to science fiction, for humans to learn to "inhabit . . . [the] vulnerable and wounded earth" (10). Haraway argues that it is necessary and ethical to 'stay with the trouble' of the damaged Earth and with human and nonhuman suffering, where staying with the trouble is how we can become capable of responding to 'devastating' environmental events. Turning towards (as opposed to ignoring, denying or being nihilistic about) the painful realities of widespread ecological suffering is therefore the most realistic way to develop radical methods for contributing to environmental "recuperation" (7). This implies that it is necessary to find ways of being, as it were, 'truly present' with the damaged world and ecological suffering.

I am scared that I am to blame and that I could have done more to help before it got so bad.
I am scared that I have pushed this body too far.
That this body forgets about its possibilities, enthusiasm and aliveness.
I am scared of being stuck in the past, and yearning for how it used to be.
Of being attached to an ideal of this body and wishing it would return to its former glory.
I am scared of living with too much regret.

Furthermore, for Haraway recuperation is not about recovering ecologies to an idealised 'natural' state but about the possibilities for "finite flourishing" within a damaged earth (10). For me, finite flourishing is the condition of living with chronic pain – there is an ongoing process of loss, and of acceptance that my body is finite in its capacities and possibilities.

I've spent a lot of time hating you and a lot of energy to carry on hating you. I've hidden you, ignored you, played you down and planned many times that this time you will disappear for good. But you've hung around. You've stayed with me for 18 years – you've seen me grow into an adult, study, make friends, fall in love, fall out of love, work hard, be

sure of myself, lose my confidence, grieve, become an aunty, welcome in a new sexuality and start to grow grey hair.

Even when you're not loud, not making yourself so known, I think about you every day. You're never not here. You are so committed to me.

You have a pattern that you don't stick to.
You are ever so present and ever so ungraspable.
You are too real and you are not always believed.
I feel as though I know you very well and that I don't know you at all.

Living with chronic pain can be an experience of everyday precarity, where stability – if it exists at all – is a kind of constantly crumbling bridge. Anna Tsing explores "the conditions of precarity, that is, life without the promise of stability", where she proposes that it is "only an appreciation of current precarity as an earthwide condition [that] allows us to notice . . . the situation of our world" (2013, 2-4). Can chronic pain experience involve the development of skills in living with precarity where this might lead to skills in noticing the precarity of the world that we live in?

You might never leave me.
You are my intimate companion.
My unwanted lover.
You know about rage, shame, anxiety, panic and overwhelm.
You know about kindness, fragility and calm.
You know about those lines that go "ring the bells that still can ring, ring the bells that still can ring, forget your perfect offering, there is a crack a crack in everything, there is a crack a crack in everything, that's how the light gets in, that's how the light gets in, that's how the light gets in."
You contain power.
You contain love.
Because of you I care more.
I respect you.

Perhaps what is needed when it comes to engaging with, and responding to, the crises of the pandemic, of wider ecological pain, is an art of 'staying with the trouble', where what artistic practice might offer is the exploration of creative methods for acknowledging and relating to pain?

Seeking the Sea: Performance in a Pandemic

Laura Bissell

January 12, 2021 [1]

Maddie Granlund, Further Down the Beach, Propel festival 2020

An article I had published earlier this year opens with the line "Performance as an art form is live, ephemeral, and of the moment" (Bissell 2020). Are these words still relevant in the context of this global pandemic?

As a performance-researcher I am keen to examine the way in which contemporary performance-making responds to social, political, ecological and cultural events. I have previously written about the flurry of creative activity which was provoked by the Scottish

[1] This text originally appeared in the Royal Conservatoire of Scotland's Research Knowledge Exchange, The Green Room in June 2020.

Referendum in 2014 and the way in which performance became a site for debate and dialogue alongside various political events including the EU referendum and a General Election (Bissell and Overend 2015c; Bissell 2019).

The article I cited initially uses case studies of live performances which happen on tidal spaces to explore ideas of memorialising. Since the government guidelines for quarantine started on 23rd March, I haven't been to a coastline or seen a live performance. What I have witnessed is performance-makers responding to the challenge of how to make art in a pandemic, both practically, since the 'art of assembly' discussed by Nicholas Berger (2020) is no longer possible, and also conceptually, as themes of isolation, connection, communication and community permeate the work.

I may not have travelled beyond my own home and certainly not to a coastline, but the site-responsive nature of my enquiries is not completely redundant. I have come to know my own home very intimately and in different guises. It is now my workplace, my daughter's nursery, my bar, my restaurant, my social space, sleeping space and performance space. It is a place where I am audience now.

If performance is "live, ephemeral, and of the moment" as I confidently claimed a few months ago, how do each of those defining terms stand up to scrutiny in this current context? Firstly, there is no 'live', or certainly not as we understood it previously. What there is instead is the mediated live, a performer, in their space, while I watch them remotely in my space in real time. The invitation to watch their live action remains the same, however, physical proximity and a sense of shared physical space is impossible. With this, the complex transaction of audience and performer must be reconfigured, the subtle shifts in body language and the lingering eye-contact which has been so vital to nurturing connection, intimacy and trust, has been disrupted by the screen.

When I called performance ephemeral, I was thinking of Peggy Phelan (1993) and Philip Auslander's (2008) debate about whether live performance is a fleeting, once-in-a-moment experience, "its only life is in the present" or if mediation can also be considered a part of the live; and, as Auslander claimed "live forms have become mediatised".

I said that performance was 'of the moment'. This concept moves away from having temporal significance and can be considered literally. The performances being developed over digital platforms just now are of the moment in fact, they are distinctively and uniquely of *this* moment. The context of quarantine and self-isolation is demanding that performance changes, in some ways quite radically, in order to exist. It is *of the moment* because unlike previous social or political situations that might shape content of work, the global pandemic has completely shifted the context, forms and mediums in which we can work.

Seminal companies such as Forced Entertainment, largely theatre-based, have moved to the digital platform of choice, Zoom, to critique and question how we connect in this new online forum in their three part series *End Meeting for All.* Artistic Director of Gateshead International Festival of Theatre (GIFT), Kate Craddock, took the bold decision to move the entire festival online (May 2020). One of the stand-out performances of the festival was Icelandic artist (and Contemporary Performance Practice directing mentor) Gudrun Soley Sigurdardottir's live performance *Elision*, amended for a digital platform. Its themes of isolation and division originally responding to her experience of living in the UK during Brexit took on an added resonance in this time of isolation.

I argued in my doctoral thesis, that, as artistic director of Belgian company CREW Eric Joris claimed, technology can be a way to *regress* rather than progress. He uses the term regression without negative connotations, instead implying that technology's greatest gift might be its capacity to remind us of a more embodied way of being, a means of heightening the senses so we can return to a recognition and an awareness of our corporeal being. It has not always felt like this in these months of constant screen time, but there is a lot we can take from this current moment in terms of our understanding and appreciation of the live. The definition of 'contemporary' is 'existing or happening now', and in my capacity as a scholar of contemporary performance I will interrogate the impossibility of the live, the differently live, the new demands of audiences and performers as we navigate this moment. What will performance be after this? What will it look like? How will it feel?

These questions offered a framework for the Contemporary Performance Practice Propel festival which took place from 3-12 June 2020. Propel showcases work from all levels of the BA (Hons) Contemporary Performance Practice and is the culmination of all of the performance-making processes of the academic year. In 2020, for the first time, due to the lockdown restrictions, the Propel festival was presented as a festival of digital performance and was performed over various online platforms including Zoom, Zoom Webinar, YouTube Live, Instagram, a website, chatroom, and even a live performance over the phone. Final assessments for modules such as Re-Imagining Classic Text, Choreography, Performance Writing and Artist Commissions in Directing, Site-specific Practice and Arts in Inclusive Practice were shared online over two weeks, supplemented with artist talks and a final Contemporary Performance Critical Encounters event. The student (and staff) learning this term has been not only how to offer our curriculum online, but actually how artistically we can create new work online. The platforms available are not designed for creating performance, but students quickly adapted them and used them for this purpose. Did the festival feel 'live'? I hope so. It was ephemeral as it is now over (although we do have documentation of the work) and Propel was certainly of *this* moment. The global response to George Floyd's murder meant we opened the festival a day late and many of the events suggested ways of donating to anti-racist causes in support of the Black Lives Matter movement.

Oh, and I also 'visited' a coastline via Maddie Granlund's *Further Down the Beach*, part of a diptych of site-specific works called *A Site Seen From Within and Without* alongside Craig McCorquodale's *Intervals*. While there is a sense of grief and anxiety for what is being lost at this moment, I am also immensely energised and excited about what a new generation of artists can do to respond to what is happening in the world and to help us understand it, question it, mourn it, celebrate it, and learn from it. What else is art for?

References

Anderson, J and K. Peters. 2014. *Water Worlds: Human geographies of the ocean.* Ashgate

Angelaki, V. 2017. *Social and Political Theatre in 21ˢᵗ-Century Britain: Staging crisis.* Bloomsbury Methuen Drama

Augé, M. 2009. *Non-places: Introduction to an anthropology of supermodernity.* Verso Books

Auslander, P. 2008. *Liveness: Performance in a mediatized culture.* Routledge

Bectu. 2020. 'Theatre job losses jump from 3000 to 5000 in a month, reports Bectu'. http://bit.ly/routes01

Berger, N. 2020. 'The forgotten art of assembly or, why theatre makers should stop making'. *Medium.* http://bit.ly/routes02

Berry, W. 2012. 'The Peace of Wild Things', *New Collected Poems.* Counterpoint

Birch, A. 2012. Editorial. *Contemporary Theatre Review,* 22 (2), 199-202

Bissell, L. 2011. 'The Female Body, Technology and Performance: Performing a feminist praxis.' PhD Thesis. University of Glasgow

_____ 2019. There *is* Such a Thing: Feminist mimesis in contemporary performance in the UK, *Contemporary Theatre Review* 28 (4), 522-536

_____ 2020. 'Ecologies of Practice: Landscaping with beavers'. *RUUKKU: Studies in Artistic Research* 14

_____ 2021. 'Tidal Spaces: Choreographies of remembrance and forgetting'. *Cultural Geographies* 28 (1), 177-184

Bissell, L. and D. Overend. 2015a. 'Reflections on a Mobile Train Conference from Helsinki to Rovaniemi'. *Cultural Geographies* 22 (4), 731–735

_____ 2015b. 'Regular Routes: Deep mapping a performative counterpractice for the daily commute'. *Humanities* 4 (3), 476-499

_____ 2015c. 'Early Days: Reflections on the performance of a referendum'. *Contemporary Theatre Review* 25 (2), 242-250

Bourriaud, N. 2009. *The Radicant*. Lucas & Sternberg

Braidotti, R. 2011. *Nomadic Subjects: Embodiment and sexual difference in contemporary feminist theory* 2nd ed. Columbia University Press

Brown, M. and B. Humberstone (eds). 2015. *Seascapes: Shaped by the sea*. Ashgate

Büscher, M. and J. Urry. 2009. 'Mobile Methods and the Empirical', *European Journal of Social Theory* 12 (1), 99-116

Carr, N. 2009. Is Google making us stupid?. *The Atlantic*, http://bit.ly/routes03

_____ 2010. *The Shallows: How the internet is changing the way we think, read and remember*. Atlantic Books

Carson, R. 2014a. *The Edge of the Sea*. Unicorn Press

_____ 2014b. *The Sea Around Us*. Unicorn Press

Cixous, H. 1997. *Rootprints: Memory and life writing*. Routledge

Collignon, F. 2011. Soft Technology. *Skying: Art, landscape and renewable energy*. http://bit.ly/routes04

Conrad, J. 1988. *The Mirror of the Sea and a Personal Record*. Oxford University Press

Crab & Bee, Lockdown Boat Burn, Youtube. http://bit.ly/routes06

_____ The Box, Plymouth. http://bit.ly/routes07

Cresswell, T. 2020. 'Valuing Mobility in a Post COVID-19 World', *Mobilities*

Dadvand, P., *et al*. 2017. 'Lifelong Residential Exposure to Green Space and Attention: A population-based prospective study', *Environmental Health Perspectives* 125 (9)

De Botton, A. 2003. *The Art of Travel*. Penguin Books

De Certeau, M. 1988. *The Practice of Everyday Life*. University of California Press

Deleuze, G. and F. Guattari. 1988. *A Thousand Plateaus*. The Athlone Press

Delgado, M.. and C. Svich. 2002. *Theatre in Crisis?: Performance manifestos for a new century*. Manchester University Press

Donald, M., 2012. 'The Urban River and Site-specific Performance', *Contemporary Theatre Review* 22 (2), 213-223

Edensor, T. 2003. Defamiliarizing the Mundane Roadscape. *Space and Culture* 6 (2), 151–168

_____ 2011. Commuter: Mobility, rhythm and commuting. In T. Cresswell and P. Merriman (eds.), *Geographies of Mobilities: Practices, spaces, subjects*, 189–204. Surrey: Ashgate

Elliott, A. and J. Urry. 2010. *Mobile Lives*. Routledge

Farley, P. and M. Symmons Roberts. 2011. *Edgelands*. Jonathan Cape

Friedlingstein, P. *et al.* 2020. Global Carbon Budget 2020, *Earth System Science Data* 12 (4), 3269–3340

Gallagher, W. 2009. *Rapt: Attention and the focused life*. Penguin

Gilroy, P. 2013. *The Black Atlantic: Modernity and double consciousness*. Verso.

Groot Nibbelink, L. 2019. *Nomadic Theatre: Mobilizing theory and practice on the European stage*. Methuen Drama

Guggenheim, M. and O. Söderström. 2010. *Re-shaping Cities: How global mobility transforms architecture and urban form*. Routledge

Haanappel, P.P.C. 2020. Slots: Use it or Lose it, *Air and Space Law* 45, 83-93

Haraway, D. 2016. *Staying with the Trouble: Making kin in the Chthulucene*. Duke University Press

Hartman, S. 2007. *Lose Your Mother: A journey along the Atlantic slave route*. Farrar Straus Giroux

Hirata, A. 2011. *Tangling*. INAX Publishing

hooks, b. 2003. *Teaching Community: A pedagogy of hope*. Routledge.

Ingold, T. 2000. *The Perception of the Environment: Essays on livelihood, dwelling and skill*. Routledge

_____ 2016. *Lines: A brief history*. Routledge

International Federation for Theatre Research. 2013. Theatre and the nomadic subject mobile train conference call for papers. http://bit.ly/routes08

Jamie, K. 2003. Into the Dark. *London Review of Books* 25 (24), 29-33

_____ 2012. *Sightlines: A conversation with the natural world*. Sort of Books

Julie's Bicycle. 2010. *Moving Arts: Managing the carbon impacts of our touring (theatre report)*. http://bit.ly/routes10

Kaye, N. 2000. *Site-specific Art: Performance, place and documentation.* Routledge

Kerr, M. and D. Key. 2013. *Evidence of Natural Change: Case studies from the Scottish education sector.* Natural Change Foundation

Kershaw, B. 2007. *Theatre Ecology: Environments and performance events.* Cambridge University Press

_____ 2012. '"This is the way the world ends, not ...?": On performance compulsion and climate change'. *Performance Research* 17 (4), 5-17

Klein, N. 2014. *This Changes Everything.* Penguin Random House

Kühn, S., *et al.* 2017. 'In Search of Features that Constitute an "Enriched Environment" in Humans: Associations between geographical properties and brain structure'. *Sci Rep* 7. 11920

Lefebvre, H. 2004. *Rhythmanalysis: Space, time and everyday life.* A&C Black

Lone Twin. 2012. *The Boat Project: Maiden voyage.* Lone Twin Programme Guide

Lorimer, J. and R. Fairfax-Cholmeley. 2020. *The Wild Ways of the Oak.* Flagstone Press

Mack, J. 2011. *The Sea: A cultural history.* Reaktion Books

Massey, D. 2005. *For Space.* Sage Publications

Merriman, P. and T. Cresswell. 2012. *Geographies of Mobilities: Practices, spaces, subjects.* Ashgate.

Monbiot, G. 2015. 'Thinking like an elephant'. http://bit.ly/routes11

Morton, T. 2018. *Being Ecological.* Penguin Random House

Muir, J. 1979. *John of the Mountains: The unpublished journals of John Muir.* University of Wisconsin Press

Natural Change. http://www.naturalchange.co.uk

Newport, C. 2016. *Deep Work: Rules for focused success in a distracted world.* Piatkus

Ogden, L, C. Marambio and C. Gast. 2017. Dreamworlds of Beavers. *Ensayos.* http://bit.ly/routes12

Overend, D. 2011a. 'Underneath the Arches: Developing a relational theatre practice in response to a specific cultural site.' PhD Thesis. University of Glasgow

_____ 2011b. 'David Overend explores pathways in performance'. *Making Routes*, http://bit.ly/routes13

_____ (ed.). 2012. *Making Routes: Journeys in live art*. Live Art Development Agency

_____ 2013a. 'Making Routes: Relational journeys in contemporary performance'. *Studies in Theatre and Performance* 33 (3), 365-381

_____ 2013b. 'World Wide Wandering: E-drifting in Paris and London'. *Scottish Journal of Performance* 1 (1), 31–52

_____ 2015. 'Dramaturgies of Mobility: On the road with Rob Drummond's *Bullet Catch*'. *Studies in Theatre and Performance* 35 (1), 36-51

_____ 2021. 'Field Works: Wild experiments for performance research', *Studies in Theatre and Performance*. Advance online publication

Overend, D. and J. Lorimer. 2018. 'Wild Performatives: Experiments in rewilding at the Knepp Wildland Project', *GeoHumanities* 4 (2), 527-542

Pearson, M. 2006. *"In comes I": Performance, memory and landscape*. University of Exeter Press

_____ 2010. *Site-Specific Performance*. Palgrave Macmillan

Phelan, P. 1993. *Unmarked*. Routledge

Rae, P. and M. Welton. 2007. Editorial: 'Travelling performance'. *Performance Research: A Journal of the Performing Arts* 12 (2), 1-4

Reason, M. 2003. 'Archive or Memory? The detritus of live performance'. *New Theatre Quarterly* 19 (1), 82-89

Remen, R. N. 1999. 'Educating for Mission, Meaning, and Compassion' in S. Glazer (ed.). *The Heart of Learning: Spirituality in education*. Tarcher/Putnam. pp. 33-50

Roach, J. 1996. *Cities of the Dead: Circum-Atlantic performance*. Columbia University Press

Ross, B. 2002. *How to Haiku: A writer's guide to Haiku and related forms*. Tuttle Publishing

Shapiro, D. 2013. *Still Writing. The perils and pleasures of a creative life*. Grove Press

Sheller, M. and J. Urry. 2006. 'The New Mobilities Paradigm'. *Environment and Planning A* 38 (2), 207–226

Shoard, M. 2000. 'Edgelands of Promise'. *Landscapes* 1 (2), 74-93

Six Wild Ways of the Oak, the. Jamie Lorimer, Sofie Narbed, David Overend, Jenny Swingler and Scott Twynholm. Available as an audio track at http://bit.ly/routes14

Skantze, P. A. 2013. *Itinerant Spectator/Itinerant Spectacle*. Punctum Books

Smith, P. 2010. *Mythogeography*. Triarchy Press

_____ 2012. *Counter-tourism: The handbook*. Triarchy Press

_____ n.d. Counter-tourism: An important statement. *Counter-tourism* http://bit.ly/routes15

Solnit, R. 2006. *A Field Guide to Getting Lost*. Canongate

_____ 2013. *The Faraway Nearby*. Granta Books

_____ 2020 'The impossible has already happened': What coronavirus can teach us about hope. *The Guardian* http://bit.ly/routes16

Tree, I. 2018. *Wilding: The return of nature to a British farm*. Picador

Trubridge, S. 2016. 'On Sea/At sea: An introduction'. *Performance Research* 21 (2), 1-6

Tsing, A. L. 2013. *The Mushroom at the End of the World: On the possibility of life in capitalist ruin*. Princeton University Press

Urry, J. 2007. *Mobilities*. Polity

_____ 2013. *Societies Beyond Oil: Oil dregs and social futures*. Zed Books

Vera, F. 2000. *Grazing Ecology and Forest History*. CABI Publishing

Watts, L. 2008. Travel Time Use in the Information Age Key Findings: Travel times (or journeys with Ada). London: Department for Transport. http://bit.ly/routes17

Watts, L. and G. Lyons. 2011. 'Travel Remedy Kit: Interventions into train lines and passenger times'. In M. Büscher, J. Urry and K. Witchger (eds.). *Mobile Methods*, 104–18. Routledge

Welton, M. 2007. 'Feeling like a Tourist'. *Performance Research* 12 (2), 47-52

Wilkie, F. 2008. 'The Production of "Site": Site-specific theatre' in N. Holdsworth and M. Luckhurst (eds.) *Concise Companion to Contemporary British and Irish Theatre*, 87-106. Blackwell

_____ 2012. 'Site-specific Performance and the Mobility Turn'. *Contemporary Theatre Review* 22 (2), 203–212

_____ 2015. *Performance, Transport and Mobility: Making passage.* Palgrave Macmillan

Williams, D. (ed.). 2012. *The Lone Twin Boat Project.* Chiquilta Books

Wyles K.J. *et al.* 2019. 'Are Some Natural Environments More Psychologically Beneficial Than Others? The importance of type and quality on connectedness to nature and psychological restoration', *Environment and Behavior* 51 (2), 111-143

Yuill, S. (2012). 'Given to the People'. http://www.giventothepeople.org/

Also available from Triarchy Press

On Walking... and Stalking Sebald
Phil Smith ~ 2014, 198pp.
"a life-changing beautiful book!" **Avi Allen, Capel y Graig**
Phil describes a walk he made in Suffolk in the footsteps of W.G.
Sebald and sets out his approach to 'conscious walking'.

A Sardine Street Box of Tricks Crab Man & Signpost
(Phil Smith & Simon Persighetti) ~ 2012, 84pp.
*"a terrific resource...a handbook for making a one street 'mis-guided
tour'."* **John Davies**, author of *Walking the M62*

Enchanted Things: Signposts to a New Nomadism
Phil Smith ~ 2014, 98pp.
A photo essay focusing on signs, simulacra, objects and places that
prove to be more, less or other than what they seem.
*"...you'll find our cities and countryside ripe with hidden meanings, visual
puns and unintended contradictions..."* **Gareth E Rees**

Mythogeography: A guide to walking sideways
Phil Smith ~ 2010, 256pp.
The book that started it all *"mocks and subverts traditional expectations
... in a field where silly concepts are written of with gaunt severity,
Mythogeography might be singled out for its dedication to chaos."* **Journal
of Cultural Geography**

**Counter-Tourism: A Pocketbook: 50 odd things to do in a heritage
site** ~ **Phil Smith** ~ 2012, 84pp.
*"Buy the book! Just think what we could do in Poland with this. I love
Mythogeography. A whole new take on the world. Always fresh. Great
way to shake loose entrenched forms of heritage
tourism."* **Prof. Barbara Kirshenblatt-Gimblett**

Walking's New Movement
Phil Smith ~ 2015, 98pp.
A guide to developments in walking and walk-performance for
enthusiasts, practitioners, students and academics.

Desire Paths
Roy Bayfield ~ 2016, 142pp.
"Roy Bayfield rises from the dead and re-discovers walking as a way of life... a fine mythogeographical grimoire." **Gareth E Rees**

Counter-Tourism: The Handbook
Phil Smith ~ 2012, 228pp.
"...funny and irreverent ...Heritage sites and museums would do well to take on some of his ideas, especially those on multiple meaning and injecting fun into visits." **Museums Journal**

Alice's Dérives in Devonshire
Phil Smith ~ Foreword: **Bradley L. Garrett**, 2014, 216pp
A modern fairy tale. *"I have found every possible excuse to creep away and read it... how beautiful, bewildering and breathtaking it is. I don't want it to end..."* **Katie Villa**

Anywhere: A mythogeography of South Devon
Cecile Oak (Phil Smith) ~ 2017, 366pp.
A vivid portrait of a small part of South Devon... An adventure, momentous and fleshy as any novel. It is also the first, detailed mythogeographical survey of a defined area.

The Footbook of Zombie Walking
Phil Smith ~ 2015, 150pp.
Despair, climate change, zombie films, apocalypses, city life, walking & walk-performance... *"a very fine book... I recommend it to everyone with an interest in walking-philosophy"* **Ewan Morrison**

The MK Myth Phil Smith & K ~ 2018, 192pp.
A novel for decaying times set in Milton Keynes.

Rethinking Mythogeography
John Schott & Phil Smith ~ 2018, 52pp.
An illustrated upgrade to the principles & practice of mythogeography.
"...ideas spin in high frequency, creating a shadow walk more vivid than the real one." **Mary Paterson**

Bonelines
Phil Smith & Tony Whitehead ~ 2020, 362pp.
A dark novel set in Devon's Lovecraft Villages.

Walking Art Practice: Reflections on Socially Engaged Paths
Ernesto Pujol ~ 2018, 160pp.
A text for performative artists, art students and cultural activists that brings together Pujol's experiences as a monk, performance artist, social choreographer and educator.

Walking Bodies
eds **Helen Billinghurst, Claire Hind, Phil Smith** ~ 2020, 340pp.
Papers, provocations and actions from the 'Walking's New Movements' conference (University of Plymouth, Nov.2019)

Guidebook for an Armchair Pilgrimage
John Schott, Phil Smith, Tony Whitehead 2019, 144pp.
"It is wonderful - a brilliant idea, beautifully done, with a sweetly companionable tone to the writing." **Jay Griffiths**

The Pattern: a fictioning
Helen Billinghurst & Phil Smith (Crab & Bee) ~2020, 208pp.
A handbook for exploration, embodiment and art making. Describes the secrets of 'web-walking'.

The Architect-Walker
Wrights & Sites ~ 2018, 120pp.
An anti-manifesto for changing a world while exploring it.

Walking Stumbling Limping Falling: A Conversation
Alyson Hallett & Phil Smith ~ 2017, 104pp.
An email conversation between the authors about being prevented from walking 'normally' by illness.

Ways to Wander
eds. **Claire Hind & Clare Qualmann** ~ 2015, 80pp.
54 intriguing ideas for different ways to take a walk - for enthusiasts, practitioners, students and academics.

Ways to Wander the Gallery
eds. **Claire Hind & Clare Qualmann** ~ 2018, 80pp.
25 ideas for ways to walk in and beyond an art gallery.

www.triarchypress.net/walking